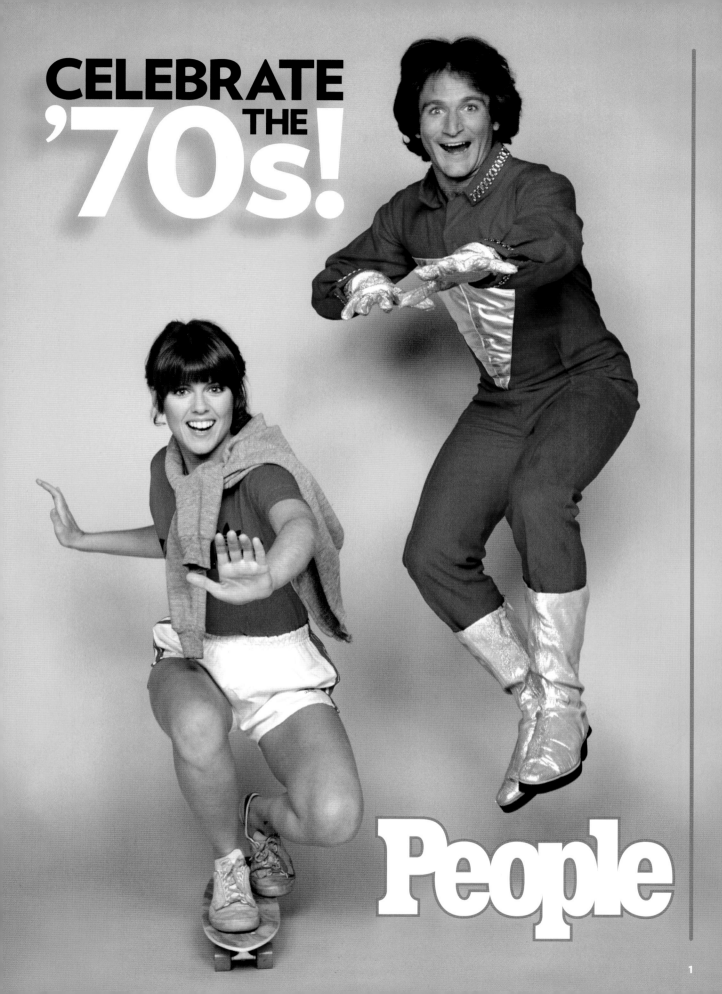

CELEBRATE THE '70s!

People

Contents

6
John Travolta

137
The Smiley Face

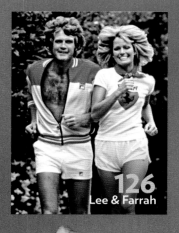

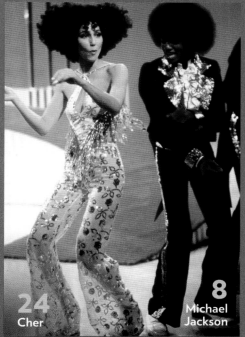

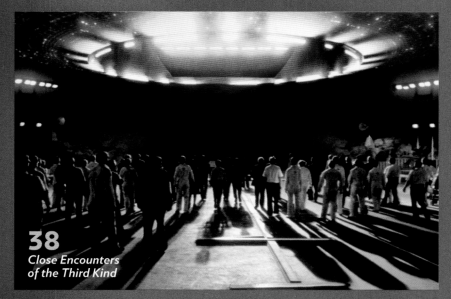

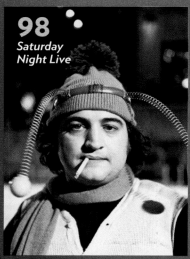

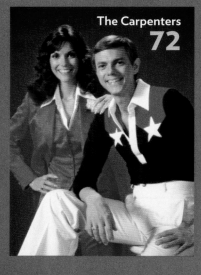

Introduction

FARRAH AND NIXON, Travolta and Jackie O, *Star Wars,* muscle cars, mood rings and Manilow. Put them all together, add some disco and David Cassidy, a pinch of Patty Hearst, a smidgen of *Smokey and the Bandit,* an ounce of ABBA, two slices of *Saturday Night Live* and a fresh cup of Charo. Bake for exactly 22 minutes (the length of a *Brady Bunch* episode) in an avocado-colored oven, and you've got . . . the '70s, a decade of Day-Glo hues, presidential drama, much personal experimentation and—experts of almost every political persuasion agree—far too much shag carpeting.

Come with us now as we explore, from an anthropological perspective, the curious habits of a people who lived long, long—well, at least 30 years—ago. *See* how they build their colorful, often hot-tub-equipped nests! *Marvel* at their exotic mating dances, bright plumage and late-night worship of the glittering "disco ball"! Who were they? What did they want? Why did they drive AMC Pacers painted orange?

These questions and more will be answered if you simply . . . turn the page.

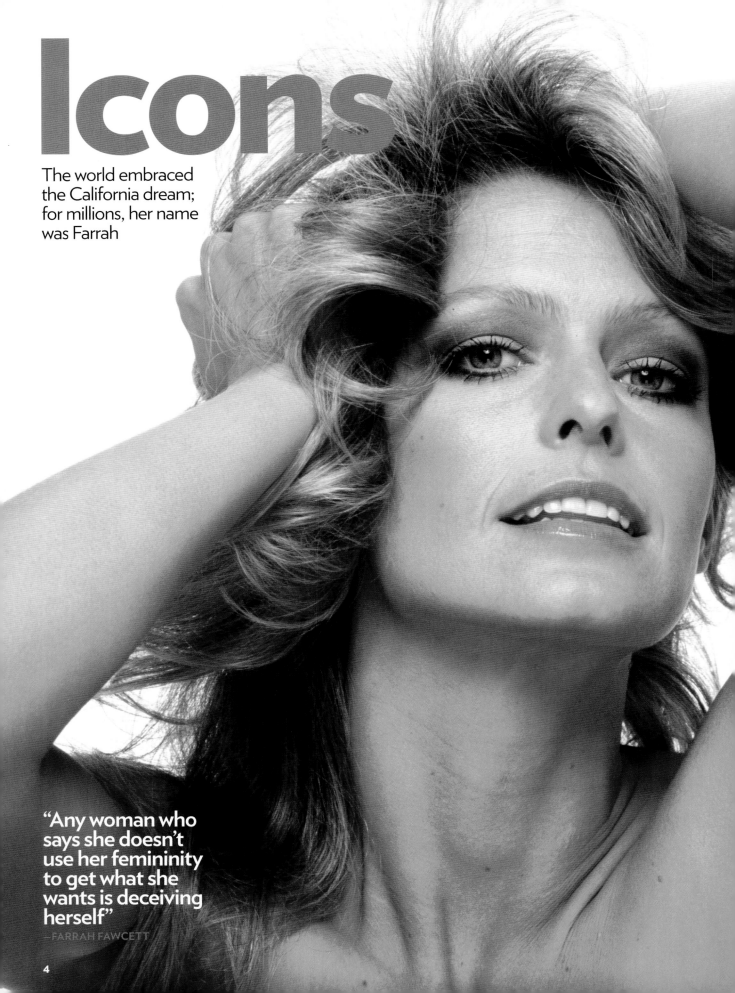

Icons

The world embraced the California dream; for millions, her name was Farrah

"Any woman who says she doesn't use her femininity to get what she wants is deceiving herself"
—FARRAH FAWCETT

Farrah Fawcett

CHARLIE'S ANGELS PREMIERED on ABC on Sept. 22, 1976, and 60 minutes later Farrah Fawcett—all leonine mane and Panavision smile—was a national obsession. Her poster sold a record 12 million copies, and Fawcett-inspired products, from shampoos to cosmetics, flooded the land.

Drama in her personal life added to the fascination. When *Charlie's Angels* began, the Texas-bred Fawcett, 29, was married to Lee Majors, 37, star of the hit series *The Six Million Dollar Man.* Famously, she insisted that her *Angels* contract free her from work in time to return home and cook his dinner. "I do it because I love Lee and I love cooking," she said. She wanted to keep her man happy—which, given their conflicting work schedules, posed challenges. "The other day I caught him coming out of the shower and grabbed him," she told an interviewer. "'Okay,' I said, 'this is it! Now or never!'"

Then, one year into stardom, Fawcett stunned fans and angered Hollywood by quitting the mega-hit show—because, she said later, "I was a sex symbol who wanted

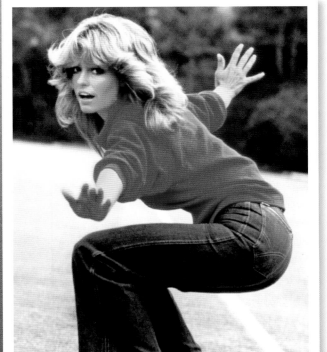

FUN IN THE SUN
Hair, bell-bottoms, skateboard, Nikes: Fawcett captured a '70s moment and the attention of wannabe teen girls, their fashion-curious moms and boys of all ages.

to be an actress." Soon there was a revolution in her marriage too. "When Lee married me, he married a very compliant person who just wanted to . . . be dependent," said Fawcett. "I still like to cook his meals and clean his house, but I'm not dependent anymore." Majors, a good ol' boy from Kentucky, struggled to keep pace with a changing wife and world. "The bottom line," he said, "is I'm lonely and miserable without her."

The couple divorced in 1982; Fawcett went on to have a long relationship with actor Ryan O'Neal. Now 62, she revealed in 2006 that she was battling cancer.

John Travolta

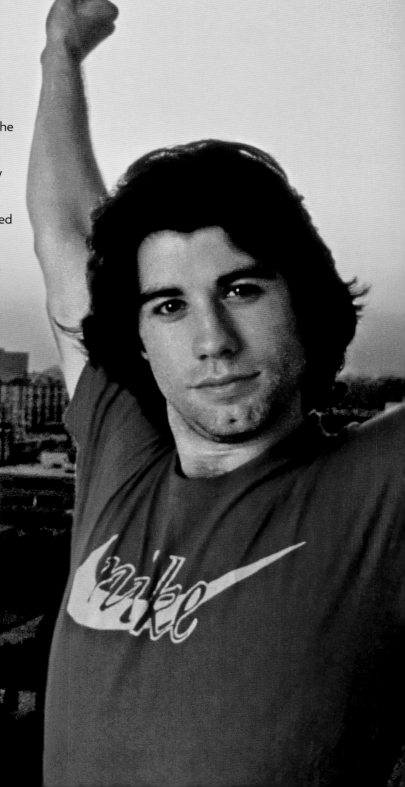

"I NEVER KNOCK VINNIE," SAID JOHN TRAVOLTA. "He broke me through the sound barrier."

Indeed: Vinnie Barbarino, the greaser-with-a-heart-of-gold character on ABC's *Welcome Back, Kotter*, made Travolta, overnight, a teen heartthrob. But the 21-year-old actor-dancer-singer—ambitious, serious and hyper-confident—had much bigger plans and made them come true. First came a couple of hit singles, "Whenever I'm Away from You" and "Let Her In." Then, in quick succession, came two game-changing films: *Saturday Night Fever* in 1977 and *Grease* in 1978 (for good measure, he followed with the boot-scootin' hit *Urban Cowboy* in 1980). After *Fever*, it was no longer just the little girls who understood; *New Yorker* critic Pauline Kael reveled in his "thick raw sensuality. . . . Travolta gets so far inside the role he seems incapable of a false note."

That sort of talk about a teen idol may have surprised many, but probably not Travolta. Flash in the pan? "It's hard to be a flash in the pan," he said, "when your career is booked for the next three years with records, movies and television—that's an awfully long flash."

"My friends thought I was a bit off because I was interested in the theater" —JOHN TRAVOLTA

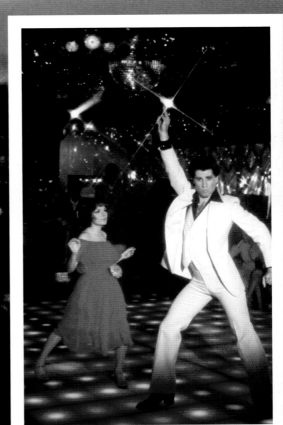

GOTTA DANCE!
Travolta (with Karen Lynn Gorney) honed his boogie for five months before cameras rolled

The Jackson 5

SO HOW DID IT BEGIN? "WE ALL STARTED SINGING together after Tito started messin' with Dad's guitar and singin' with the radio," a precocious—and well-rehearsed—Michael Jackson, age 12, told an interviewer in 1971. "It was Tito decided we should form a group, and we did, and we practiced a lot. . . . And then we did this benefit for the mayor, and Diana Ross was in the audience, and afterward we was in the

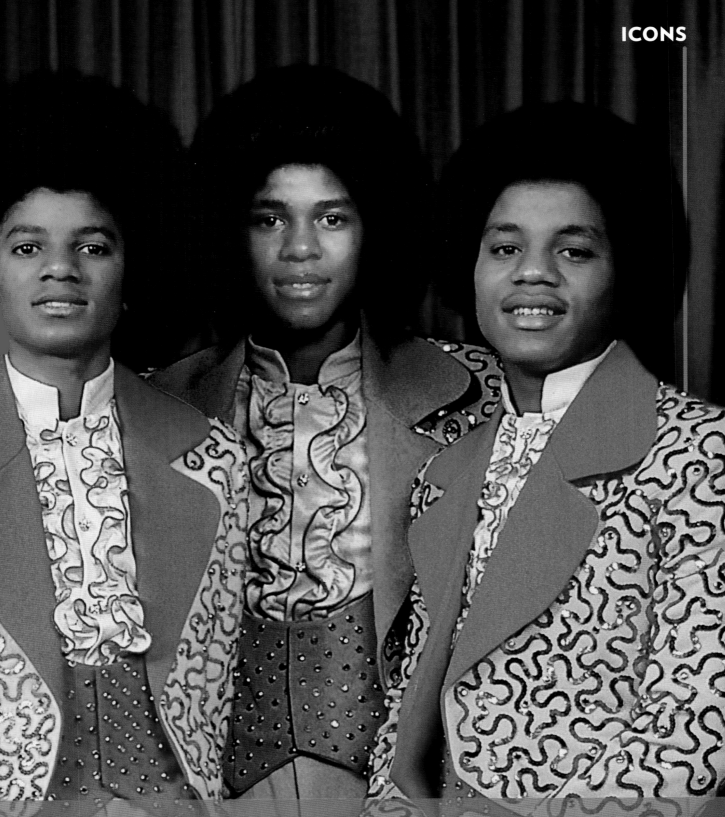

dressin' room and Diana Ross knocked on the door and she brought us to Motown in Detroit and that was it."

Years later, of course, some Jackson children would tell a different story: Michael would claim that his father beat him; sister LaToya that Dad threatened the kids with guns. But in the early '70s the Jackson 5, the mega-selling brother act, were, said TIME, "the most likable and natural" kids "ever to survive the pressures of teenage stardom." Even at the end of the decade, just before *Off the Wall* launched his solo career, gentle, soft-spoken Michael worked hard to appear wholesome. Liquor? Drugs? "People are always shovin' it at you, but it's not beautiful, it's sloppy," he said. "If people want to escape they should walk the beach or be around children."

Jacqueline Kennedy Onassis

SHE WAS INCREDIBLY FAMOUS AND famously private. As the '70s began, Jacqueline Kennedy Onassis was the widow of President John F. Kennedy, the wife of Greek tycoon Aristotle Onassis and a conscientious mom trying hard to raise her children John and Caroline well.

When Onassis died in 1975, she received $20 million. Free to start a new life, she took a job as a book editor in New York City, longing to be treated at the office like anyone else. It wasn't clear that would happen until, shortly after joining Doubleday, Onassis walked into the company snack bar, stopping traffic—and the cashier, a veteran, looked up and said, "Well, Jackie, what'll it be?" The ice was broken.

CASUAL STYLE
Onassis on Madison Avenue in 1971.

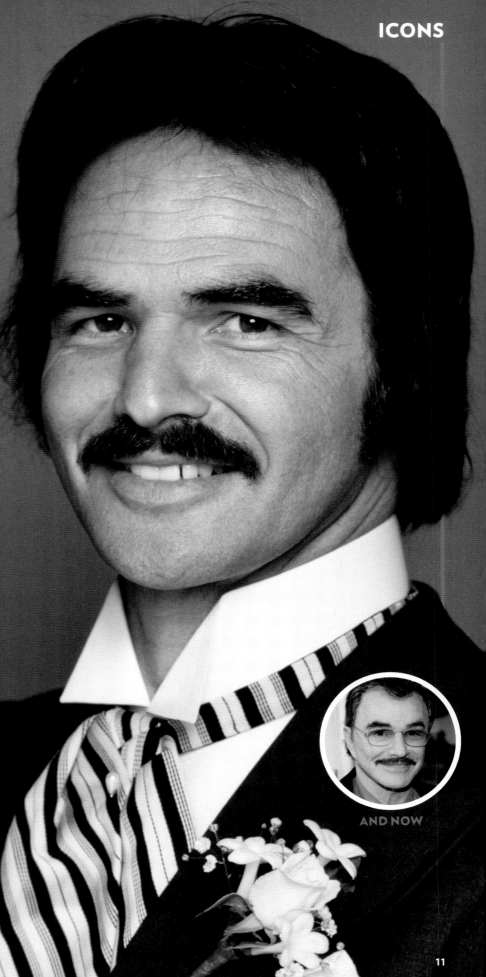

Burt Reynolds

THERE WASN'T MUCH YOU COULD say about Burt Reynolds—or his hairpiece, mustache or affection for double-knit suits—that he wouldn't say himself. And better. When a PEOPLE reporter was stunned to silence by the garish decor of his Sunset Boulevard pad, Reynolds cheerily agreed. "It looks," he said, "like a bullfighter threw up on it, doesn't it?"

And so it went. After shaving his trademark 'stache—live, on *The Tonight Show,* following a dare from Steve Martin—he noted "now I look like a guy who makes love in the bedroom instead of on the living-room floor." When he opened a dinner theater in Florida, he promised season-ticket buyers, "You'll never see a star here that you thought was dead." And he completely understood that his good ol' boy looks left many women unmoved—although, he added, he loved it when "women [rushed] across the room at a cocktail party just to say they don't find me attractive."

No matter; moviegoers loved him, and a string of films including *Hooper* and *Smokey and the Bandit* made him *the* '70s box office behemoth.

AND NOW

11

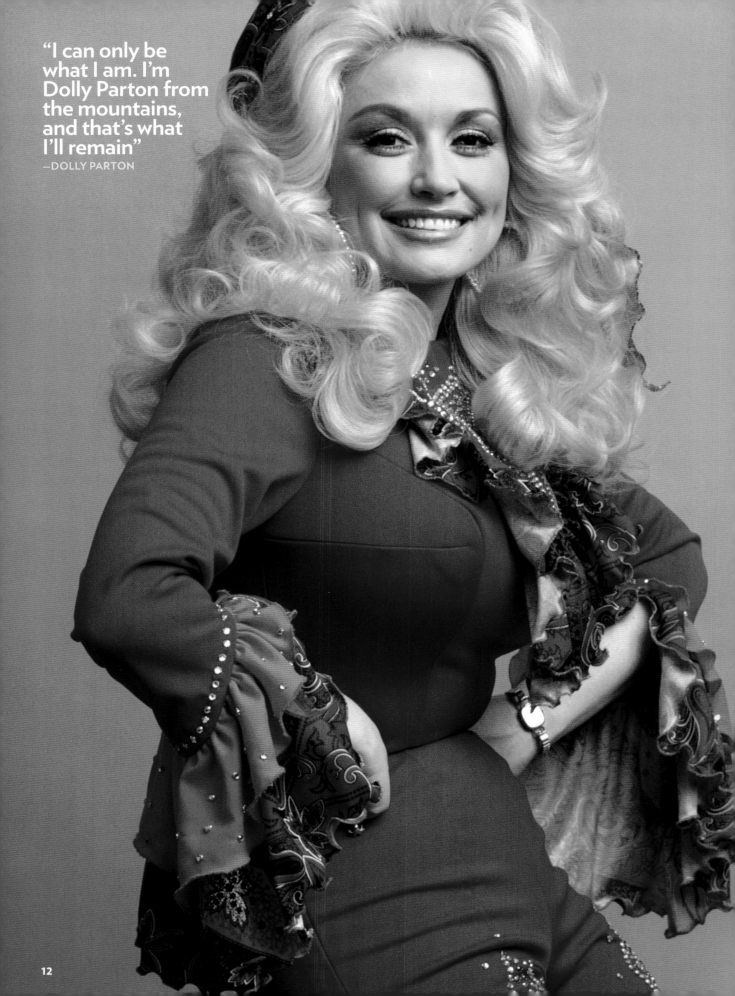

"I can only be what I am. I'm Dolly Parton from the mountains, and that's what I'll remain"
—DOLLY PARTON

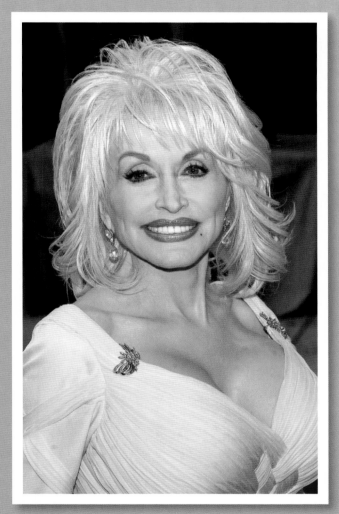

Dolly
Parton

DOLLY PARTON WAS IN ON THE joke; although only 5 ft. tall, she was, she said proudly, "6 ft. 4 ins. with wigs and heels!" Her spangled stage costumes were so tight that, if she sneezed, exploding sequins could injure fans in the first four rows. But beneath the Daisy Mae-on-steroids persona lurked a remarkable voice and prodigious songwriting talent. "She's as creative as anyone I've ever met," said country star Porter Wagoner, who helped discover her, "including Hank Williams."

The '70s saw Parton move from pure country toward pop—and some Nashville purists yelped. It didn't help when Parton let go her old band—which included some of her relatives—in pursuit of a more varied and sophisticated sound. "I want people to know there is a lot more to me—good or bad—than they've seen so far," she said. "These are awfully hurtful decisions I've had to make. . . . I may be an eagle when I fly, but I'm a sparrow when it comes to feelings." She had her first big crossover hit, "Here You Come Again," in 1978; in 1986, she opened her own theme park, Dollywood, in Pigeon Forge, Tenn.

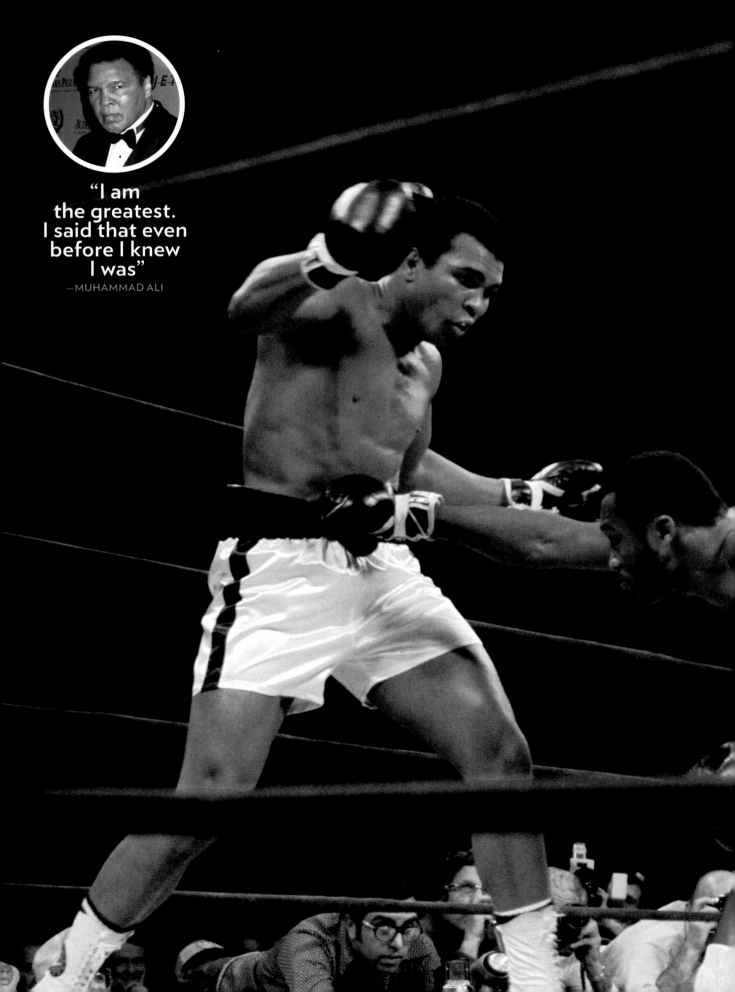

"I am the greatest. I said that even before I knew I was"
—MUHAMMAD ALI

Muhammad **Ali**

ON THE DAY BEFORE THE RUMBLE IN THE JUNGLE, his legendary bout in Zaire against George Foreman, Muhammad Ali—irrepressible, boyish, a sometime magician—opened his hand in the ring and a sparrow flew out. "That's what I am," he said. "When I fight George Foreman, I'm going to fly like a bird."

The moment was classic Ali—lighthearted and teasing in the face of the fight of his life, in which he was a 3-1 underdog and, many thought, hours away from a brutal thrashing by the powerful Foreman. But the bird was also a mental trick, meant to divert the challenger, the press and—it turned out—his own entourage from Ali's real plan. Rather than dance in the ring, he stood and parried Foreman's blows, eventually exhausting the younger fighter and sending him to the canvas in the eighth round.

The Greatest, who had been stripped of the World Heavyweight title seven years before, when he refused to be drafted, was once again King of the World.

LIKE A BUTTERFLY
Ali (dancing away from Joe Frazier at Madison Square Garden) won three brutal fights in a 12-month stretch.

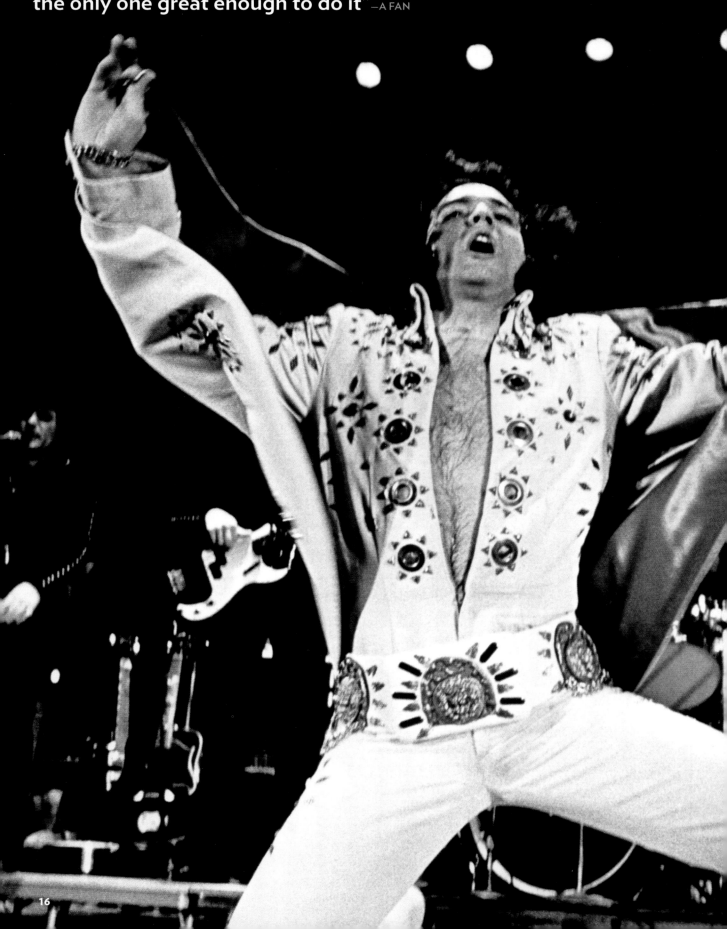

"Elvis is leading God's choir, because he's the only one great enough to do it" —A FAN

Elvis Presley

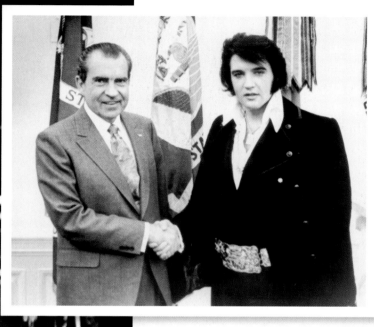

HE RECORDED 107 TOP 40 hits (more than twice the total of the Beatles), but, halfway through the '70s, the King was one crazy hound dog. At home in Graceland, he kept vampire's hours, spending his nights watching kung fu movies, singing gospel with pals and shooting the occasional TV. Rosemary Alden, whose sister Ginger was Elvis's last girlfriend, recalled watching the two of them argue. "Next thing I knew, he took a gun and blew out [his daughter] Lisa Marie's television set," she said. "My heart was in my throat. He just did it, then called downstairs and asked the guy to bring up another. . . . I guess that was someone's job—to throw away the shot-up TVs."

Elvis's sudden death—officially from a heart attack, at age 42 on Aug. 16, 1977—shocked the nation. So, over the next few months, did revelations of his gargantuan appetite for prescription drugs. In later medical hearings, his doctor admitted that during one 20-month period he had prescribed more than 12,000 pills for Elvis and his entourage, "to keep him in good health and physically able to perform for his millions of admirers."

Longtime girlfriend Linda Thompson, exhausted from trying to tame Elvis's wild side, moved out a few months before his death. "Elvis required an unfathomable amount of attention," she said later. "[He] had a self-destructive vein, and I couldn't watch him self-destruct."

NOT-SO-SECRET AGENT
After an out-of-the-blue request from Elvis, President Richard Nixon named him an honorary narcotics agent in 1970. As a thank-you, Elvis gave Nixon a commemorative WW II chrome-plated Colt .45.

Star Tracks
'70s STYLE

What a party! Ten years long! You should have been there too—in bell-bottoms!

18

Jack Nicholson & Anjelica Huston

Fresh from nabbing his *Cuckoo's Nest* Oscar, the actor arrived with a Cheshire grin and longtime steady Anjelica Huston.

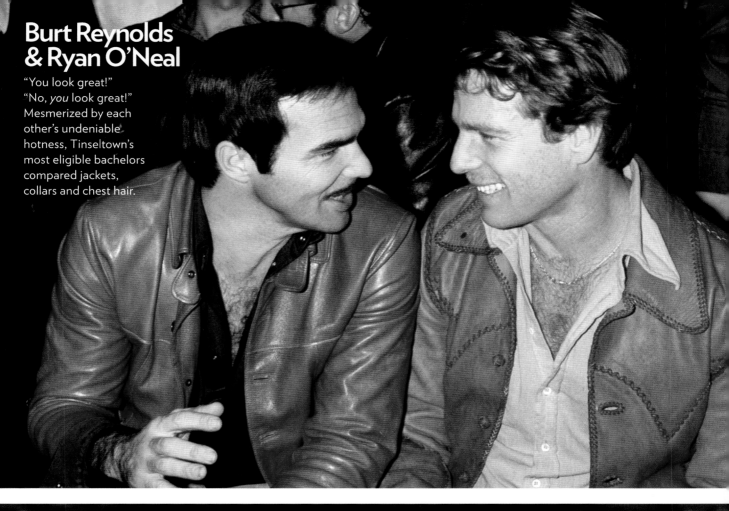

Burt Reynolds & Ryan O'Neal

"You look great!"
"No, *you* look great!"
Mesmerized by each other's undeniable hotness, Tinseltown's most eligible bachelors compared jackets, collars and chest hair.

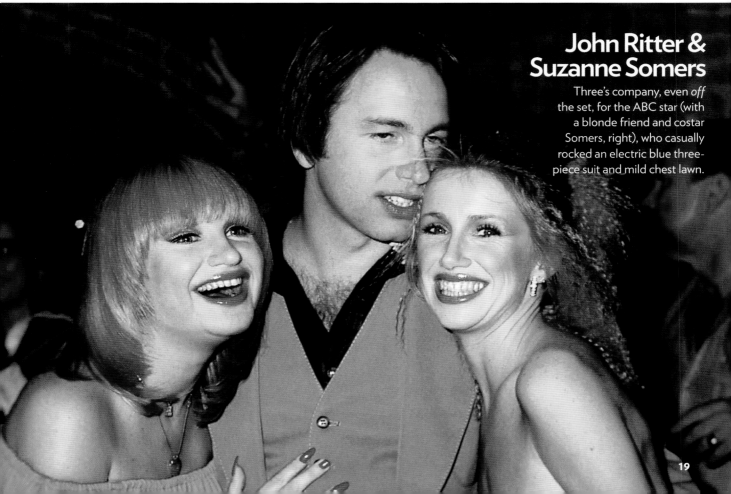

John Ritter & Suzanne Somers

Three's company, even *off* the set, for the ABC star (with a blonde friend and costar Somers, right), who casually rocked an electric blue three-piece suit and mild chest lawn.

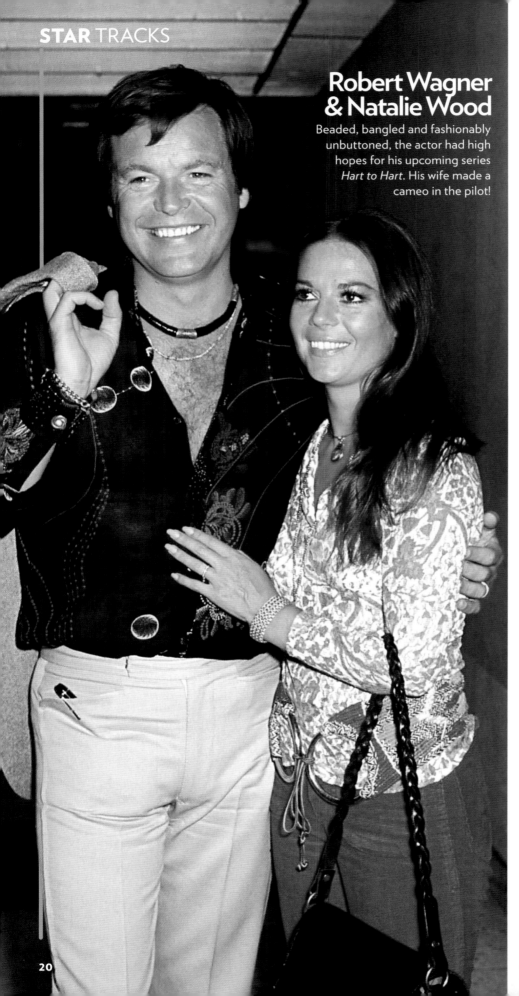

Robert Wagner & Natalie Wood

Beaded, bangled and fashionably unbuttoned, the actor had high hopes for his upcoming series *Hart to Hart*. His wife made a cameo in the pilot!

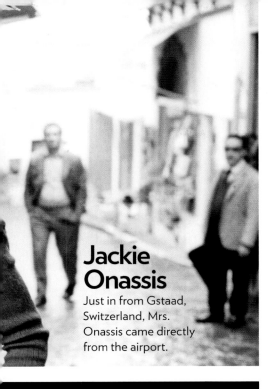

Jackie Onassis

Just in from Gstaad, Switzerland, Mrs. Onassis came directly from the airport.

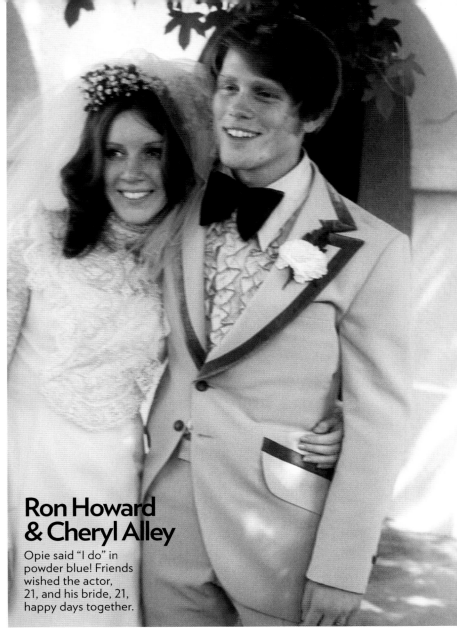

Ron Howard & Cheryl Alley

Opie said "I do" in powder blue! Friends wished the actor, 21, and his bride, 21, happy days together.

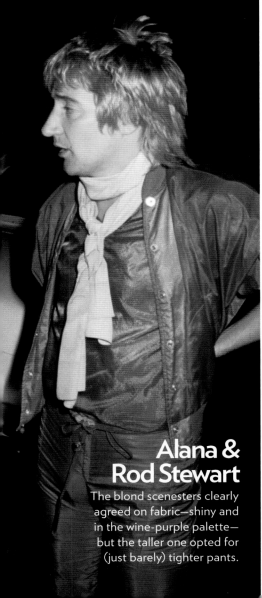

Alana & Rod Stewart

The blond scenesters clearly agreed on fabric—shiny and in the wine-purple palette— but the taller one opted for (just barely) tighter pants.

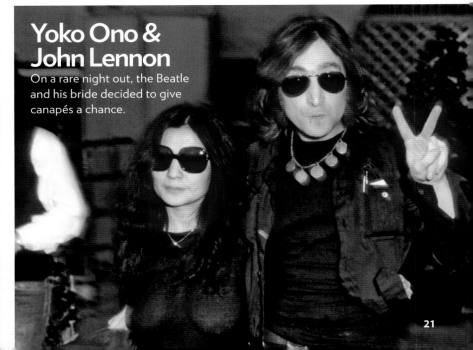

Yoko Ono & John Lennon

On a rare night out, the Beatle and his bride decided to give canapés a chance.

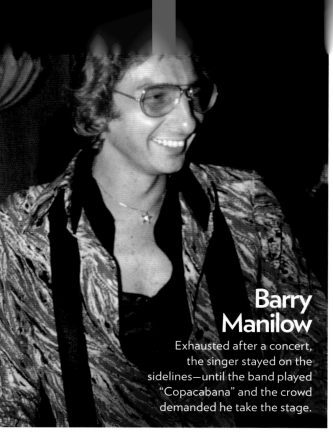

Barry Manilow

Exhausted after a concert, the singer stayed on the sidelines—until the band played "Copacabana" and the crowd demanded he take the stage.

John Belushi & Judy Jacklin

Putting the kibosh on unfounded speculation, *Animal House*'s wild man (with Mary Louise Weller, left, and wife Judy) proved that he owned a suit and tie.

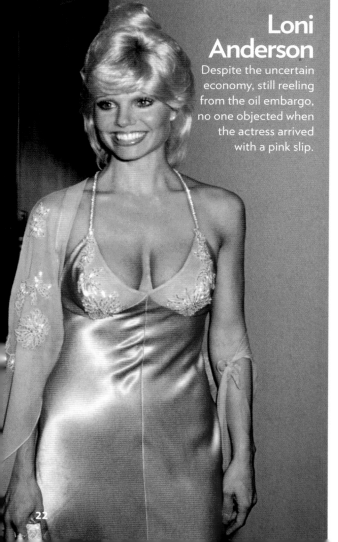

Loni Anderson

Despite the uncertain economy, still reeling from the oil embargo, no one objected when the actress arrived with a pink slip.

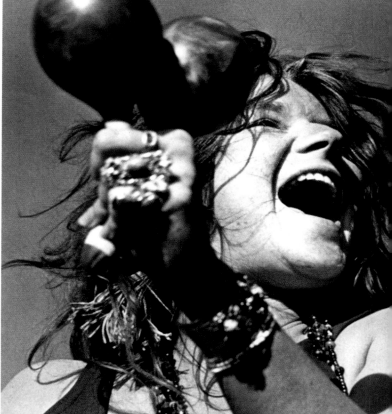

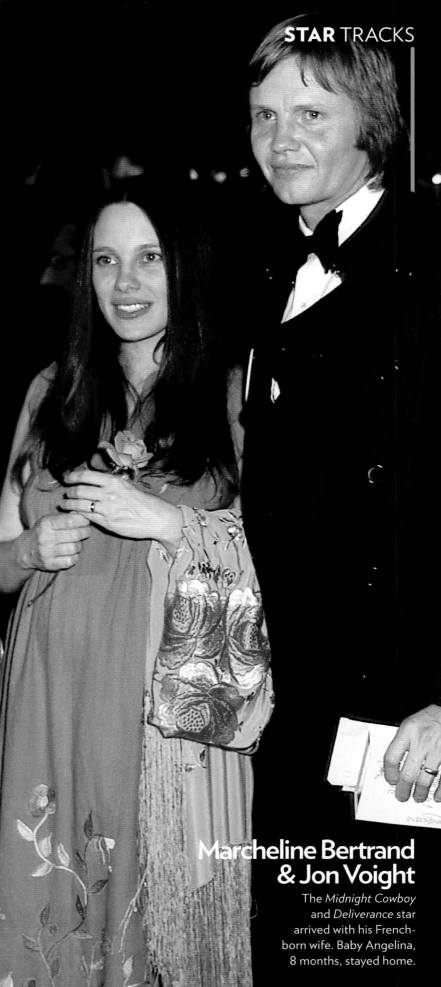

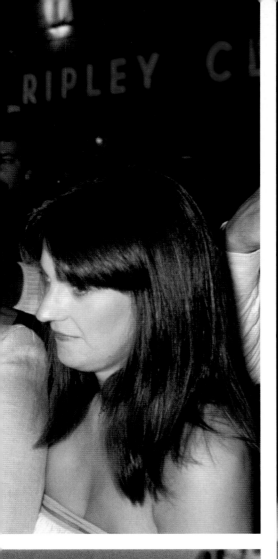

Janis Joplin
Delightfully unpredictable as ever, Pearl—as friends called her—shook her maracas and put on a show.

Marcheline Bertrand & Jon Voight
The *Midnight Cowboy* and *Deliverance* star arrived with his French-born wife. Baby Angelina, 8 months, stayed home.

'70s Style

If you've got it, flaunt it—in hot pants, hip-huggers and peacock colors. '70s fashion was a once-in-a-lifetime experience (if we're lucky)

Cher
THAT'S HOW SHE ROLLED
Carefree and almost clothes-free, Cher, at trendy Venice Beach, Calif., rolled with the latest exercise fad.

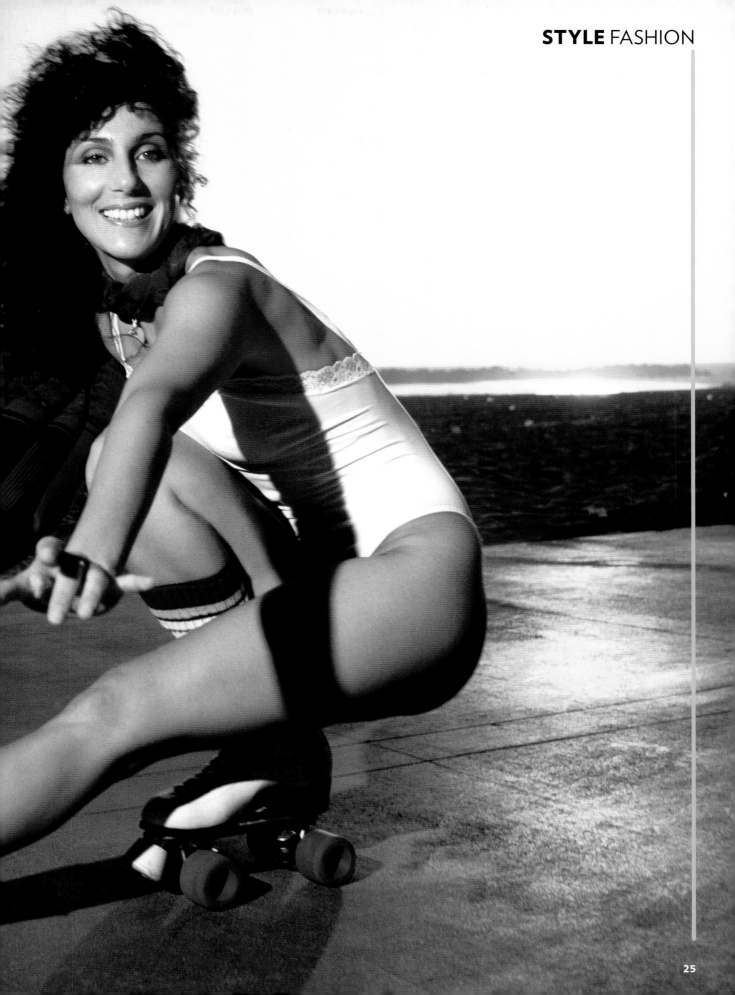

John Denver

Dutch-boy haircut? Check. Two-tone denim sport coat? Check. Flowered shirt, medallion, bell-bottom cords and fur-'n'-leather guitar case? Checkity check-check-check. Citified country boy Denver was ready to (soft) rock.

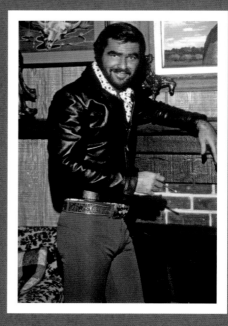

Burt Reynolds

"Hi. I'm Burt. Welcome to my home. And my fireplace. And my art. And my jacket. It can all be a little overwhelming, I know. You look a little faint. May I get you a white-wine spritzer?"

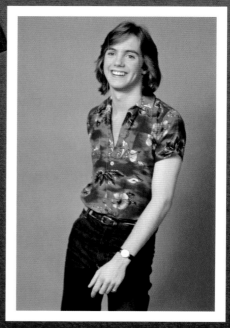

Shaun Cassidy

Hawaiian shirt, skinny jeans, skinny belt: The chances that anyone captured this look better? Slim to none.

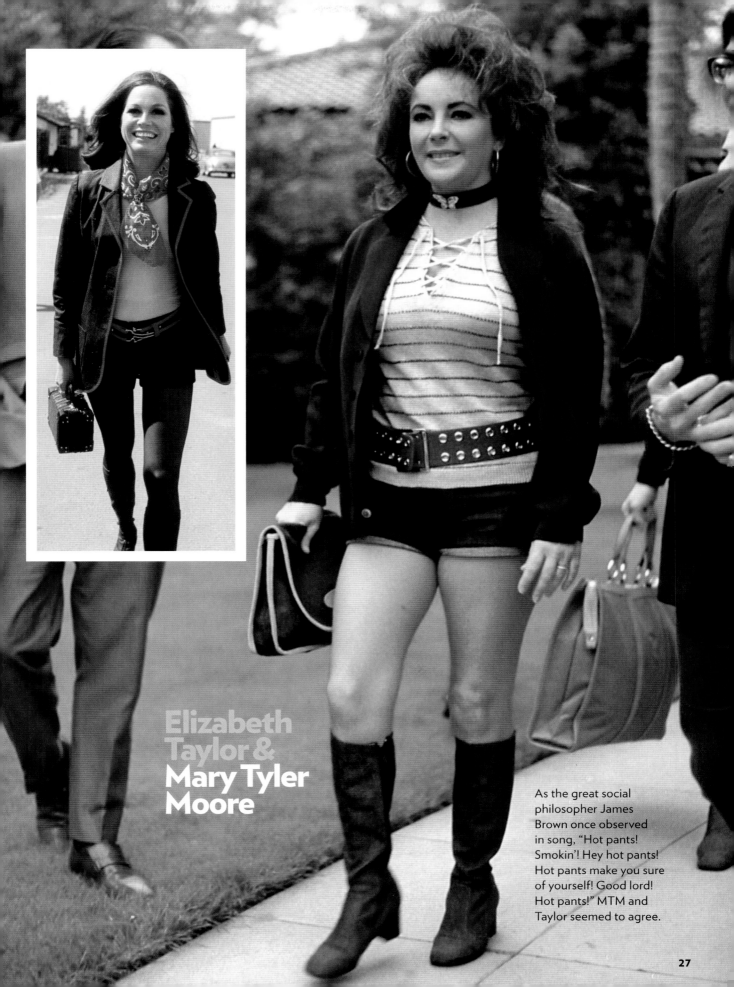

Elizabeth Taylor & Mary Tyler Moore

As the great social philosopher James Brown once observed in song, "Hot pants! Smokin'! Hey hot pants! Hot pants make you sure of yourself! Good lord! Hot pants!" MTM and Taylor seemed to agree.

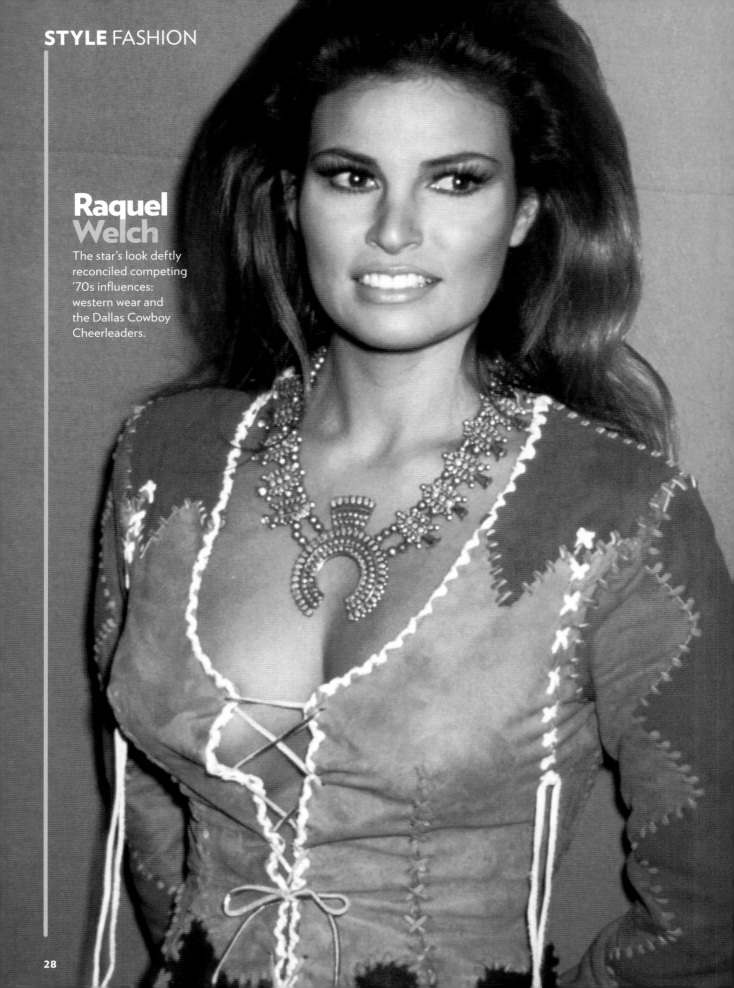

Raquel
Welch

The star's look deftly
reconciled competing
'70s influences:
western wear and
the Dallas Cowboy
Cheerleaders.

'70s HAIR Go Big or Go Bouncy

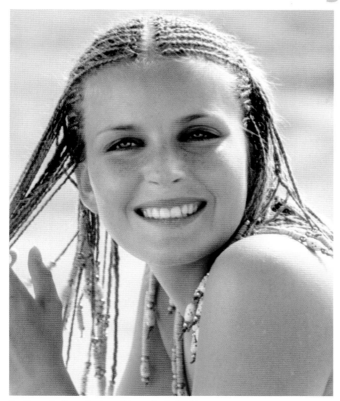
Bo Derek, beaded and braided, 1979.

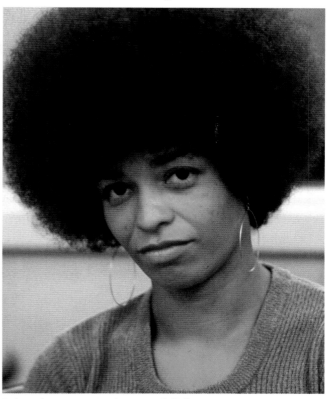
Political activist Angela Davis, full 'fro, 1972.

Olympic great Dorothy Hamill and her "Hamill Wedge," 1977.

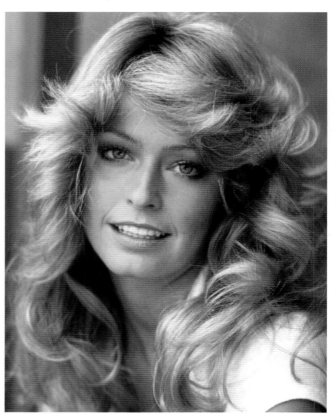
Farrah Fawcett, hair of the gods, ca. 1975.

THE THINGS WE LOVED

Kids: In retrospect, we apologize. But, somehow, shag carpet, trippy typefaces and avocado-hued ovens made sense at the time

Make It Big & Make It Orange

THE 1970 MERCURY CYCLONE SPOILER, a proud totem of the muscle-car era, weighed 3,947 lbs., could pump out 370 horsepower and rolled for nine miles on a ($.35) gallon of gas. Compared to a 2009 Toyota Prius, that's about 1.3 times the weight, 3.4 times the horsepower and one fifth the mpg.

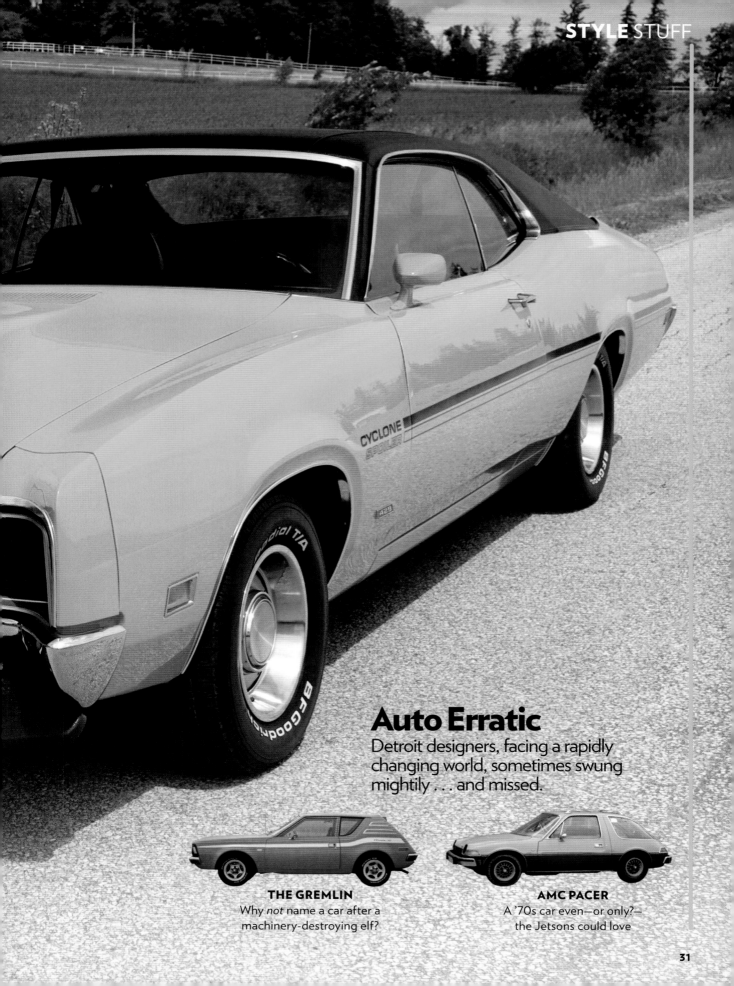

Auto Erratic

Detroit designers, facing a rapidly changing world, sometimes swung mightily . . . and missed.

THE GREMLIN

Why *not* name a car after a machinery-destroying elf?

AMC PACER

A '70s car even—or only?— the Jetsons could love

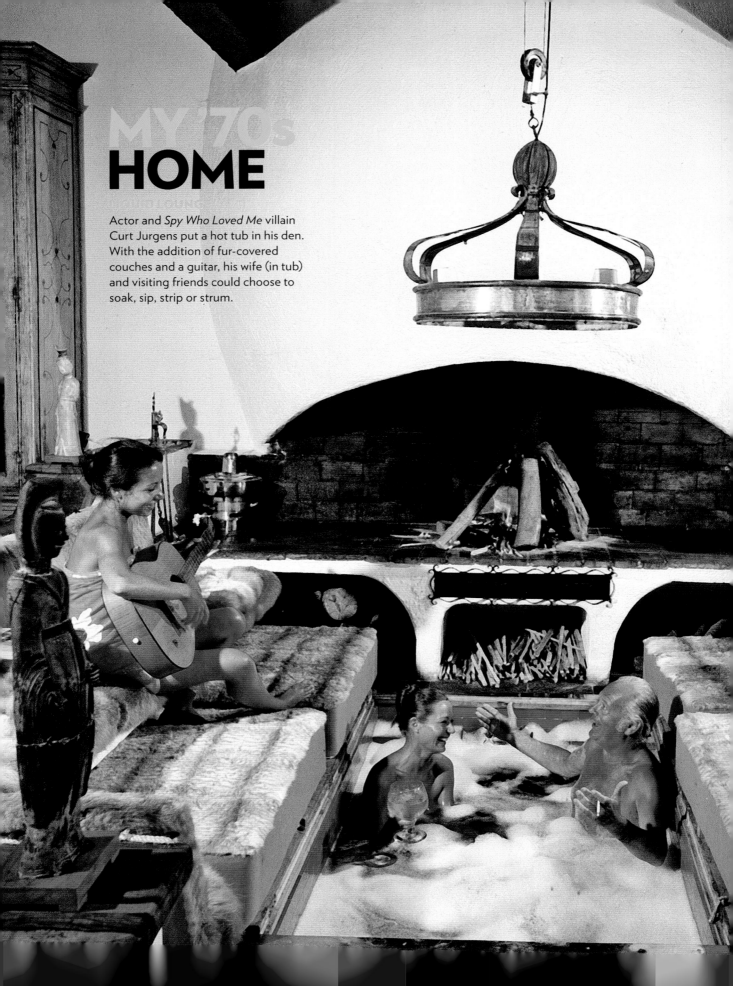

MY '70s
HOME

Actor and *Spy Who Loved Me* villain Curt Jurgens put a hot tub in his den. With the addition of fur-covered couches and a guitar, his wife (in tub) and visiting friends could choose to soak, sip, strip or strum.

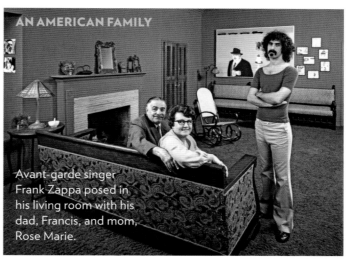

AN AMERICAN FAMILY

Avant-garde singer Frank Zappa posed in his living room with his dad, Francis, and mom, Rose Marie.

THE REC ROOM

Basketball great Wilt Chamberlain, who claimed to have become good friends with 20,000 women, still found time for pool.

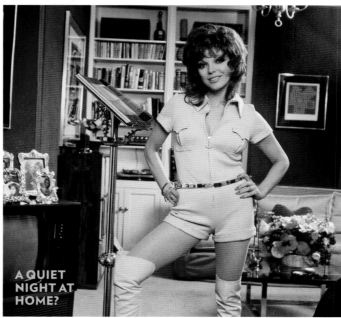

A QUIET NIGHT AT HOME?

Actress Joan Collins (ca. 1977, pre-*Dynasty*) makes a rare fashion statement in go-go boots and a modified onesie.

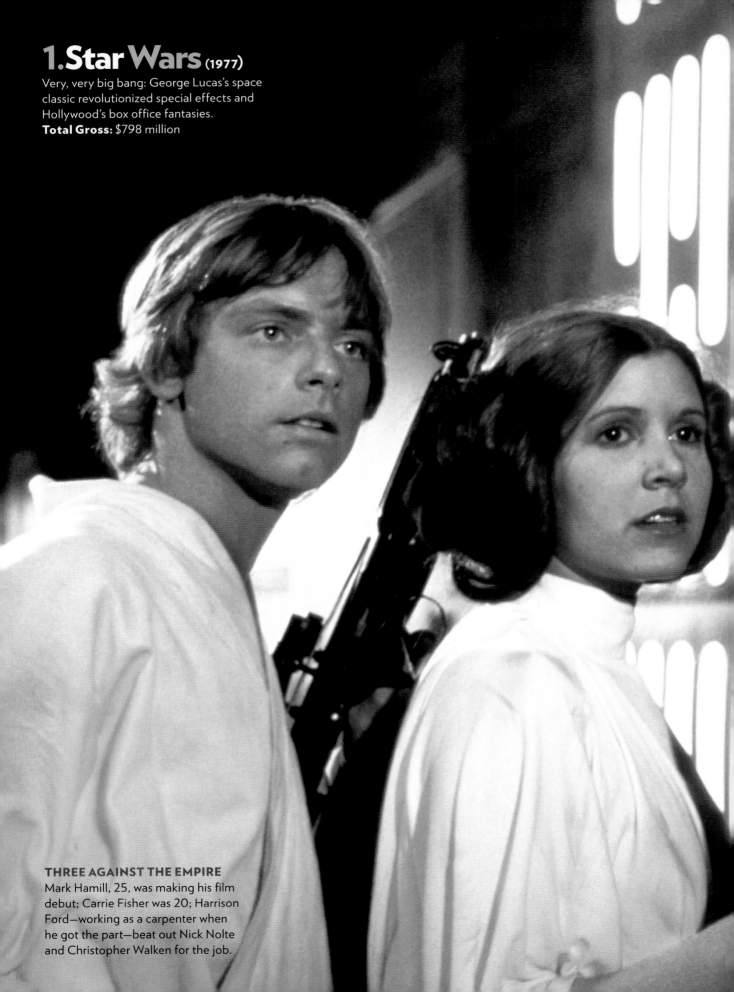

1. Star Wars (1977)

Very, very big bang: George Lucas's space classic revolutionized special effects and Hollywood's box office fantasies.
Total Gross: $798 million

THREE AGAINST THE EMPIRE
Mark Hamill, 25, was making his film debut; Carrie Fisher was 20; Harrison Ford—working as a carpenter when he got the part—beat out Nick Nolte and Christopher Walken for the job.

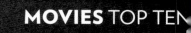

Movies

Star Wars and *Jaws* ruled the box office; *Annie Hall* and
Animal House captured the spirit of the times

The Force Was with George Lucas

THE PLAN WAS SIMPLE: "MY MAIN REASON FOR MAKING *STAR Wars*," said director George Lucas, only 33 at the time, "was to give young people an honest, wholesome fantasy life the way we had. All they've got now is *Kojak* and *Dirty Harry*." Lucas's special-effects-filled fantasy—it averages three per minute—exceeded *his* fantasies, spawning two sequels and four prequels (one animated), a three-decade merchandising bonanza and a still-thriving special-effects business, Industrial Light & Magic. Trivia facts that might surprise normal mortals (but not the series' fanboy legions): Luke Skywalker was called Luke Starkiller until the first day of shooting; and the robot R2-D2 got his name from film editing slang for "Reel 2 of the second dialogue track."

ANGRY OBI Sir Alec Guinness (with C-3PO and Hamill) got grumpy when, after a script revision, his character was killed off earlier than originally planned.

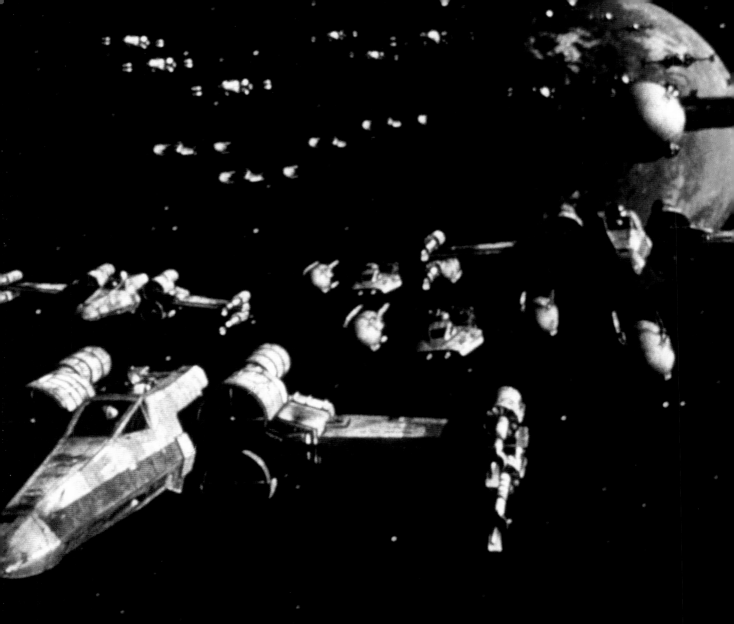

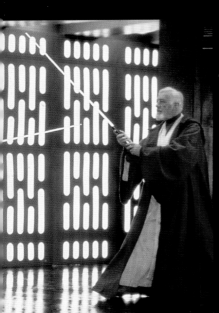

WE MEET AGAIN!
Actor David Prowse played intergalactic malcontent Darth Vader, but the Evil One's apocalyptic voice was dubbed by (uncredited) James Earl Jones.

BIG BUDDY
Chewbacca's "voice" included sounds made by bears, badgers, walruses and camels.

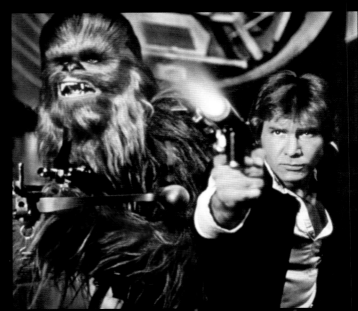

2. **Jaws** (1975)

The highest-grossing movie of all time—until *Star Wars*. During one scene, the prop shark, Bruce, accidentally sank the hunters' boat. The film sparked a fear of sharks—*and* ominous cello music.
Total Gross: $470.6 million

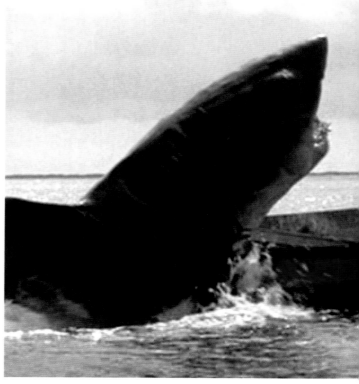

3. **Grease** (1978)

The original high school musical, featuring students who were great dancers but, perhaps, slow learners. (John Travolta was 24, Olivia Newton-John 29 and Stockard Channing 34.)
Total Gross: $386.5 million

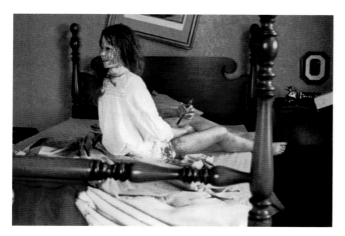

4. **The Exorcist** (1973)

Pea soup for the tortured soul? (That's what SFX people used when actress Linda Blair, possessed by the devil, vomited forth green hideousness.)
Total Gross: $357.6 million

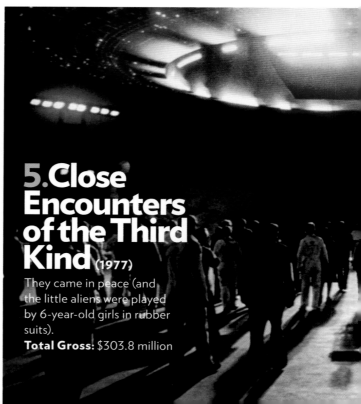

5. **Close Encounters of the Third Kind** (1977)

They came in peace (and the little aliens were played by 6-year-old girls in rubber suits).
Total Gross: $303.8 million

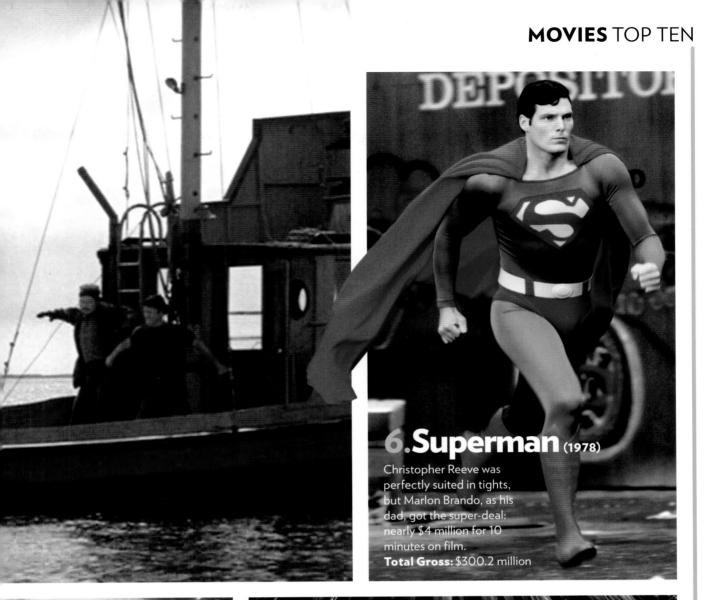

6.Superman (1978)

Christopher Reeve was perfectly suited in tights, but Marlon Brando, as his dad, got the super-deal: nearly $4 million for 10 minutes on film.
Total Gross: $300.2 million

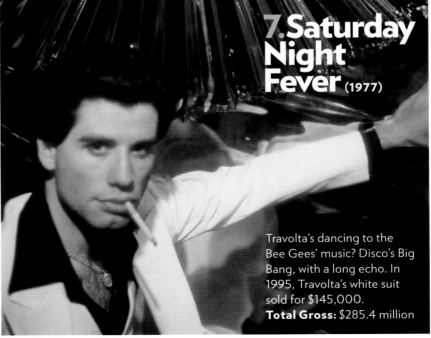

7.Saturday Night Fever (1977)

Travolta's dancing to the Bee Gees' music? Disco's Big Bang, with a long echo. In 1995, Travolta's white suit sold for $145,000.
Total Gross: $285.4 million

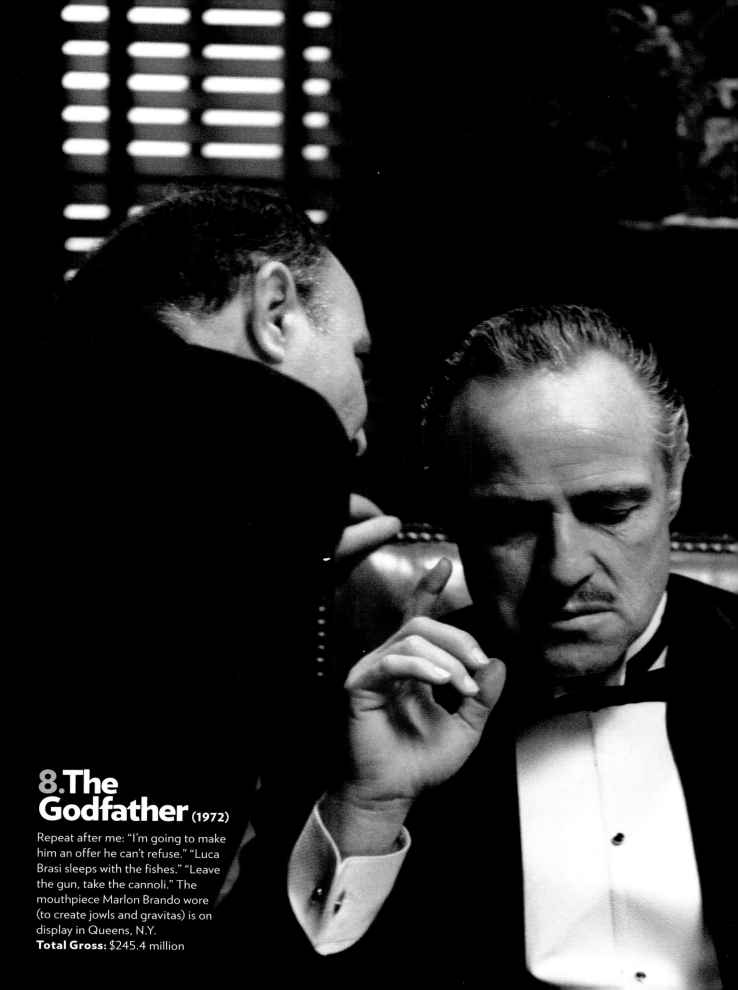

8. The Godfather (1972)

Repeat after me: "I'm going to make him an offer he can't refuse." "Luca Brasi sleeps with the fishes." "Leave the gun, take the cannoli." The mouthpiece Marlon Brando wore (to create jowls and gravitas) is on display in Queens, N.Y.
Total Gross: $245.4 million

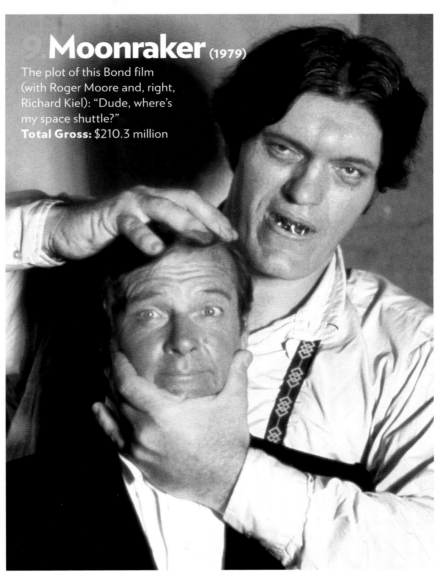

9. **Moonraker** (1979)

The plot of this Bond film (with Roger Moore and, right, Richard Kiel): "Dude, where's my space shuttle?"
Total Gross: $210.3 million

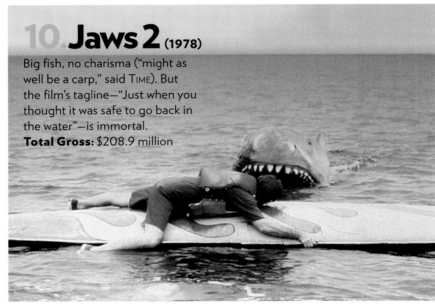

10. **Jaws 2** (1978)

Big fish, no charisma ("might as well be a carp," said TIME). But the film's tagline—"Just when you thought it was safe to go back in the water"—is immortal.
Total Gross: $208.9 million

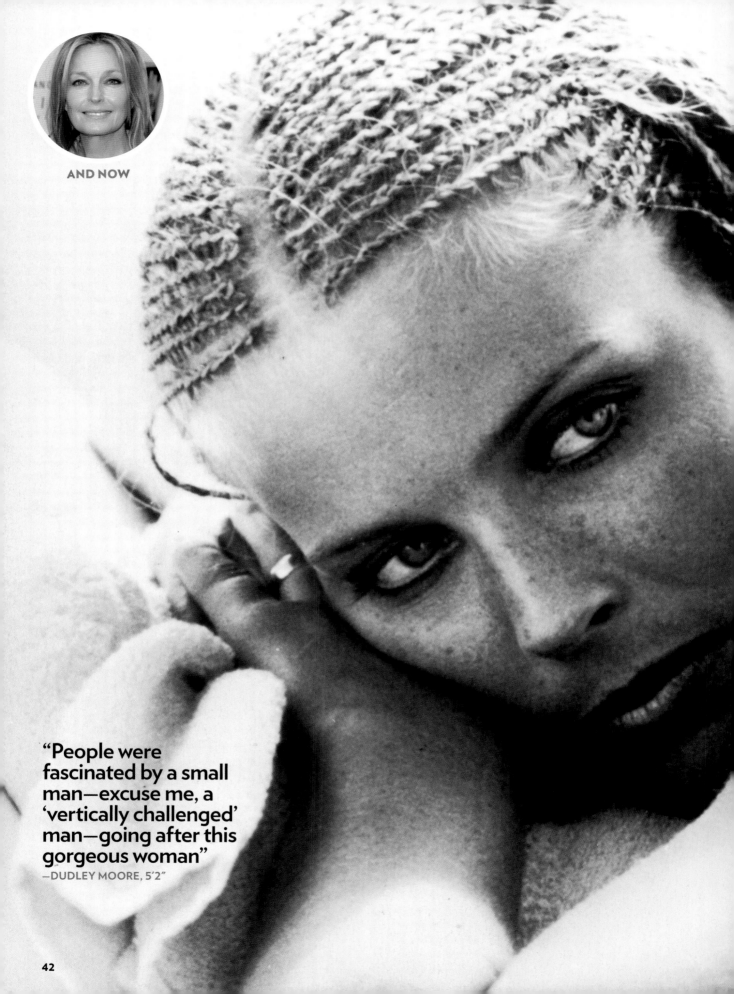

"People were fascinated by a small man—excuse me, a 'vertically challenged' man—going after this gorgeous woman"
—DUDLEY MOORE, 5'2"

THAT'S SO '70s

Like cornrows and CB radios, some films will be forever linked to the decade that gave them both

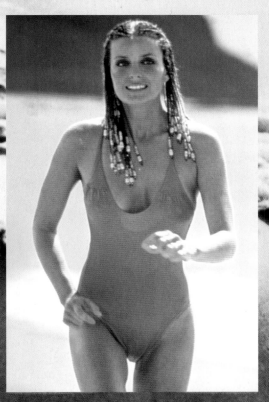

10

A FARCICAL TALE OF MIDLIFE CRISIS AND the alleged dangers of wish fulfillment, *10* posed Dudley Moore as a middle-aged composer in pursuit of his fantasy, played by Bo Derek. The hit comedy made stars of Derek, cornrows, Ravel's *Boléro* and Moore— even though, playing a romantic loser, he had been cast against type. In real life, the 5'2" comic, who referred to himself as a "sex thimble," had been married to Hollywood bombshell Tuesday Weld and dated willowy actress Susan Anton. Asked once why he dated taller women, Moore replied, "I have no choice, do I?"

Fresh
Talent

Richard Dreyfuss

Suzanne Somers

MacKenzie Phillips

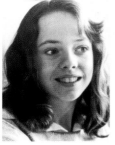

Harrison Ford

Charles Martin Smith

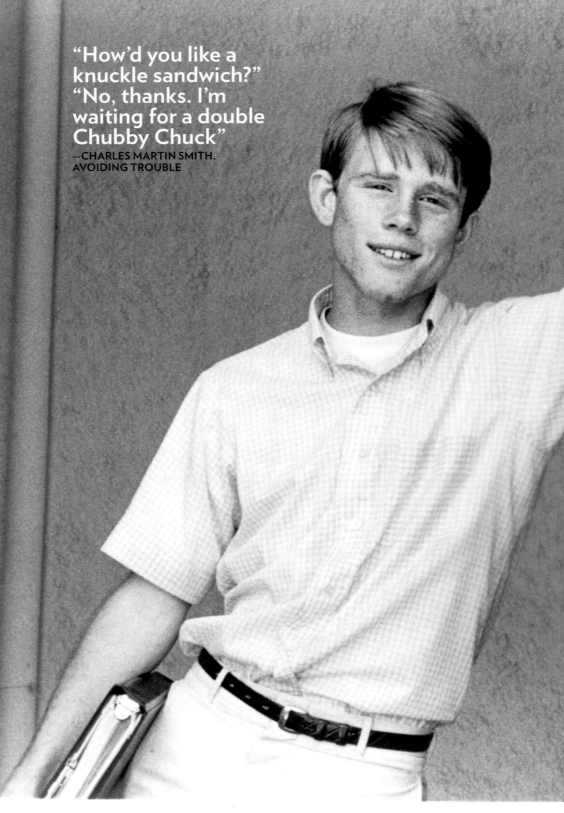

"How'd you like a knuckle sandwich?"
"No, thanks. I'm waiting for a double Chubby Chuck"
—CHARLES MARTIN SMITH, AVOIDING TROUBLE

American
Graffiti

TO SOME DEGREE, HAN SOLO, PRINCESS LEIA and even Jabba the Hutt owe their success to this romanticized look at the misadventures of four friends as they drink beer and chase girls on their last night of summer, before two of them head to college. *Graffiti*'s success—made for $750,000, it grossed over $100 million worldwide—allowed its 29-year-old director, George

Smokey and the Bandit

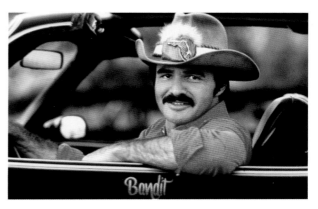

STAR WARS WAS THE 2,000-LB. WOOKIEE OF 1977, but not far behind revved the emphatically terrestrial *Smokey*, a feel-good yarn about a good ol' boy (**Burt Reynolds**), a runaway bride (Sally Field), a determined sheriff (Jackie Gleason) and a whole lotta stunt driving. In real life, Reynolds also got the girl—and Hollywood bankability second to none.

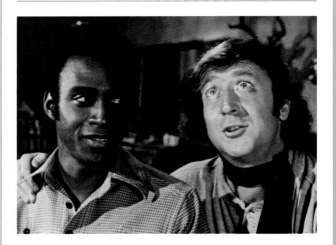

Blazing Saddles

MEL BROOKS'S KITCHEN-SINK SEND-UP OF HOLLYwood westerns—and, not at all incidentally, of Busby Berkeley musicals, politics and racial stereotyping—drew the best from **Cleavon Little** (above, left) and **Gene Wilder** and found the 14-year-old boy in all of us. In the immortal words of dance-hall queen Lili von Shtupp (Madeline Kahn), "It's twoo, it's twoo!").

LOST WORLD? Or just imaginary? Director George Lucas's sweet film (with Howard, left, and Williams) was based on his own teen years in Modesto, Calif.

Lucas, to pick his next project, *Star Wars*, and make it the way he wanted. Many newcomers in the cast—including Richard Dreyfuss, Harrison Ford, Suzanne Somers and **Cindy Williams**—quickly became part of Hollywood's Generation Next. The star, **Ron Howard,** didn't do badly either: *Graffiti* also inspired *Happy Days,* the sitcom he would call home for six years.

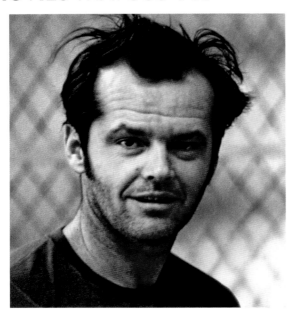

One Flew Over the Cuckoo's Nest

KEN KESEY'S NOVEL, ABOUT A REVOLT IN A MENTAL institution, captured the antiestablishment spirit of the times; **Jack Nicholson**'s portrayal of McMurphy, the roguish, doomed inmate, brought him his first Academy Award (the film won all five major Oscars, a rare feat). There was, however, no award for, and little mention of, Kesey, who later sued over financial issues. "These people, they're like pump salesmen," he said of Hollywood, but ". . . they don't even seem to know the water comes from a well."

Rocky

A CINDERELLA STORY ABOUT A no-name boxer who gets a shot at greatness, *Rocky* paralleled the unlikely story of its author: Struggling actor **Sylvester Stallone**, now 62, wrote the screenplay in four days and received tempting offers, but held out until he was promised he would get the starring role. Filmed on a shoestring budget, *Rocky* made Stallone, overnight, a Hollywood heavyweight.

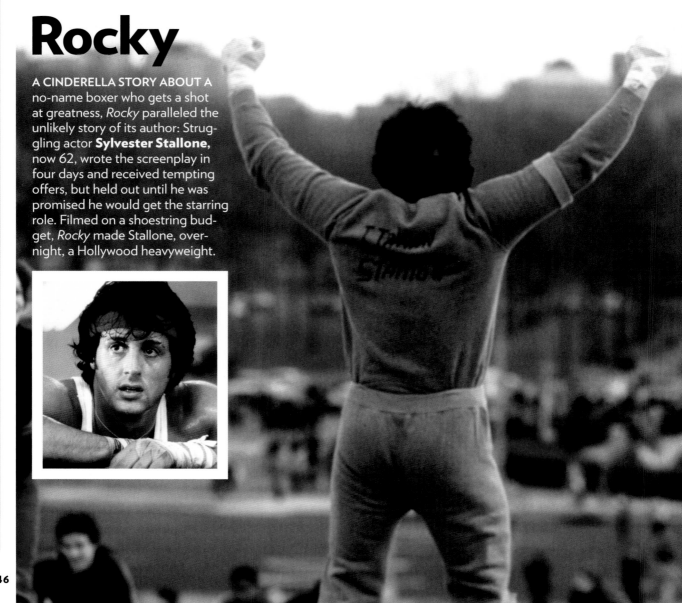

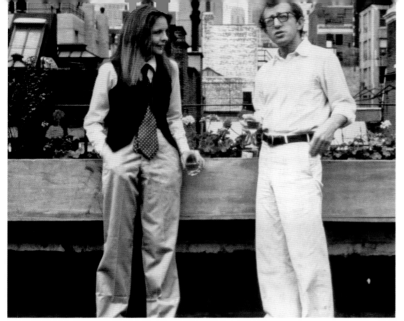

Annie Hall

ORIGINALLY, THE MOVIE WAS TO BE A COMedy about neuroses and called *Anhedonia,* a term meaning "the inability to experience pleasure." In the editing process, however, writer-director-star **Woody Allen** realized he was looking at a love story and changed the title to *Annie Hall,* the name of the cute-quirky character played by **Diane Keaton**—who, for years, had been Allen's real-life love. The film made Keaton a star and her styles a trend; although the film captured a New York moment, what it had to say about meeting, dating and lobsters is wisdom eternal.

LA-DI-DA Delightfully dippy, Diane Keaton (with ex-beau and costar Allen) made the phrase famous and her boyish style a '70s trend.

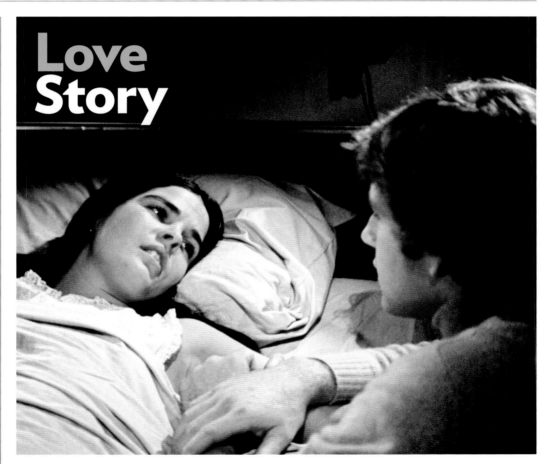

Love Story

A Time WRITER, WAITING NEAR A MANhattan theater, couldn't figure out why the crowd didn't come out when *Love Story* ended. A short time later, when the still-sniffling mass finally exited, it dawned on him: "It has actually taken them 10 minutes," he wrote, "to compose themselves enough to face the real world." One of the most successful weepies in movie history, *Love Story*—about a WASP prince (**Ryan O'Neal**) who falls for a working-class girl (**Ali MacGraw**) who's dying of cancer—left some critics wincing but hit audiences right where Hollywood was aiming: their tear ducts and wallets.

CLASSIC IMAGES

Amid the cultural flotsam, movie characters and scenes that stayed in the mind

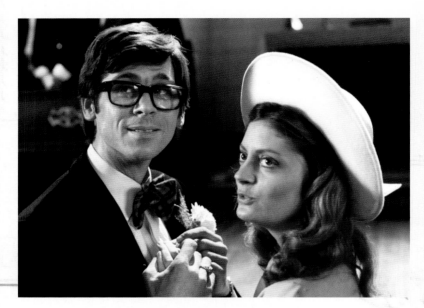

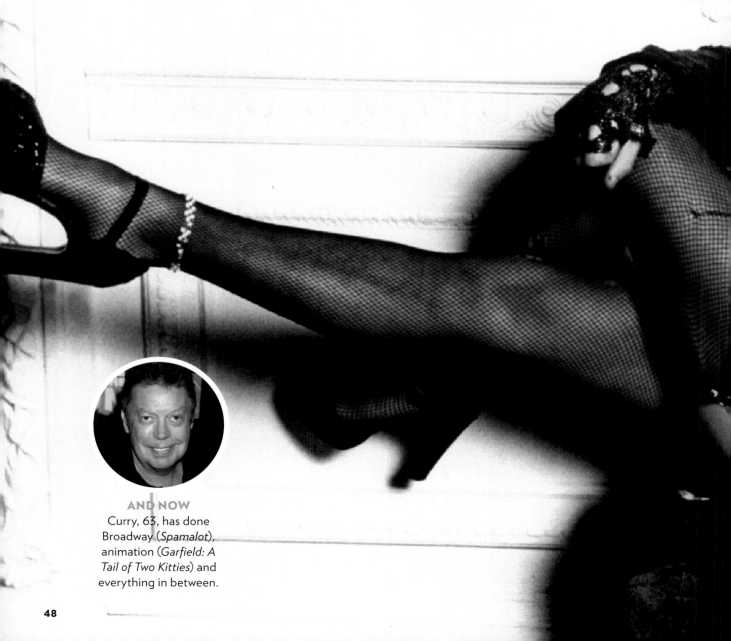

AND NOW
Curry, 63, has done Broadway (*Spamalot*), animation (*Garfield: A Tail of Two Kitties*) and everything in between.

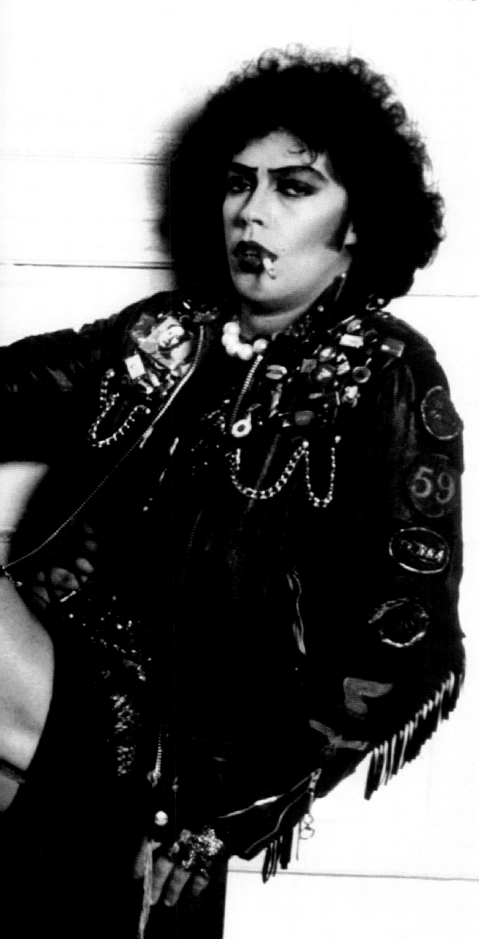

The Rocky Horror Picture Show

HE HAD LEGS, AND SO DID the movie: **Tim Curry**'s mind-bending turn as Dr. Frank N. Furter, a self-proclaimed "sweet transvestite from Transsexual, Transylvania," turned *Rocky Horror* into the biggest cult hit of all time. A musical parody of sci-fi and horror kitsch (**Barry Bostwick** and **Susan Sarandon**, far left, play newlyweds who have a flat tire and, in search of a phone, unwisely knock on the door of a really spooky mansion), *Rocky* did only so-so when first released but eventually became a staple of midnight showings in the U.S. and around the world. Made for an estimated $1.2 million in 1975, it is still in release and has grossed $139,876,417 over 34 years.

Clockwork Orange

STANLEY KUBRICK'S STYLIZED look at a dystopian future and a young man (actor **Malcolm McDowell,** right) "whose principal interests are rape, ultraviolence and Beethoven." Nearly 40 years later, the meaning of it all is fuzzy, the imagery unforgettable.

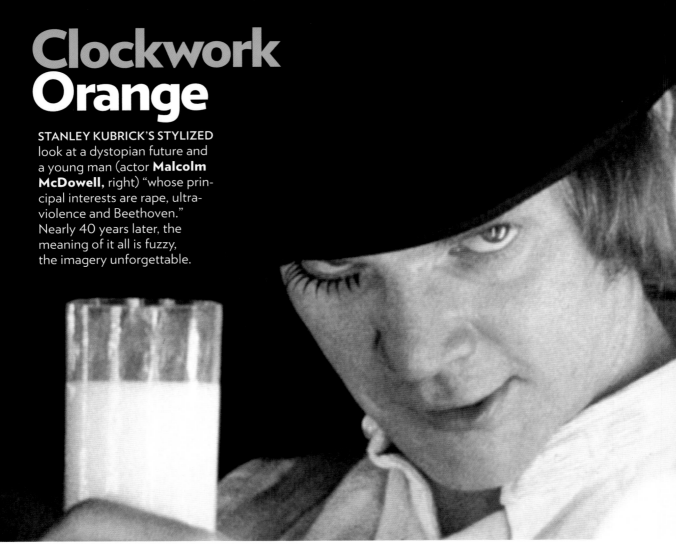

Carrie

A SOCIAL MISFIT POS-sessed of spooky telekinetic powers, Carrie (**Sissy Spacek**) thinks she's finally found acceptance when she is voted prom queen. But it's just another mean trick: As she poses with her bouquet, her nemeses dump pig's blood on her. *Bad* move: Humiliated and enraged, she lashes out, killing bystanders and turning the dance into an inferno. Among her victims: John Travolta, in his major-film debut.

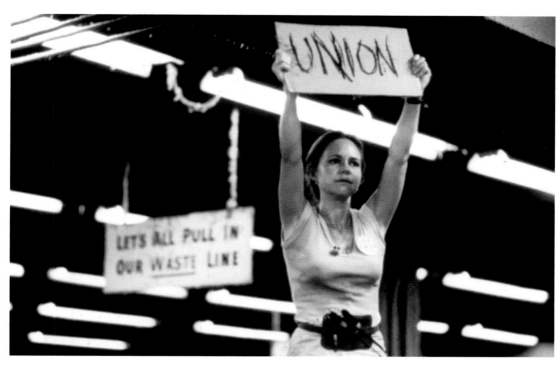

Norma Rae

TO UNIONIZE OR NOT TO UNIONIZE? THAT WAS THE question **Sally Field** pondered in this hit about tough times in a mill town. At the film's pivotal, now-or-never moment, Field's character climbs atop a table and throws her lot in the with union, inspiring her coworkers to do the same. Music swells and . . . *cut!*

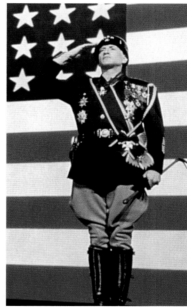

Patton

THE FAMOUS OPENING SCENE— in which **George C. Scott,** before an enormous flag, delivers a rousing speech to thousands of men—is also a tribute to his talent: He actually filmed the scene on a soundstage, alone. He won an Oscar, but having dismissed the Awards as a "meat parade," turned it down.

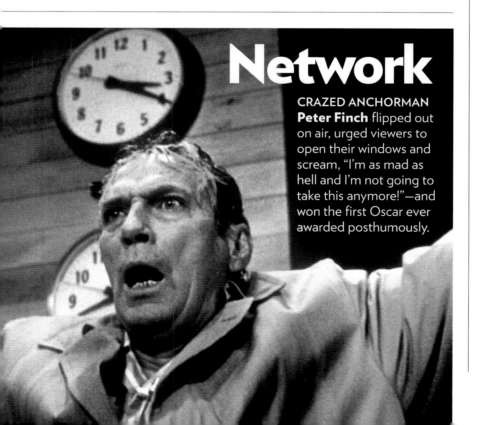

Network

CRAZED ANCHORMAN **Peter Finch** flipped out on air, urged viewers to open their windows and scream, "I'm as mad as hell and I'm not going to take this anymore!"—and won the first Oscar ever awarded posthumously.

URBAN AVENGERS

'Blaxploitation' films—a mixture of macho, politics, kung fu and kitsch—captured a not-to-be-repeated cultural moment

IN THE END, MONEY TALKED. WHEN *SHAFT*, a $500,000 film about a black private eye who is, as the theme song says, "a sex machine with all the chicks"—made $13 million in 1971, Hollywood sat up and took notice. And copied: Very quickly, films like *Super Fly, Cleopatra Jones, Coffy* and *Blacula* began hitting screens. They filled seats but angered some critics, including the NAACP, who, because the movies' plots often involved drugs or pimps, accused filmmakers of exploiting stereotypes. But *Shaft*'s director, Gordon Parks, insisted his hero—"a ballsy guy, to hell with everybody, he goes out and does his thing"—was an important, and needed, image in the black community. In one memorable scene, Shaft, despite his heroics, can't get a cab to stop for him in Manhattan. "We knew him," Samuel L. Jackson recalled years later of the film's appeal. "We felt him."

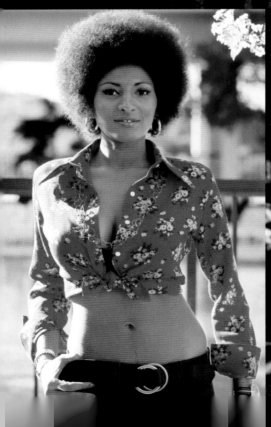

AND NOW

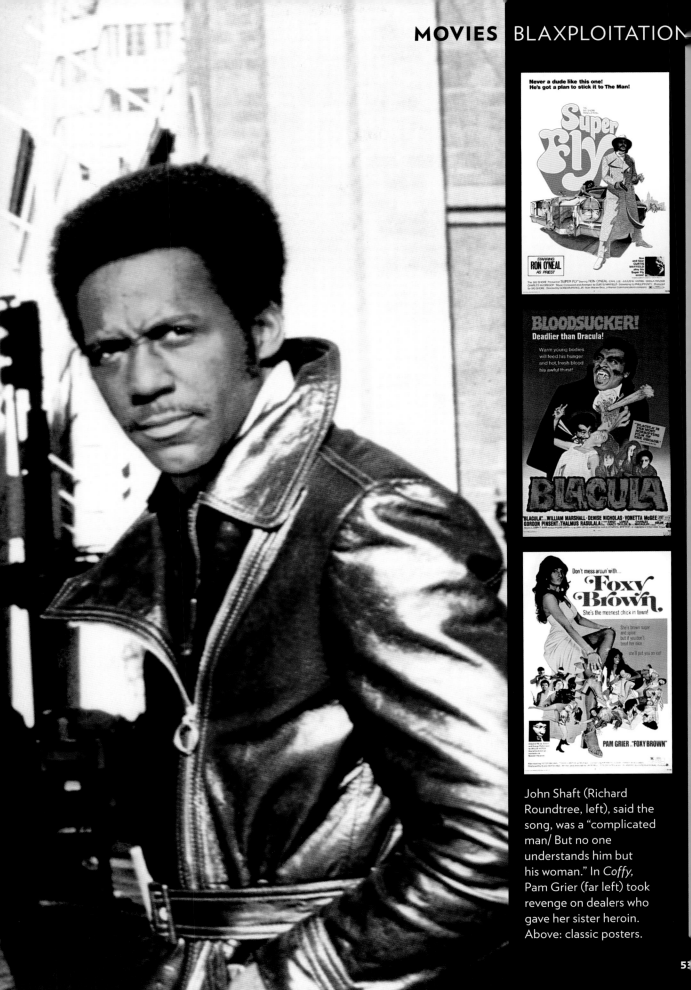

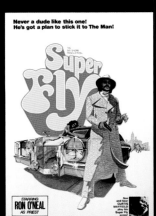

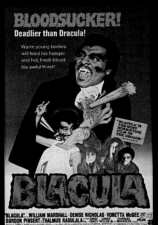

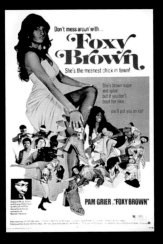

John Shaft (Richard Roundtree, left), said the song, was a "complicated man/ But no one understands him but his woman." In *Coffy*, Pam Grier (far left) took revenge on dealers who gave her sister heroin. Above: classic posters.

WHO SAID IT?

Catchphrases that crept into the culture from '70s cinema classics

"I love the smell of napalm in the morning" **3**

"SO HELP ME, ME" **1**

"You've gotta ask yourself a question, 'Do I feel lucky?' Well, do ya, punk?" **4**

"Yo, Adrian!" **2**

"Use the force, Luke" **5**

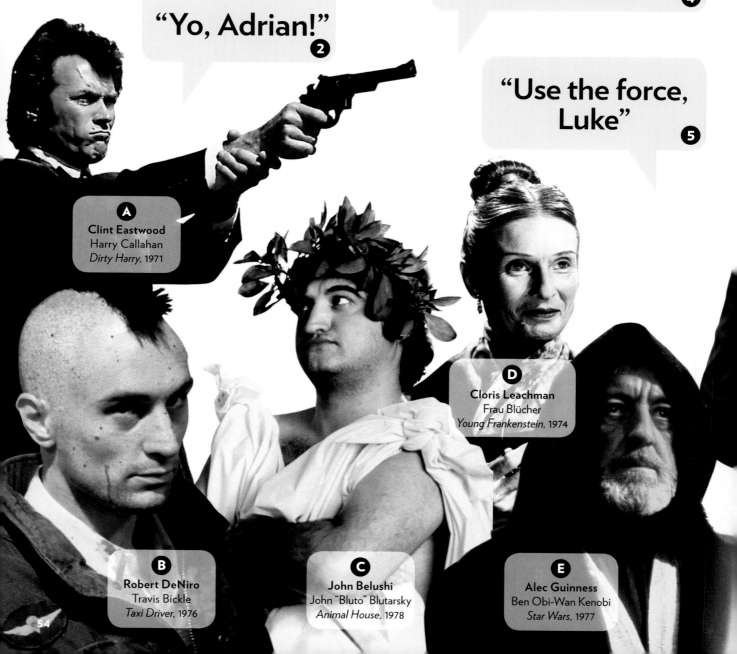

A
Clint Eastwood
Harry Callahan
Dirty Harry, 1971

D
Cloris Leachman
Frau Blücher
Young Frankenstein, 1974

B
Robert DeNiro
Travis Bickle
Taxi Driver, 1976

C
John Belushi
John "Bluto" Blutarsky
Animal House, 1978

E
Alec Guinness
Ben Obi-Wan Kenobi
Star Wars, 1977

"Willkommen! Bienvenue! Velcome! Come on in!" **6**

"Toga! Toga!" **10**

"I knew it was you, Fredo. You broke my heart" **7**

"You talkin' to *me*?" **9**

"He vas my boyfriend!" **8**

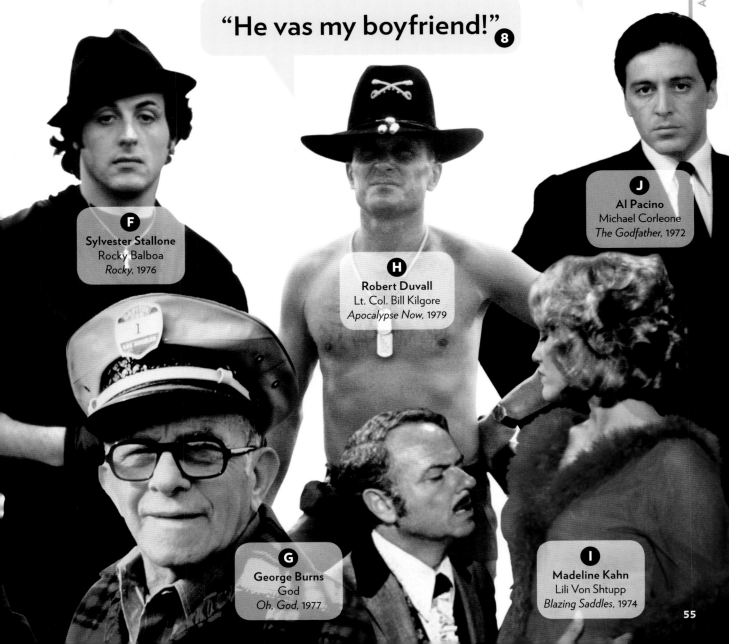

F Sylvester Stallone
Rocky Balboa
Rocky, 1976

H Robert Duvall
Lt. Col. Bill Kilgore
Apocalypse Now, 1979

J Al Pacino
Michael Corleone
The Godfather, 1972

G George Burns
God
Oh, God, 1977

I Madeline Kahn
Lili Von Shtupp
Blazing Saddles, 1974

Music
I GO, YOU GO, WE GO . . . DISCO!

Pop ran the gamut from Donny Osmond to Bob Marley and Joni Mitchell to Johnny Rotten, but the decade's iconic contribution was a dance revolution

Donna Summer

NO DOUBT "BOOGIE OOGIE Oogie" has its partisans, but *the* consensus anthem of the disco era has to be Donna Summer's "Love to Love You, Baby." The magic! The music! The . . . moans? Well, yes: The "lyrics" consist, almost exclusively, of Summer simulating a sojourn to passion's peak, 22 times in 17 minutes. Her goal, she said, was to make a record "for people to take home and fantasize in their minds"—with, of course, a good dance beat.

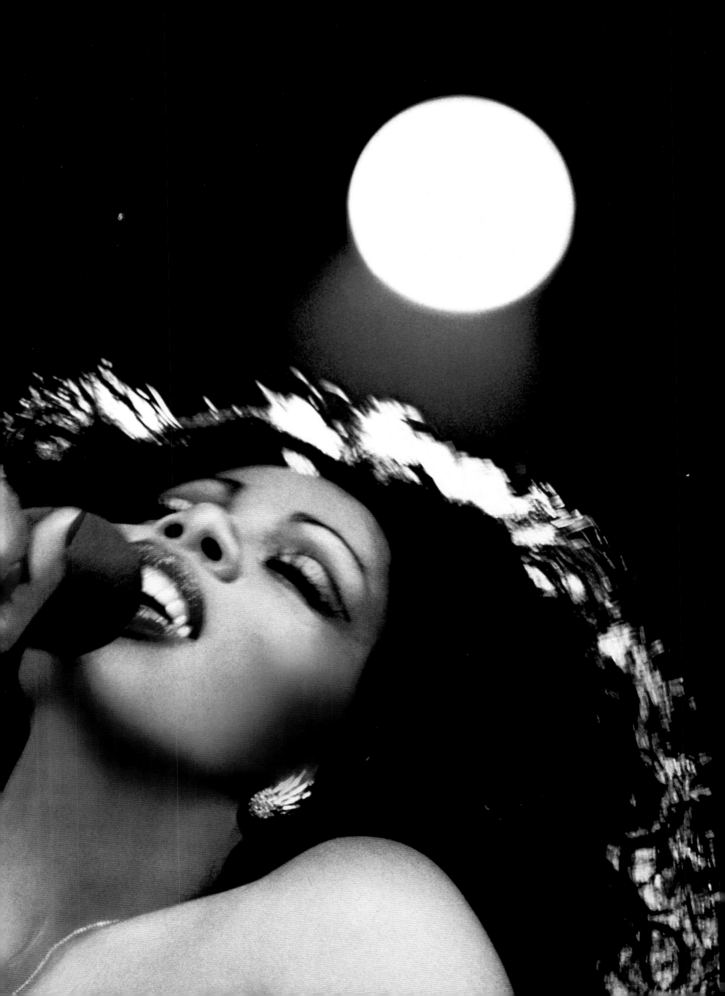

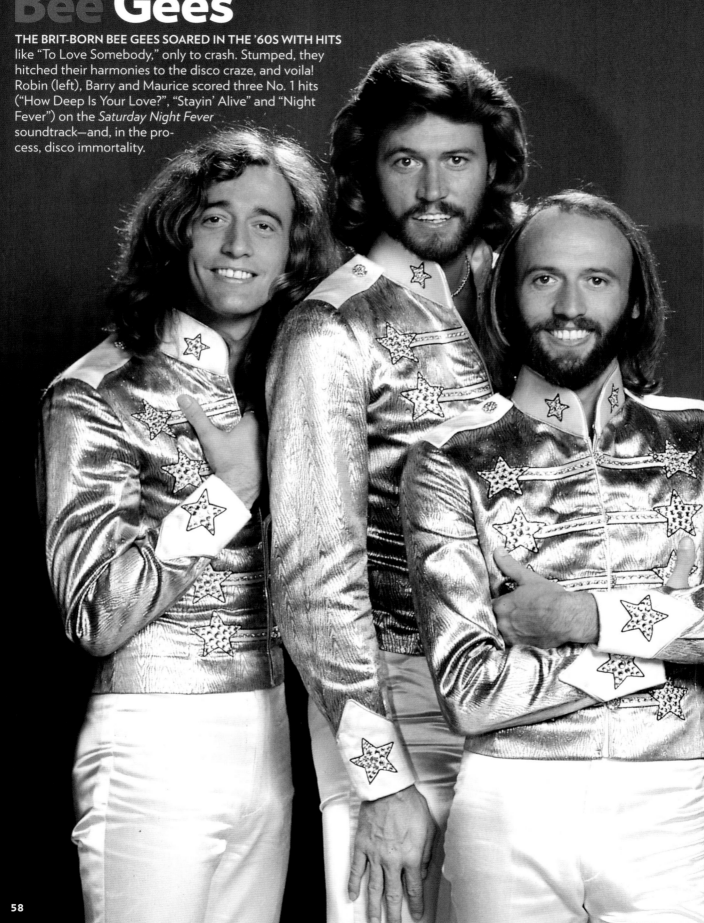

Bee Gees

THE BRIT-BORN BEE GEES SOARED IN THE '60S WITH HITS like "To Love Somebody," only to crash. Stumped, they hitched their harmonies to the disco craze, and voila! Robin (left), Barry and Maurice scored three No. 1 hits ("How Deep Is Your Love?", "Stayin' Alive" and "Night Fever") on the *Saturday Night Fever* soundtrack—and, in the process, disco immortality.

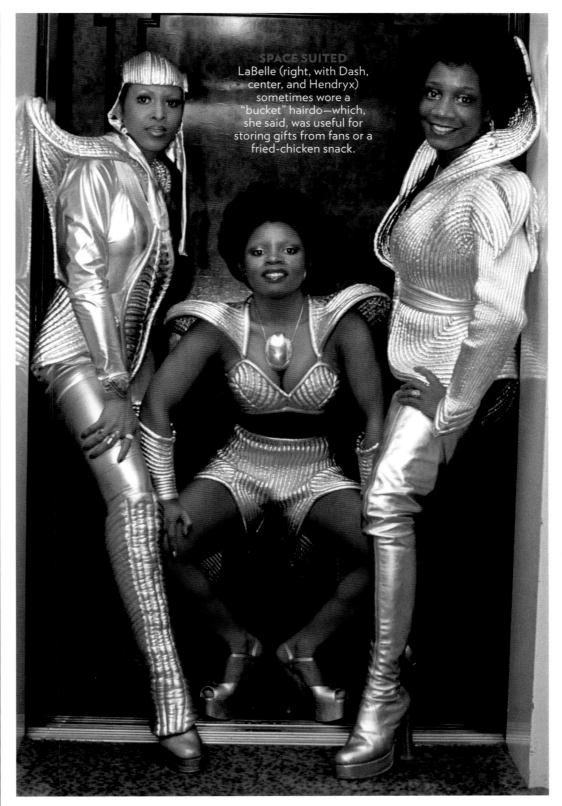

SPACE SUITED
LaBelle (right, with Dash, center, and Hendryx) sometimes wore a "bucket" hairdo—which, she said, was useful for storing gifts from fans or a fried-chicken snack.

Patti
LaBelle

VETERANS OF THE '60S soul scene who had been sideswiped by changing tastes, the group Labelle (LaBelle, Nona Hendryx and Sarah Dash) took what they were given and made marmalade—specifically "Lady Marmalade," the breakout hit that, together with wild outfits, established them as disco-era headliners.

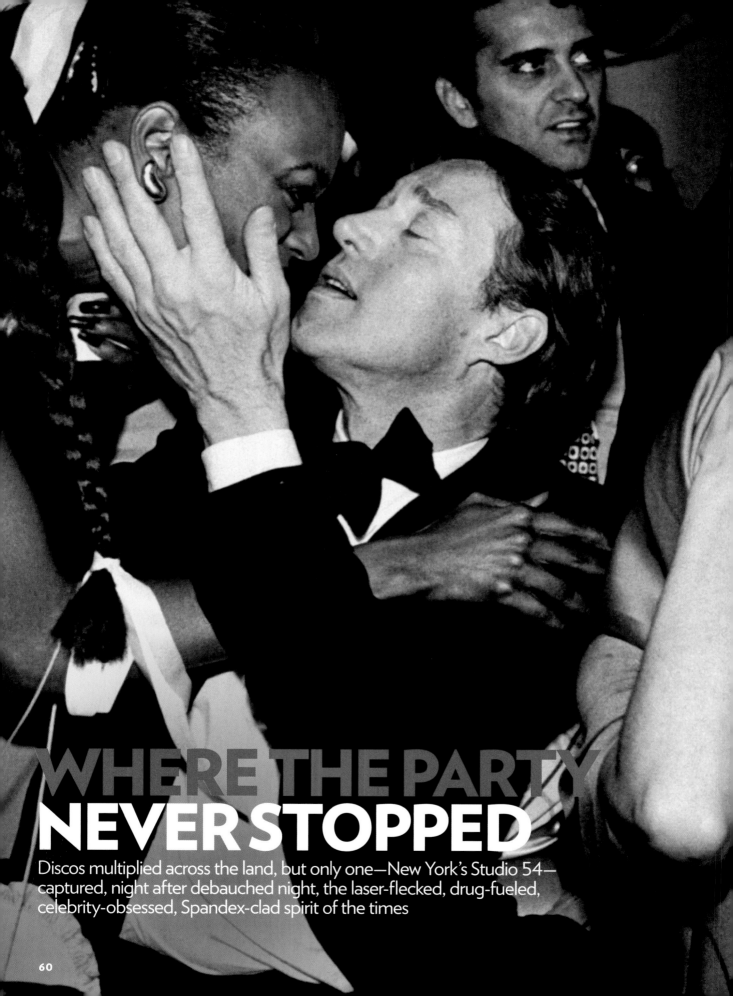

WHERE THE PARTY
NEVER STOPPED

Discos multiplied across the land, but only one—New York's Studio 54—
captured, night after debauched night, the laser-flecked, drug-fueled,
celebrity-obsessed, Spandex-clad spirit of the times

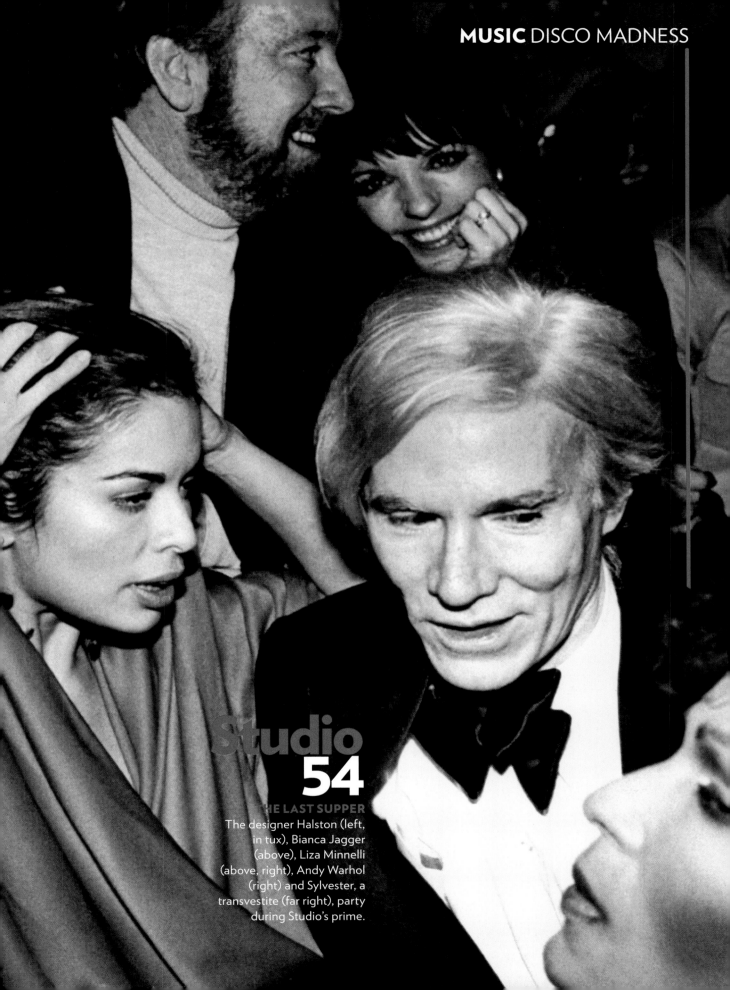

Studio
54
THE LAST SUPPER
The designer Halston (left, in tux), Bianca Jagger (above), Liza Minnelli (above, right), Andy Warhol (right) and Sylvester, a transvestite (far right), party during Studio's prime.

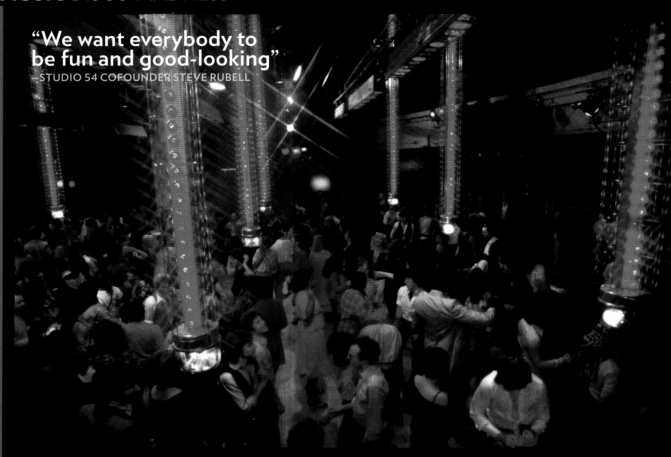

"We want everybody to be fun and good-looking"
—STUDIO 54 COFOUNDER STEVE RUBELL

Studio 54

IN THE MOVIE *Casablanca,* everybody goes to Rick's. In late '70s Manhattan, everybody went to Studio 54—*if* they could get past the doorman. Money didn't guarantee you a nod: The keys to the disco kingdom were youth, beauty and sex appeal.

And fame: Studio 54's owners, Steve Rubell and Ian Schrager, realized early that celebrities begat publicity, customers, money and more celebrities. "Everybody was a different price," said Joanne Horowitz, who was hired to lure the famous into the club, and, she told *New York* magazine, paid per star: "Once in a while, Ian and I would argue because I thought Alice Cooper [$60] was worth as much as Sylvester Stallone [$80]." Inside, celebs and civilians mingled, boogied, grabbed drinks from shirtless bartenders or sought other diver-

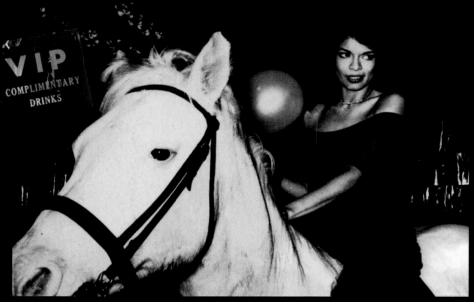

BAREBACK BIANCA On her birthday, Mrs. Jagger rode a horse led by a near-nude lad dusted with gold glitter.

sion (decor included a large image of a half moon with a coke spoon). The party ended, abruptly, when Rubell and Schrager were caught dodging taxes and sent to prison. Rubell died of AIDS in 1989; Schrager parlayed the lessons of 54 into a successful hotel empire.

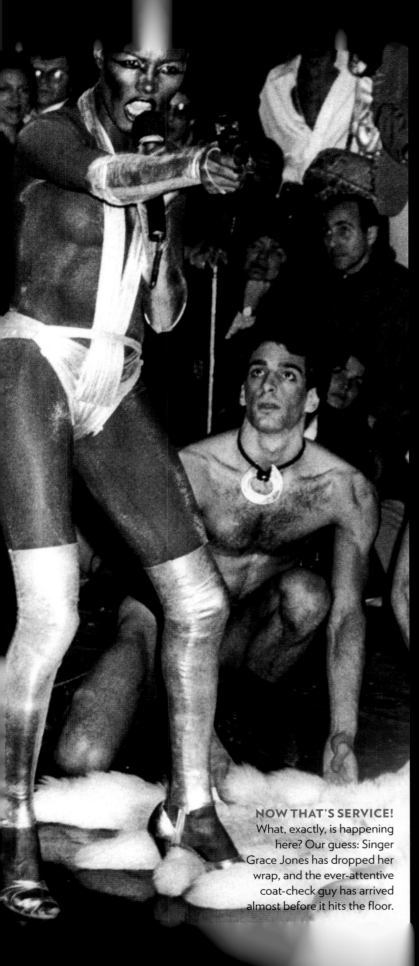

NOW THAT'S SERVICE!
What, exactly, is happening here? Our guess: Singer Grace Jones has dropped her wrap, and the ever-attentive coat-check guy has arrived almost before it hits the floor.

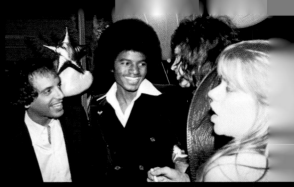

Irrepressible impresario Rubell (with Michael Jackson in 1977) was dazzled by celebs.

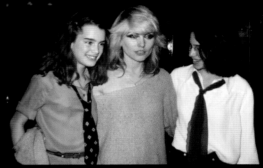

The thrill was the mix: Brooke Shields, for example, might bump into Deborah Harry.

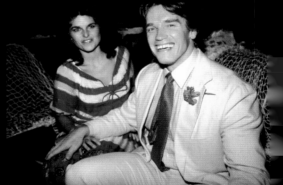

Everybody came to 54, including California's future governor and wife Maria Shriver.

A little outrageousness helped business; Divine, the 300-lb. transvestite, was happy to oblige.

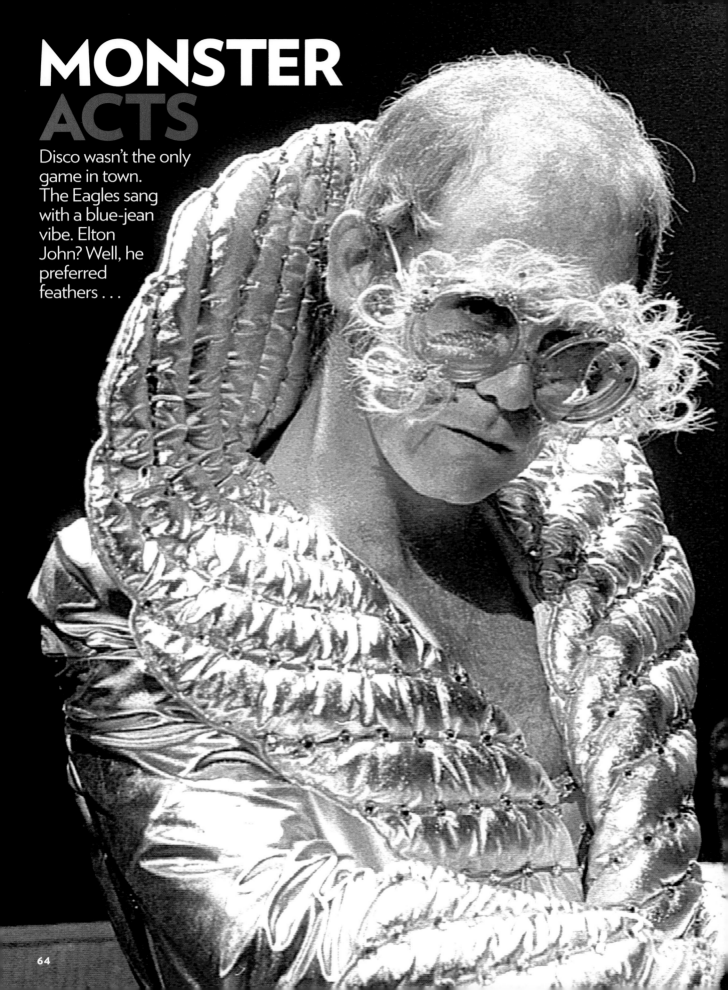

MONSTER
ACTS

Disco wasn't the only game in town. The Eagles sang with a blue-jean vibe. Elton John? Well, he preferred feathers . . .

Elton John

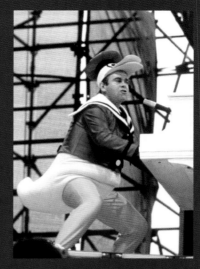

HE WAS, BY HIS OWN ADMISSION, a lonely, lumpy kid too shy "to say boo to a goose." Overcompensation, anyone? By the time Elton John unleashed himself on an unsuspecting world, he dressed like a duck, did handstands on the keyboard and wowed fans with imaginative, melodic pop. By 1975, John had sold 42 million albums and 18 million singles worldwide and acquired many, many things. "All I really crave now," he remarked, sitting near his Picasso, his Rembrandt etchings and two stuffed leopards, "is an original Toulouse-Lautrec or a Hieronymus Bosch."

POP POPINJAY

Why? "Since I'm not your rangy rock idol in skinny leather pants, I wear flamboyant clothes," said John. "It's just a joke. I'm affectionately parodying the rock and roll business by saying, 'Let's all have a laugh and enjoy ourselves.'"

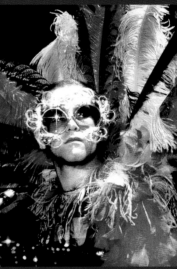

"I didn't start enjoying life until I was 21, so I'm living through my teenage period now"
—ELTON JOHN IN 1975

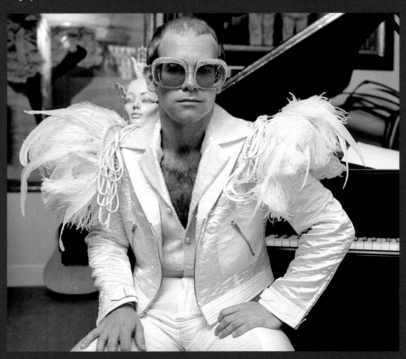

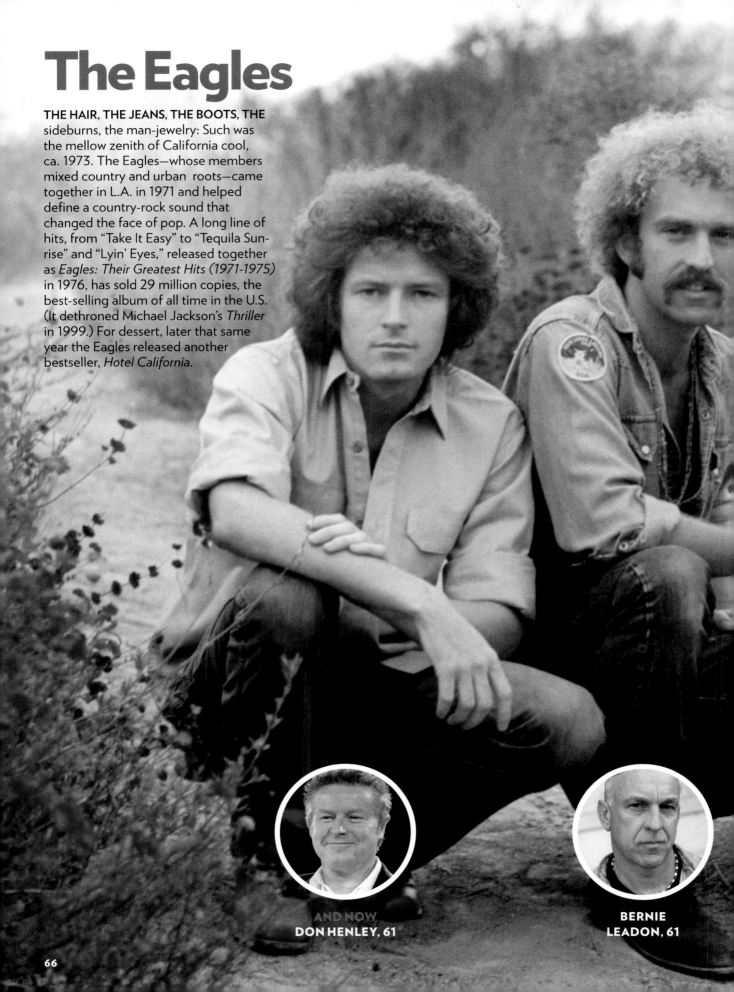

The Eagles

THE HAIR, THE JEANS, THE BOOTS, THE sideburns, the man-jewelry: Such was the mellow zenith of California cool, ca. 1973. The Eagles—whose members mixed country and urban roots—came together in L.A. in 1971 and helped define a country-rock sound that changed the face of pop. A long line of hits, from "Take It Easy" to "Tequila Sunrise" and "Lyin' Eyes," released together as *Eagles: Their Greatest Hits (1971-1975)* in 1976, has sold 29 million copies, the best-selling album of all time in the U.S. (It dethroned Michael Jackson's *Thriller* in 1999.) For dessert, later that same year the Eagles released another bestseller, *Hotel California*.

AND NOW
DON HENLEY, 61

BERNIE LEADON, 61

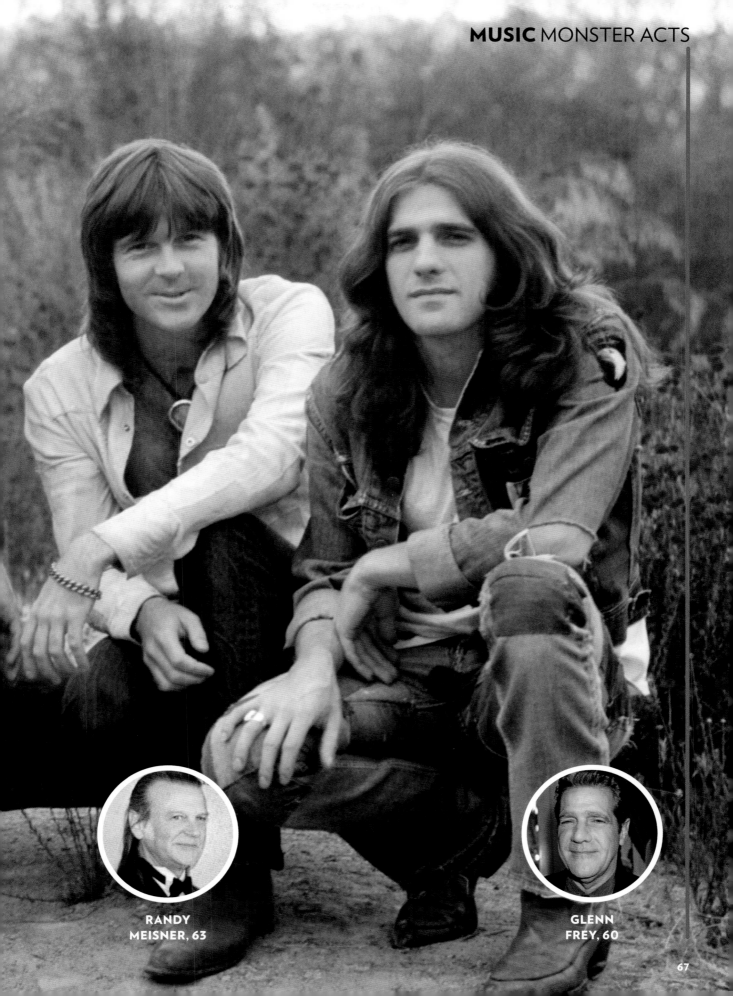

RANDY MEISNER, 63

GLENN FREY, 60

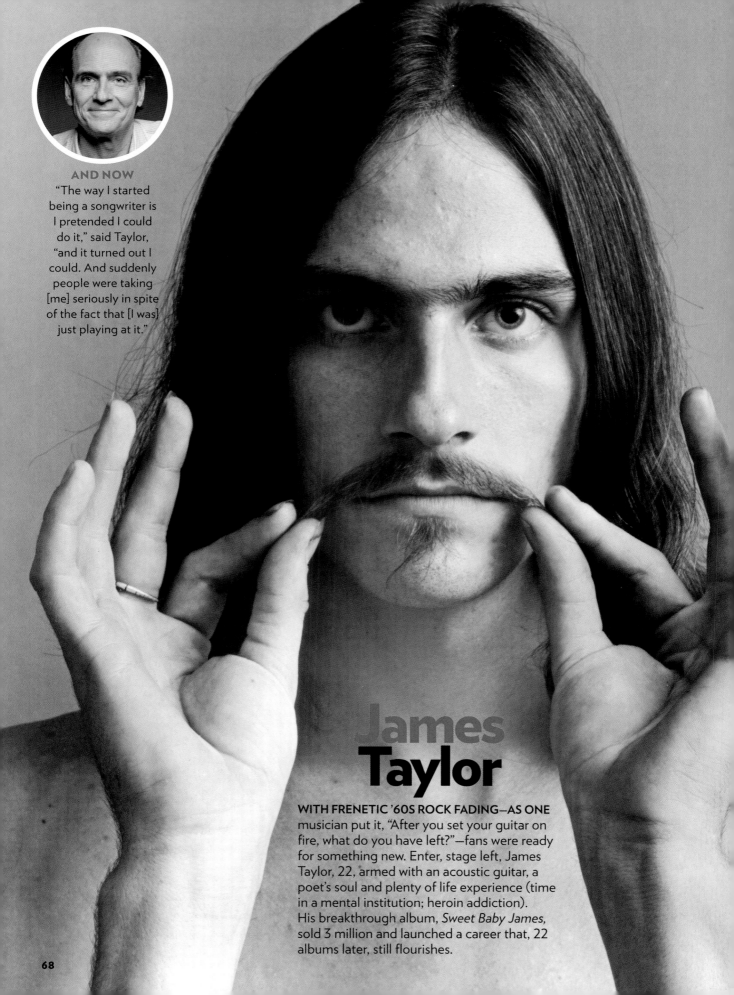

"The way I started being a songwriter is I pretended I could do it," said Taylor, "and it turned out I could. And suddenly people were taking [me] seriously in spite of the fact that [I was] just playing at it."

James Taylor

WITH FRENETIC '60S ROCK FADING—AS ONE musician put it, "After you set your guitar on fire, what do you have left?"—fans were ready for something new. Enter, stage left, James Taylor, 22, armed with an acoustic guitar, a poet's soul and plenty of life experience (time in a mental institution; heroin addiction). His breakthrough album, *Sweet Baby James*, sold 3 million and launched a career that, 22 albums later, still flourishes.

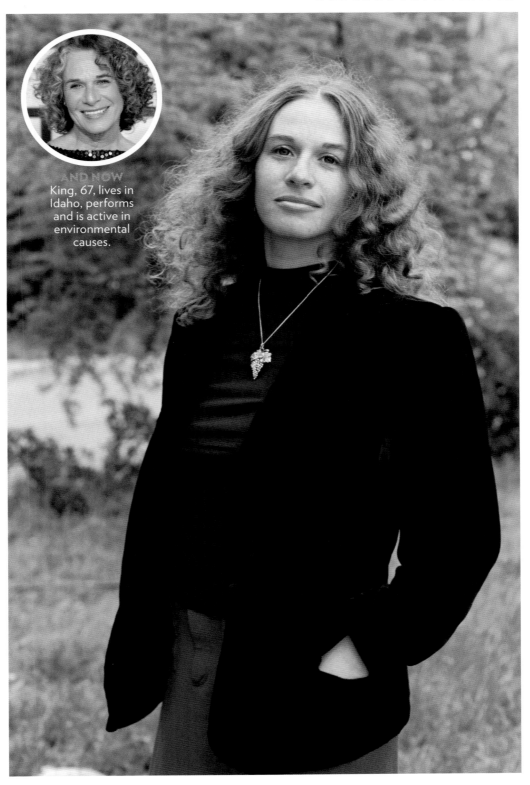

AND NOW
King, 67, lives in Idaho, performs and is active in environmental causes.

Carole King

SHE BEGAN PLAYING PIANO AT 4 AND BY 16 WAS COWRIT-ing soul-pop classics including "Up on the Roof," "The Loco-Motion" and "(You Make Me Feel Like) A Natural Woman." But Carole King remained an industry secret until, in 1971, she released *Tapestry*. Wall to wall with hits, from "I Feel the Earth Move" to "It's Too Late," it became pop music's bestseller to date and stayed on record charts for more than five years.

Pink Floyd

"AS LONG AS THERE ARE POTHEADS, water beds and freshman philosophy majors," a *New York Times* critic wrote, *Dark Side of the Moon,* Pink Floyd's art-rock extravaganza, will sell. True, that: *Moon* stayed on the *Billboard* Top 200 albums chart for more than 14 *years. The Wall,* a later concept album about an artist doomed to suffer in a world in which parents, teachers and lovers just, you know, just don't *understand,* sold 23 million.

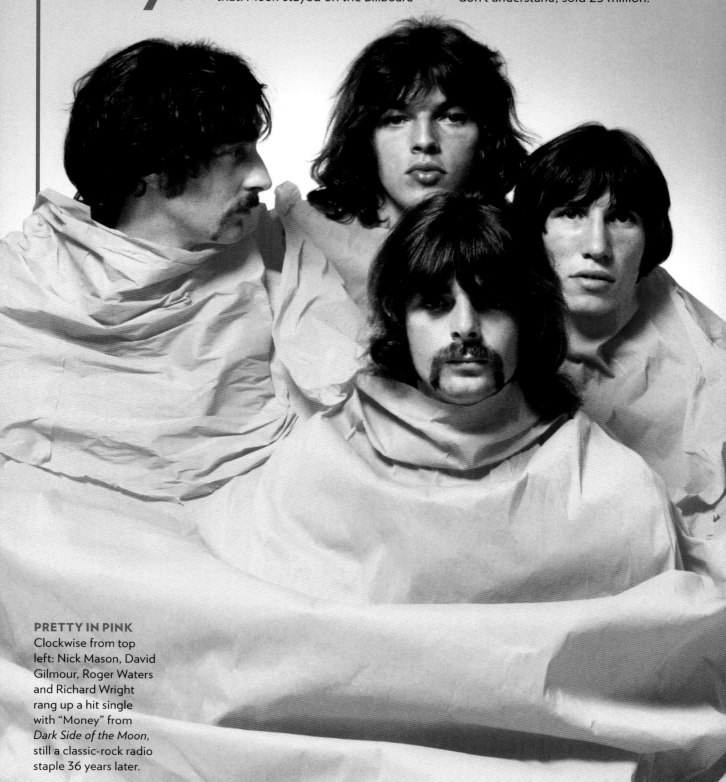

PRETTY IN PINK
Clockwise from top left: Nick Mason, David Gilmour, Roger Waters and Richard Wright rang up a hit single with "Money" from *Dark Side of the Moon,* still a classic-rock radio staple 36 years later.

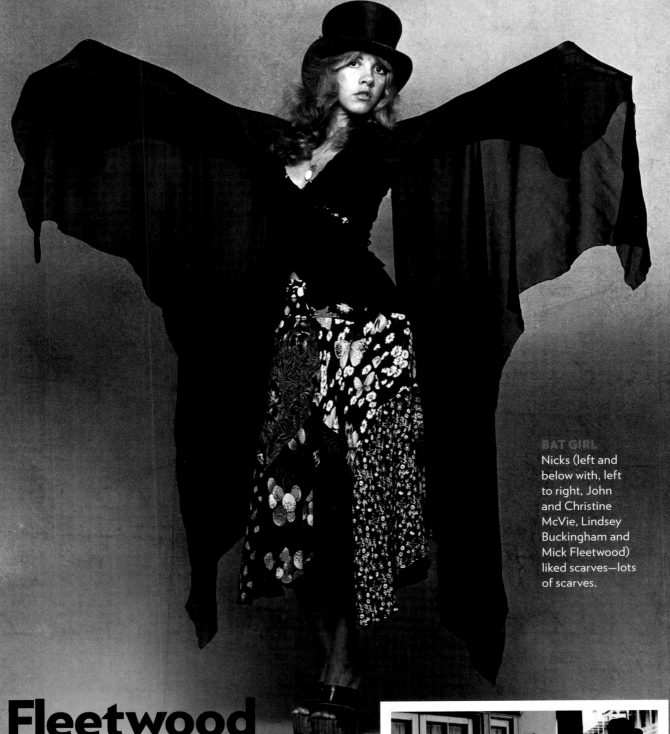

Fleetwood Mac

BASSIST JOHN McVIE AND SINGER CHRISTINE McVIE WERE divorcing; singer Stevie Nicks had just left guitarist Lindsey Buckingham; and drummer Mick Fleetwood was splitting from his wife, an ex-model. So when it came time for the gossip-magnet band to name their 1977 album, John came up with the perfect title: *Rumours.* Upbeat, highly produced songs about love and loss—and Nicks's sexy-gypsy image—proved catnip to pop fans: The album sold more than 17 million copies in the U.S.

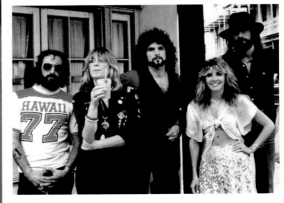

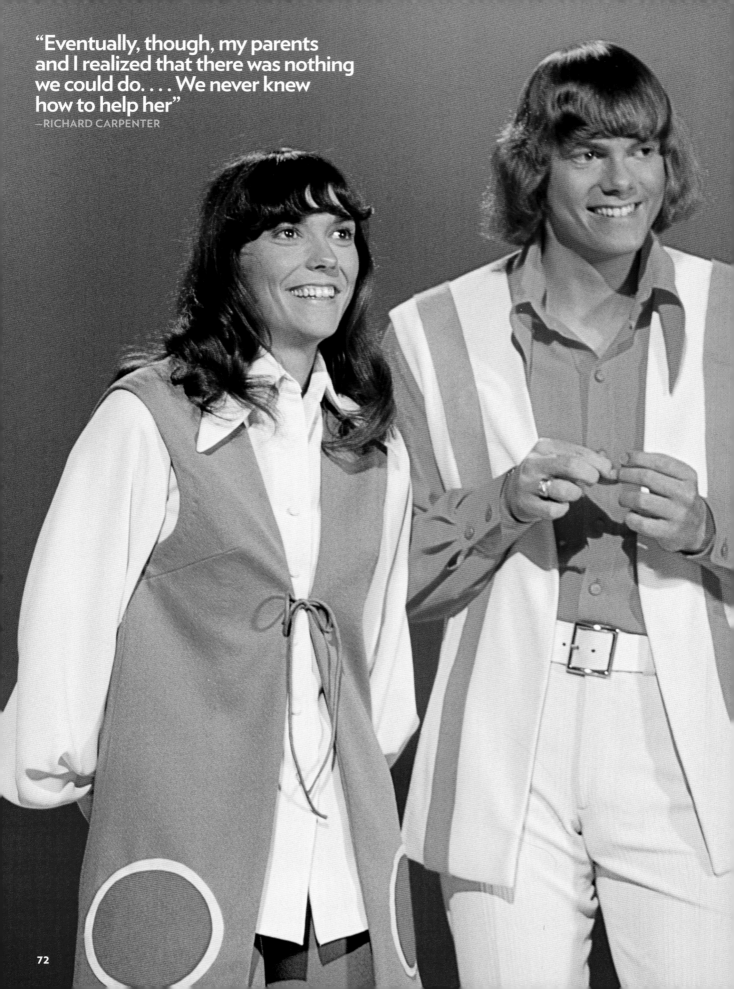

"Eventually, though, my parents and I realized that there was nothing we could do. . . . We never knew how to help her"
—RICHARD CARPENTER

ROCKIN' THAT '70s STYLE

The Carpenters, ABBA and the Captain and Tennille created unique sounds—and unforgettable outfits—that helped define a decade

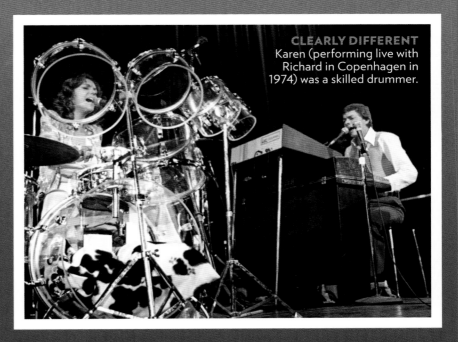

CLEARLY DIFFERENT
Karen (performing live with Richard in Copenhagen in 1974) was a skilled drummer.

The Carpenters

A SUGAR-SWEET YING TO THE COUNTERCULTURE'S hard-rocking yang, the Carpenters sang of smiles, dreams and new love. "Why do birds suddenly appear, every time you are near?" Karen Carpenter, whose dulcet voice propelled the brother-sister act, sang in their 1970 breakthrough hit, "Close to You," "Just like me, they long to be, close to you . . ." Sadly, the Carpenters' bubbly, kids-next-door image hid problems: Richard Carpenter developed a dependency on quaaludes; Karen became obsessed with her weight. Her sudden death in 1983, at 32, shocked their millions of fans and introduced many Americans to a word they had never heard: anorexia.

AND NOW
Married for 25 years and a father of five, Richard, 62, lives in Thousand Oaks, Calif., writes and produces, and collects cars.

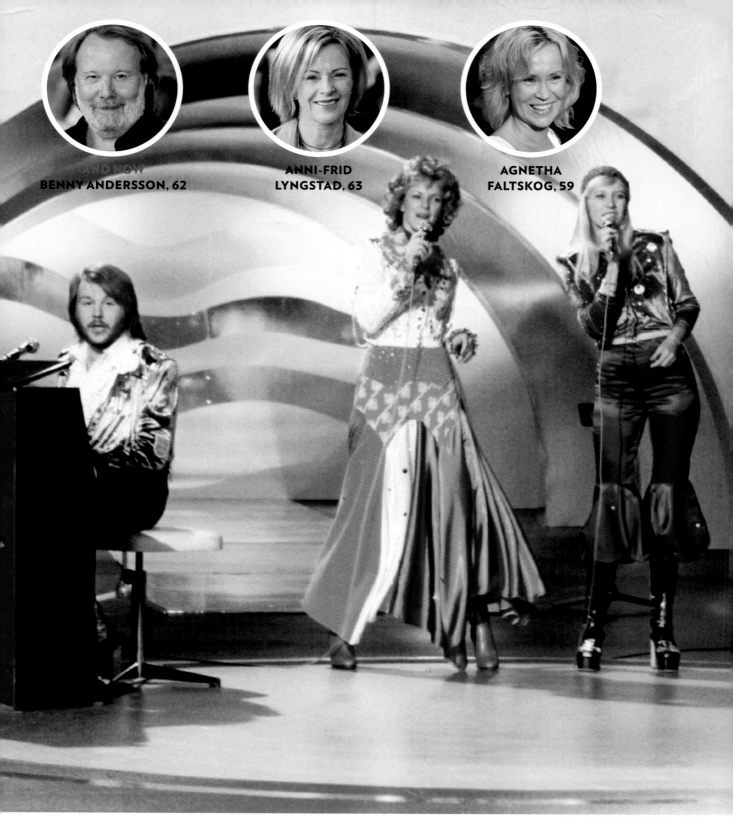

AND NOW

BENNY ANDERSSON, 62

ANNI-FRID LYNGSTAD, 63

AGNETHA FALTSKOG, 59

ABBA

FIRST EUROPE—THEY WON THE 1974 EUROVISION SONG
contest with "Waterloo"—then the world: Paragon pur-
veyors of an inimitable brand of pop without borders,
ABBA sold more singles than any group since the Beatles
and, at the height of their fame—after expanding into
oil and real estate businesses—was the most profitable
corporation in Sweden. Although all four appeared for
the Stockholm premier of the ABBA-inspired musical
Mamma Mia!, Björn Ulvaeus, now 64, says they will never
perform again: "We would like people to remember us as
we were: young, full of energy and ambition."

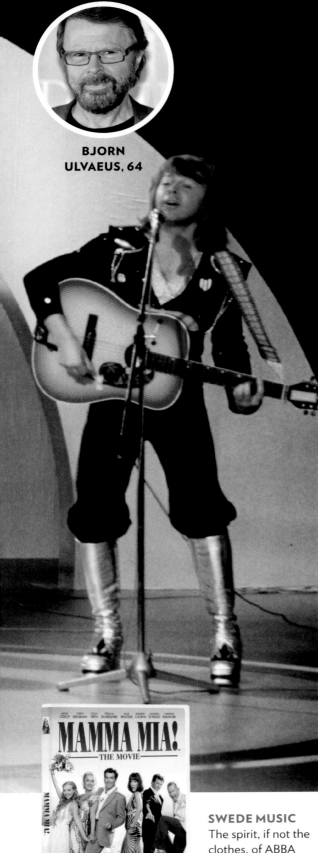

**BJORN
ULVAEUS, 64**

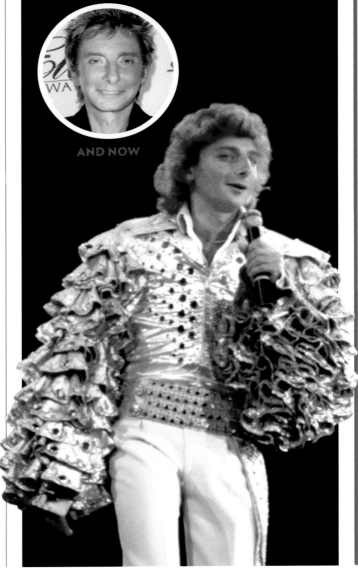

Barry Manilow

HE SCORED 14 HITS IN FOUR YEARS, EVEN AS critics dismissed him as "Barry Marshmallow," the king of sticky-soft pop. But fans still flock to his show at the Las Vegas Hilton and sing along with "Copacabana" and "I Write the Songs." Now 66, Manilow doesn't miss '70s fashion ("We all looked like morons, but I think I win for the *most* moronic outfit") but does lament that the great pop songs aren't what they used to be. "I don't think you'll ever hear lyric-writing like this again: 'Love is a many splendored thing,'" he says. "These days you hear, 'My humps, my lumps, my bumps!'"

AND NOW

SWEDE MUSIC
The spirit, if not the clothes, of ABBA (above, in 1974) lives on in last year's *Mamma Mia!,* starring Meryl Streep.

75

The Village People

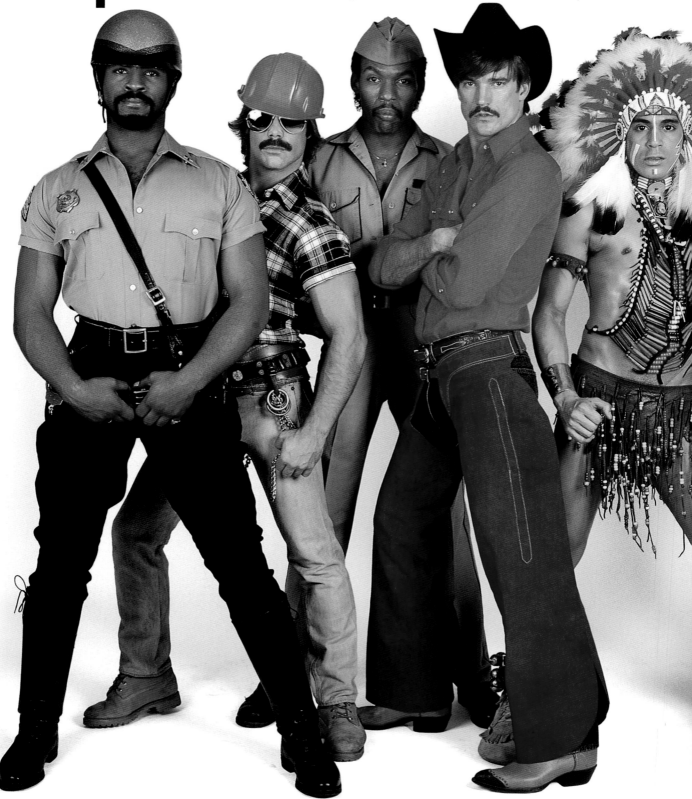

THE COP	THE HARD HAT	THE GI	THE COWBOY	THE INDIAN
Victor Willis	David Hodo	Alex Briley	Randy Jones	Felipe Rose

like we'd been group-loved by the world, then all of a sudden group-rejected," said David Hodo (the hard hat)—the band achieved a kind of nostalgia equilibrium, making a living performing 80 to 100 shows a year. Hodo once said, "We thank God every time we have 'Macho Man' or 'YMCA' to do."

A VILLAGER REMEMBERS

THE COSTUMES; THE CHEESY LYRICS: What neon and Lycra were to the '80s, the Village People were to the '70s. "The decade that taste forgot," says Felipe Rose, the group's founding member, who was discovered while dancing in his full Native American regalia (he is Lakota Sioux) at a New York City nightclub. Rose admits that even he found the band's original concept deeply ridiculous. "It was going to be a landmark tribute to the gay lifestyle back in the day," Rose says. "But then it started to go down the camp, tacky road." Yet aside from a 15-month "breakup" in 1985, and replacing a few orignial members , the group has been touring every year since 1977. For Rose, 55, who has produced several Native American Music Award-winning records, his heart is still with the People. Fans—including Cher, with whom they toured in 2005—still thrill to the brilliant absurdity of it all, and the band, he says, has more offers than they can accept. "The phone never stops," says Rose. "Disco lives."

Barry White

HIS BIGGEST HIT ("LOVE'S THEME") was an instrumental, but Barry White will always be remembered for singing late-night love songs ("It's Ecstasy When You Lay Down Next to Me") in a voice so deep it made the earth move. Where did it come from? "I just woke up one morning," he recalled, "went to speak to my mother and scared us both to death." As a songwriter, White, who died of kidney failure in 2003, never strayed from his favorite topic. "I just write about love," he said. "That's what I'm about."

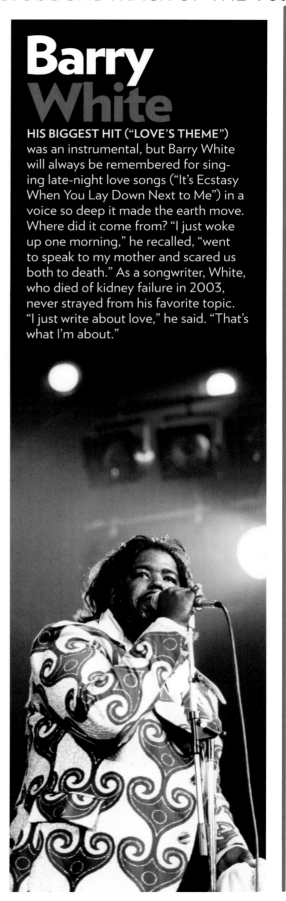

Carly Simon

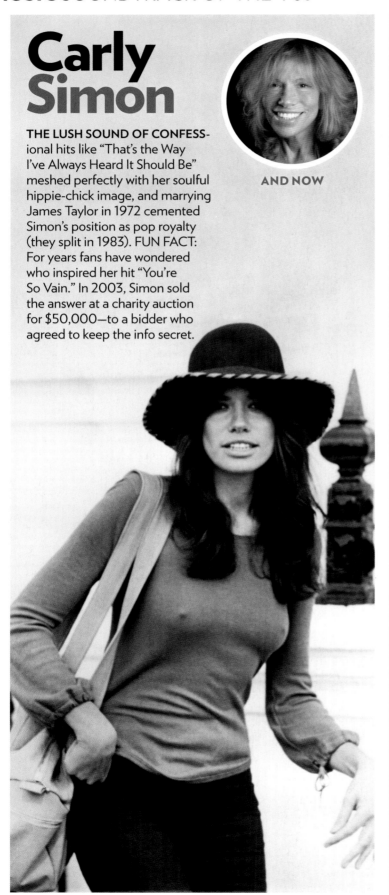

AND NOW

THE LUSH SOUND OF CONFESS-ional hits like "That's the Way I've Always Heard It Should Be" meshed perfectly with her soulful hippie-chick image, and marrying James Taylor in 1972 cemented Simon's position as pop royalty (they split in 1983). FUN FACT: For years fans have wondered who inspired her hit "You're So Vain." In 2003, Simon sold the answer at a charity auction for $50,000—to a bidder who agreed to keep the info secret.

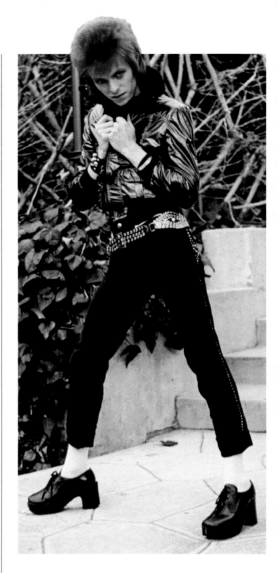

David Bowie

WHEN IT CAME TO TRANSGENDER GLAM space rock, no one did it better than David Bowie, a personality born to entertain—his training included mime lessons—who delighted in visual shock. Verbal, too: Boasting to the press about his bisexuality, he claimed to have met his then-wife, fashion model Angela Barnett, "when we were both laying the same bloke."

Ah, youth! Since marrying the model Iman in 1992, Bowie, 62, has lived the life of a gentleman squire.

AND NOW

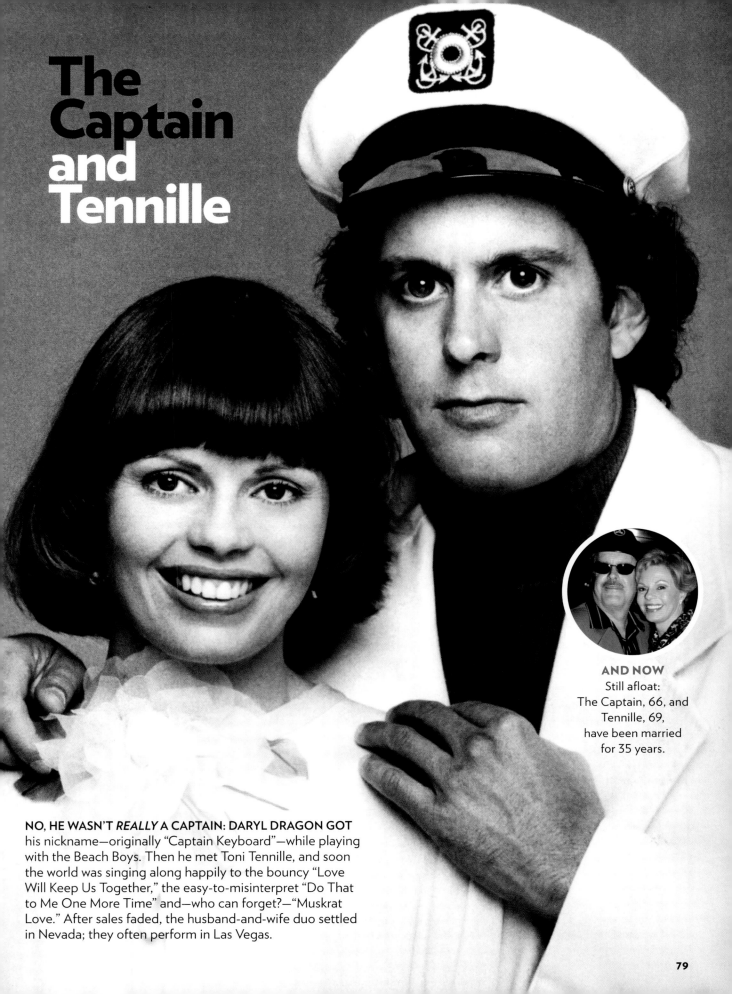

The Captain and Tennille

AND NOW
Still afloat: The Captain, 66, and Tennille, 69, have been married for 35 years.

NO, HE WASN'T *REALLY* A CAPTAIN: DARYL DRAGON GOT his nickname—originally "Captain Keyboard"—while playing with the Beach Boys. Then he met Toni Tennille, and soon the world was singing along happily to the bouncy "Love Will Keep Us Together," the easy-to-misinterpret "Do That to Me One More Time" and—who can forget?—"Muskrat Love." After sales faded, the husband-and-wife duo settled in Nevada; they often perform in Las Vegas.

THE REVOLUTIONARIES

Some musicians create hits. Reggae's king
and Britain's proto punks created genres

Bob Marley

"ME SPEAK TO ALL THE CHIL-
dren," said Marley. "Me speak
to everything that moveth and
liveth 'pon the Earth." The planet
responded: After Eric Clapton
recorded the singer's classic
"I Shot the Sheriff" in 1974,
Marley—the man who wedded
utopian, Rastafarian beliefs to
the angry politics of Jamaica's
underclass—became reggae's
first superstar. When he died,
age 36, of cancer in 1981, he
was awarded a state funeral.

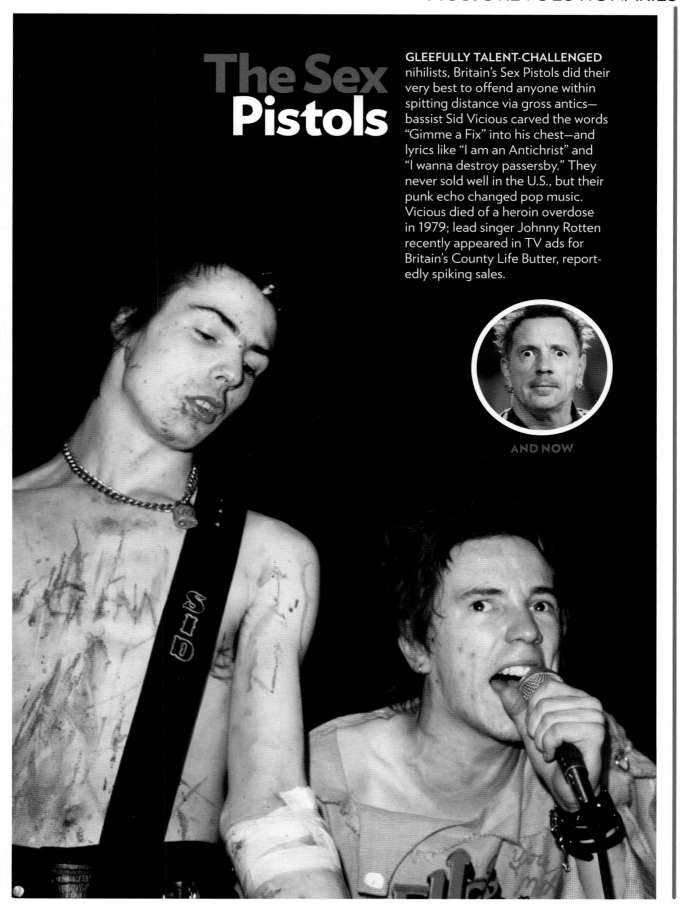

The Sex Pistols

GLEEFULLY TALENT-CHALLENGED nihilists, Britain's Sex Pistols did their very best to offend anyone within spitting distance via gross antics—bassist Sid Vicious carved the words "Gimme a Fix" into his chest—and lyrics like "I am an Antichrist" and "I wanna destroy passersby." They never sold well in the U.S., but their punk echo changed pop music. Vicious died of a heroin overdose in 1979; lead singer Johnny Rotten recently appeared in TV ads for Britain's County Life Butter, reportedly spiking sales.

AND NOW

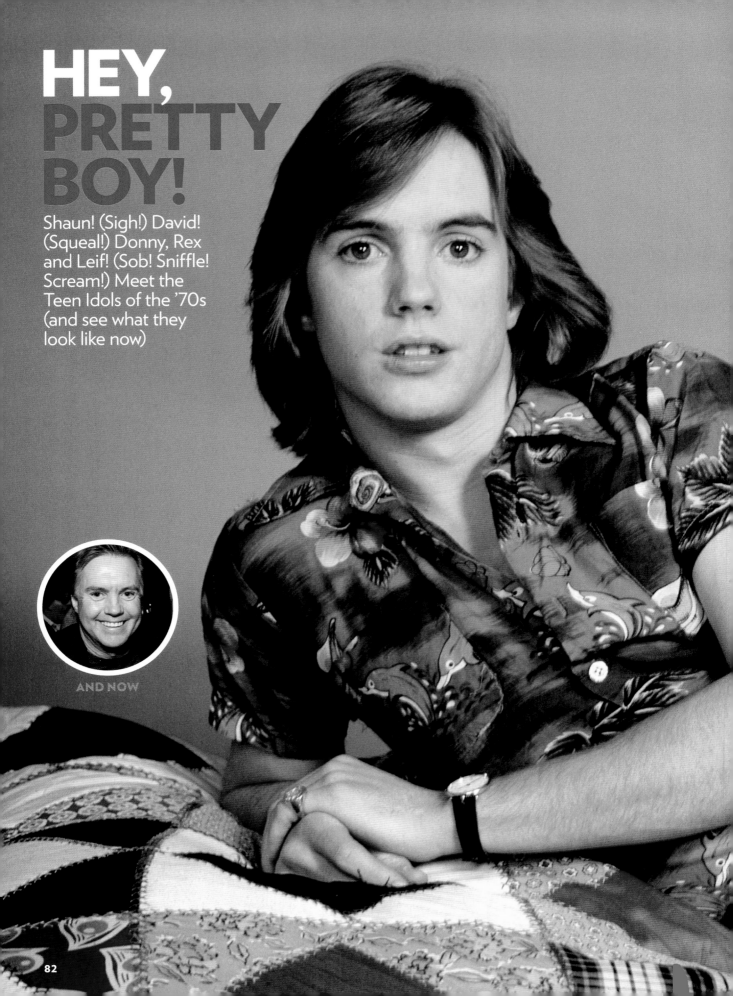

HEY, PRETTY BOY!

Shaun! (Sigh!) David! (Squeal!) Donny, Rex and Leif! (Sob! Sniffle! Scream!) Meet the Teen Idols of the '70s (and see what they look like now)

AND NOW

Shaun Cassidy

A MAN, A VAN, A PLAN
Cassidy (with *Hardy Boys* costar Parker Stevenson), wrote a critic, "can provoke riotous rites of weepy nubility every time he bats his well-turned lashes."

HE HAD A SHOWBIZ CHILDHOOD (MOM AND DAD, Shirley Jones and Jack Cassidy, were actors) and half-brother David Cassidy (see page 87) had been a teen idol, so doe-eyed Shaun, 18, knew what to expect when his TV show, *The Hardy Boys*, and album took off in 1977. "The average length of a career like mine," he noted, "is five years." He marketed himself carefully ("I'm being sold from here to Timbuktu," he said, "but I'm doing the selling") and planned for a future behind the scenes. And . . . it worked: Cassidy, 50 and a father of three, is a writer and producer; his credits include *American Gothic*, *Cold Case* and the upcoming *Ruby & the Rockits*, about an aging idol.

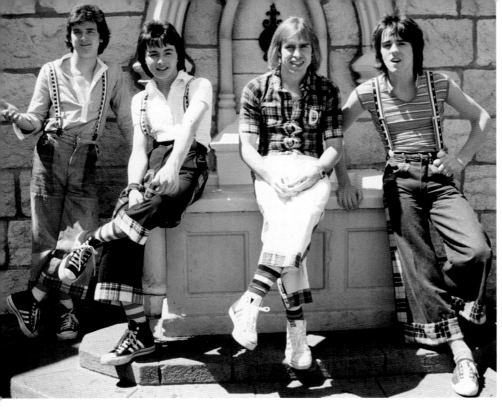

Bay City Rollers

SCOTLAND'S PLAID-CLAD LADS had a hit, "Saturday Night," and a promoter who unblushingly promised "the biggest phenomenon since the Beatles." But it all ended *very* badly: Fights over money have gone on for decades, and two band members have said they were raped by their manager, Tam Paton, who died on April 8, 2009. "I hope he is roasting in hell now," said guitarist Pat McGlynn. "When I get there, I want a job stoking the fires."

ROLLER MODELS
From left: Les McKeown, Eric Faulkner, Derek Longmuir and Stuart Wood. (Not shown: Alan Longmuir.)

Donny Osmond

AT ONE POINT, HE WAS *more* than world famous: Astronaut Neil Armstrong left a copy of one of Osmond's songs on the moon. After numerous ups and downs—a hit TV show, a flirtation with bankruptcy, five years in *Joseph and the Amazing Technicolor Dreamcoat*—Osmond, now 51, headlines a Vegas revue with sister Marie and is a father of five. (Marie has seven children.) As Mormons, "we don't smoke or drink," says Donny, "so we've got to do something."

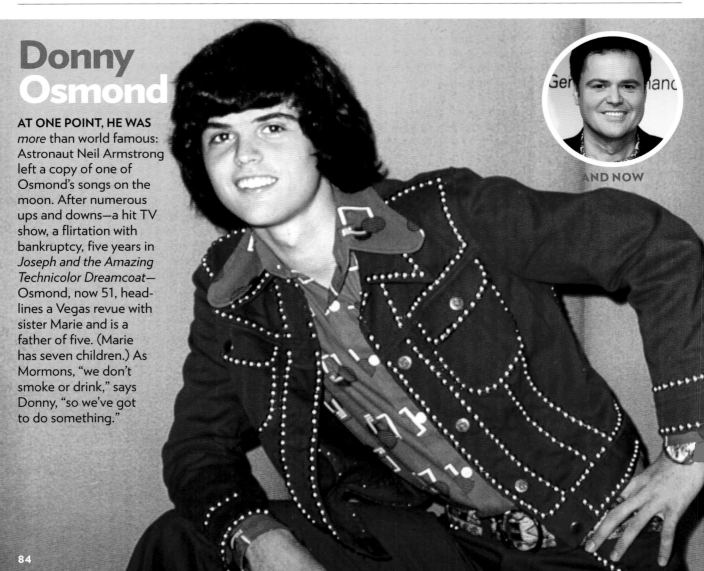

AND NOW

AND NOW

Leif **Garrett**

"MY GUT FEELING," HE SAID AT the height of his '70s success, "is that [teen idoldom] is just something I'll pass through on the way to something else." Garrett was right, but tragically: In 1979, at 17, he crashed his Porsche, leaving his passenger, a friend, disabled; in 2006, after a series of drug arrests, he was sentenced to 90 days in jail.

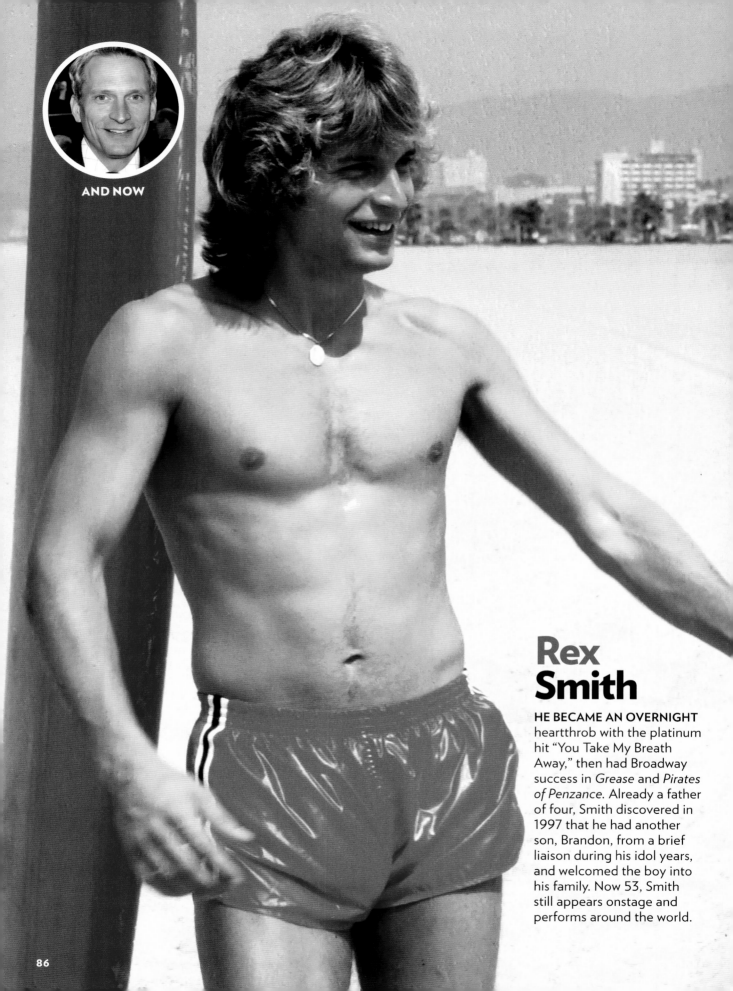

Rex Smith

HE BECAME AN OVERNIGHT heartthrob with the platinum hit "You Take My Breath Away," then had Broadway success in *Grease* and *Pirates of Penzance*. Already a father of four, Smith discovered in 1997 that he had another son, Brandon, from a brief liaison during his idol years, and welcomed the boy into his family. Now 53, Smith still appears onstage and performs around the world.

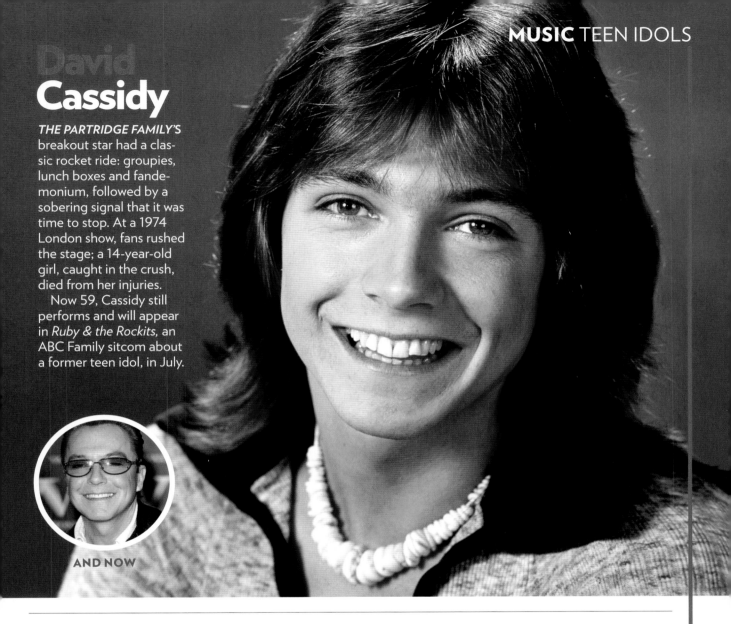

David
Cassidy

THE PARTRIDGE FAMILY'S breakout star had a classic rocket ride: groupies, lunch boxes and fandemonium, followed by a sobering signal that it was time to stop. At a 1974 London show, fans rushed the stage; a 14-year-old girl, caught in the crush, died from her injuries.

Now 59, Cassidy still performs and will appear in *Ruby & the Rockits*, an ABC Family sitcom about a former teen idol, in July.

AND NOW

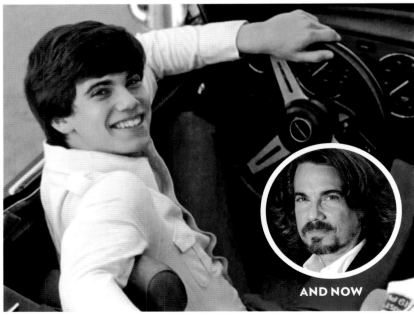

AND NOW

Robby
Benson

SOMETHING OF A RARITY IN THE teen idol world, Benson landed on fan mag covers because of his acting in films like *Ice Castles* and *One on One*, not his singing (although years later he voiced the Beast in Disney's animated *Beauty and the Beast*). When the roles dried up, Benson, now 53 and married to singer Karla DeVito for 27 years—they have a daughter, Lyric, 26, and a son, Zephyr, 17—became a peripatetic academic. He recently spent a year as Professor of Film at New York University.

WHO SANG IT?

Lyrical hooks from '70s hits to which millions can still sing along

"I'm not dumb, but I can't understand why she walked like a woman but talked like a man" **5**

"Did you think I'd crumble? Did you think I'd lay down and die?" **3**

"You got to know when to hold 'em, know when to fold 'em" **1**

"We never ever do nothin' *nice* and *easy*" **2**

"Jeremiah was a bullfrog, was a good friend of mine" **4**

A
Three Dog Night
Joy to the World

D
Jimmy Buffett
Margaritaville

B
Helen Reddy
I Am Woman

C
Gloria Gaynor
I Will Survive

E
Don McLean
American Pie

"Drove my Chevy to the levee, but the levee was dry" **8**

"Some people claim that there's a woman to blame, but I know it's my own damn fault" **10**

"If you want my body and you think I'm sexy, come on, Sugar, let me know" **7**

"I am woman, hear me roar, in numbers too big to ignore" **9**

"Loving you whether, whether times are good or bad, happy or sad" **6**

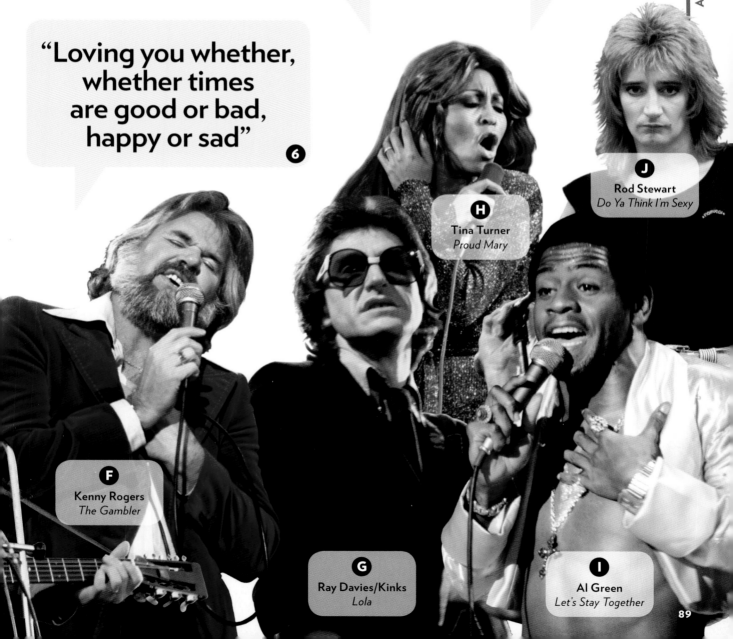

J
Rod Stewart
Do Ya Think I'm Sexy

H
Tina Turner
Proud Mary

F
Kenny Rogers
The Gambler

G
Ray Davies/Kinks
Lola

I
Al Green
Let's Stay Together

89

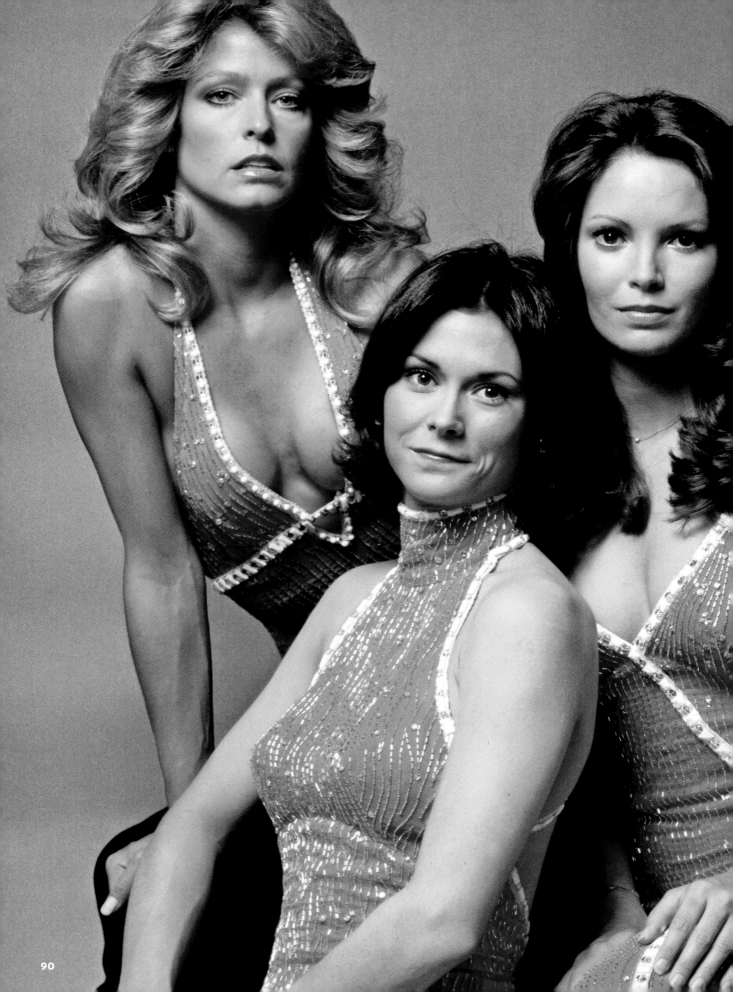

TV
BREAKTHROUGHS & BIG HITS

Farewell, *Bonanza*. Goodbye, *Gunsmoke*. A prime-time revolution brought sex (*Charlie's Angels*), controversy (*All in the Family*) and daring (*Roots*) to the small screen

Charlie's Angels

TV TRINITY
TIME called *Charlie's Angels* (starring, from left, Farrah Fawcett, Kate Jackson and Jaclyn Smith) an "aesthetically ridiculous, commercially brilliant brainstorm surfing blithely atop the zeitgeist's seventh wave." Fawcett's manager offered a shorter explanation for the show's success: "Nipples."

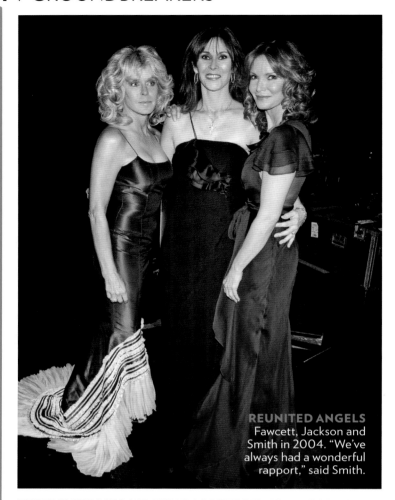

REUNITED ANGELS
Fawcett, Jackson and Smith in 2004. "We've always had a wonderful rapport," said Smith.

Mary Tyler Moore

NEARLY 40 YEARS LATER, IT'S AMAZING to think that Mary Richards, *The Mary Tyler Moore Show*'s central character, was considered a daring creation. Her risk factors? She was a single woman in her 30s, had a job and was happy. Furthermore, she had a sex life: An episode where she spent the night at her boyfriend's house was much murmured about in kitchens and around watercoolers across the nation. No contemporary young fan of *Gossip Girl* will ever believe this, but, yea, it was so.

Still, the soul of the show wasn't in its politics but in its wit and Moore's radiant, vulnerable likability. The actress noted that she was glad audiences liked the character, because, she said, "I play me. I'm scared that if I tamper with it, I might ruin it." Whether she was desperately trying to hold back inappropriate laughter at the funeral of Chuckles the Clown (crushed by an elephant while dressed as a peanut) or, in her job as an associate producer, coping with Ted Baxter, the world's most inept anchorman ("Folks, I've just received a special news bulletin: 'You have something on your front tooth'"), the audience—men *and* women—rooted for Mary to prevail.

THREE HOT BABES, WORKING AS DETECTIVES, WHOSE NEVER- seen boss gives them instructions by phone: ABC execs listened to the producers' pitch and announced, "You guys should be ashamed of yourselves."

And yet: *Charlie's Angels* went on the air Sept. 22, 1976, and made broadcasting history. "Men watch the girls," said designer Nolan Miller. "Women watch the clothes." "'Angels in Chains' was my favorite episode," coproducer Leonard Goldberg said years later, a little wistfully. "*The New York Times* ran a huge photo of the girls chained together, wading through a swamp. The show got a 56 share"— or roughly 2.4 million more viewing households than an episode of *American Idol* gets today.

Back-up Angels

Farrah's replacement, Cheryl Ladd (left) had a long tenure, but Shelley Hack and Tanya Roberts were more transitory spirits.

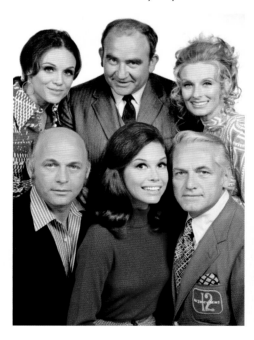

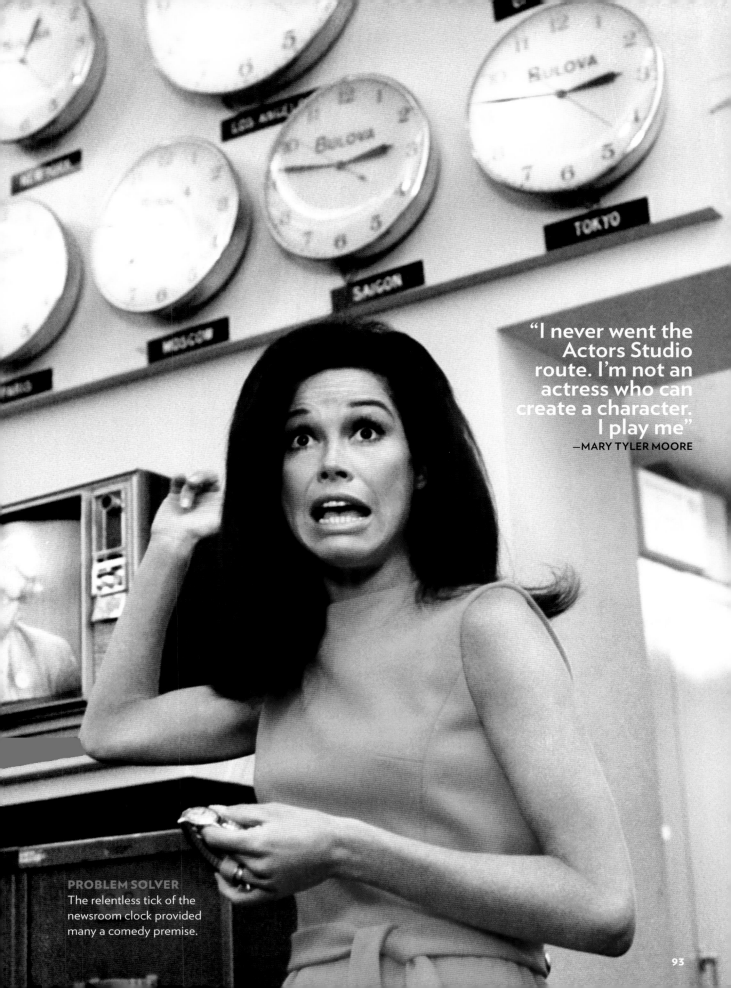

> "I never went the Actors Studio route. I'm not an actress who can create a character. I play me"
> —MARY TYLER MOORE

PROBLEM SOLVER
The relentless tick of the newsroom clock provided many a comedy premise.

93

WHO RULED PRIME TIME?
KING LEAR

Fed up with sitcom pablum, renegade writer-producer Norman Lear changed what America watched

"The more [audiences] cared," said Lear (left), "the harder they laughed."

"I'M DAMNED GLAD TO BE NORMAN LEAR," SAID NORMAN LEAR IN 1976. "I'm having a helluva good time being me."

No surprise: In the early '70s, Lear revolutionized television, won critical acclaim and made millions. Formulaic sitcoms—as well as sitcops and sitdocs—were losing steam. Lear roused nodding audiences—and terrified network execs—with a radical idea: topical comedy touching on racism, sexism, politics and religion. Spouting terms like "spic," "wops," "spades" and "Hebes," Archie Bunker, the blue-collar protagonist at the heart of Lear's biggest hit, *All in the Family,* kept millions tuning in to find out each week if there was anything that *couldn't* be said on TV. One good controversial hit spawned the next until, by 1976, Lear had eight shows on the air and a weekly audience of 120 million. "Not since Disney," said TIME, "has a single showman invaded the screen and the national imagination with such a collection of memorable characters."

What drove Lear? "I consider myself a writer who loves to show real people in real conflict with all their fears, doubts, hopes and ambitions rubbing against their love for one another," he said. "I want my shows to be funny, outrageous and alive. So far, so good."

Love and Ranting

Lear's formula—strong personalities, outrageous opinions, a family setting—led to the hits (from left) *Maude* (with Bea Arthur), *The Jeffersons* (Sherman Hemsley, Isabel Sanford) and *Sanford and Son* (Redd Foxx, Demond Wilson).

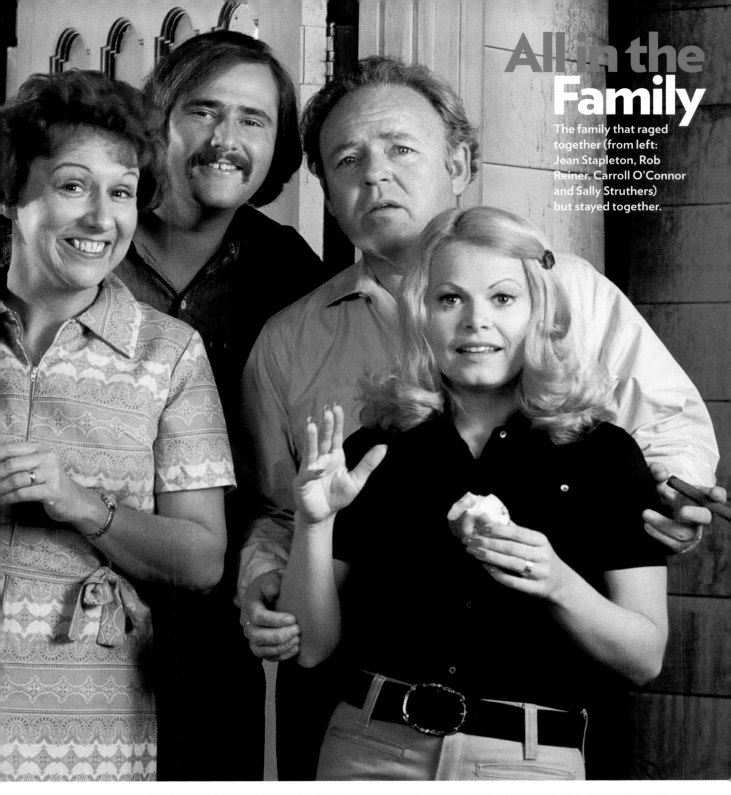

All in the Family

The family that raged together (from left: Jean Stapleton, Rob Reiner, Carroll O'Connor and Sally Struthers) but stayed together.

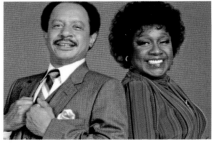

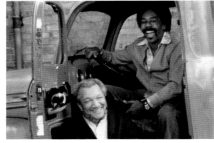

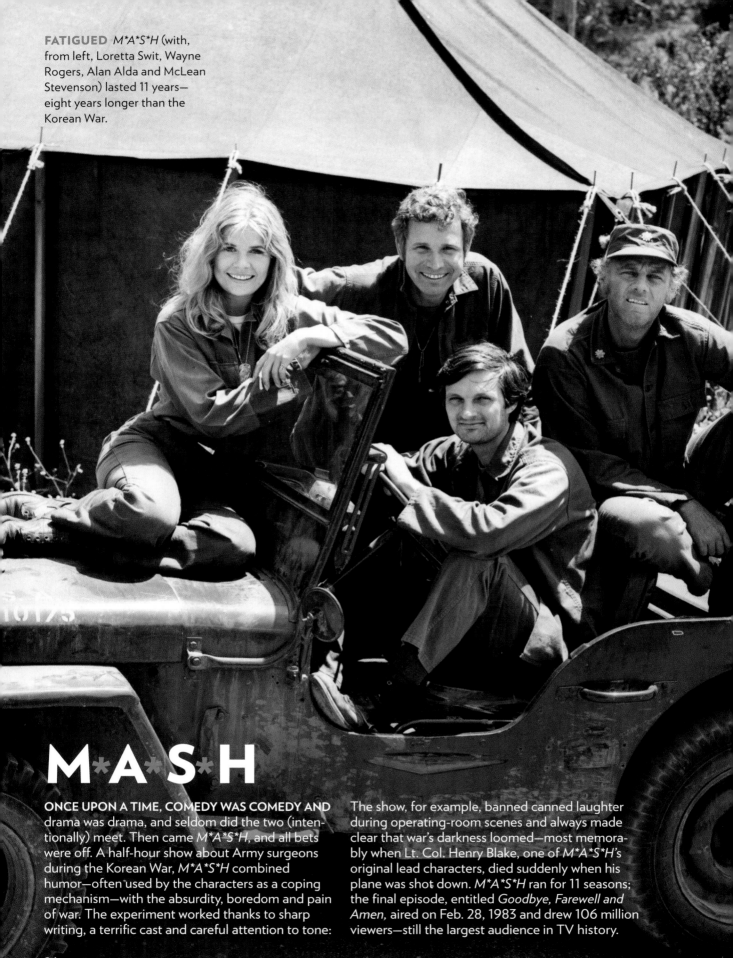

FATIGUED *M*A*S*H* (with, from left, Loretta Swit, Wayne Rogers, Alan Alda and McLean Stevenson) lasted 11 years—eight years longer than the Korean War.

M·A·S·H

ONCE UPON A TIME, COMEDY WAS COMEDY AND drama was drama, and seldom did the two (intentionally) meet. Then came *M*A*S*H*, and all bets were off. A half-hour show about Army surgeons during the Korean War, *M*A*S*H* combined humor—often used by the characters as a coping mechanism—with the absurdity, boredom and pain of war. The experiment worked thanks to sharp writing, a terrific cast and careful attention to tone:

The show, for example, banned canned laughter during operating-room scenes and always made clear that war's darkness loomed—most memorably when Lt. Col. Henry Blake, one of *M*A*S*H*'s original lead characters, died suddenly when his plane was shot down. *M*A*S*H* ran for 11 seasons; the final episode, entitled *Goodbye, Farewell and Amen,* aired on Feb. 28, 1983 and drew 106 million viewers—still the largest audience in TV history.

An American Family

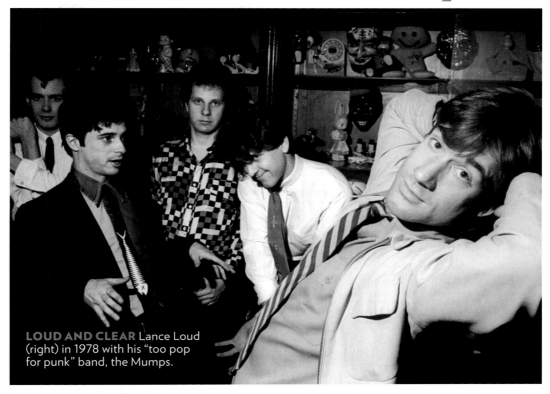

LOUD AND CLEAR Lance Loud (right) in 1978 with his "too pop for punk" band, the Mumps.

THERE WERE THREE NETWORKS, filled with similar fare. Then, on PBS, came something radically different: a 12-hour documentary about one outwardly unexceptional American family, the Louds, who had permitted a film crew to live in their Santa Barbara home for seven months. Much of *An American Family* was banal, but more was riveting: In an early episode, son Lance Loud, 21, came out to his mom as homosexual—not typical television in 1973. In later episodes parents Pat and Bill's marriage fell apart, in detail, on camera; she filed for divorce and he moved out. *An American Family* suggested that *any* home might, indeed probably did, house real human drama—and set the stage for every camera-never-blinks reality show that followed, from MTV's *Real World* to *The Hills*.

Lance, perhaps the most famous Loud, died of hepatitis C, at 50, in 2001. A friend noted at the time that the family, despite all, were "actually very loving."

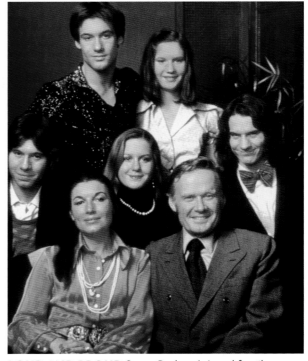

LOUD AND PROUD Santa Barbara's Loud family, reality TV pioneers, in 1973. Front row: mom and dad Pat and Bill; middle row: Kevin, Delilah and Grant; top: Lance and Michele.

Saturday Night Live

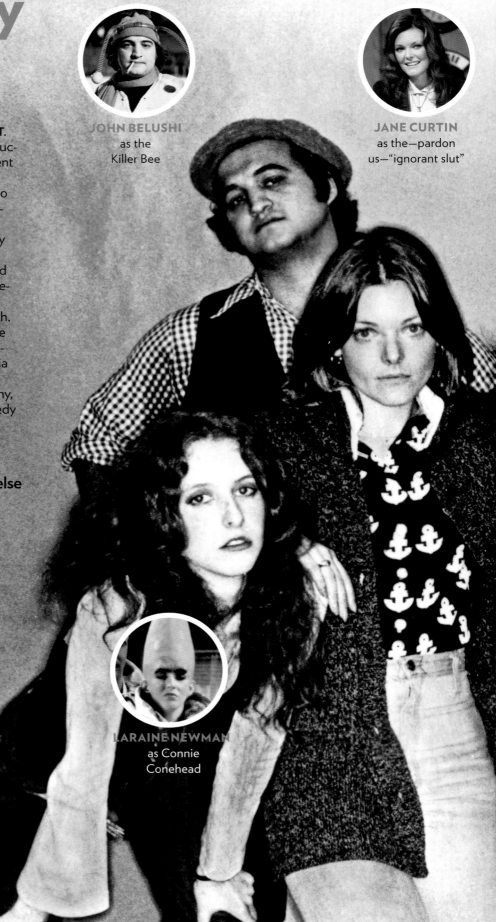

THE VERY FIRST SKETCH, ON OCT. 11, 1975, featured an earnest instructor trying to teach a foreign student (John Belushi) a new phrase. The phrase in question—"I would like to feed your fingertips to the wolverines"—suggested that this would be a very *different* type of comedy show.

Indeed. Subversive, creative and often in trouble with network taste-watchers, *SNL* heralded a generational passing of the comedy torch. Many in the cast went on to movie stardom; 34 years in, the NBC staple—whose graduates include Julia Louis-Dreyfus, David Spade, Will Ferrell, Mike Meyers, Eddie Murphy, Tina Fey and more—is still a comedy proving ground.

They Said it
And pretty soon, everyone else did too: 10 *SNL* phases that burrowed into the zeitgeist

1. "We are two wild and crazy guys!"
2. "I'm Chevy Chase, and you're not."
3. "Jane, you ignorant slut."
4. "Baseball has been berry berry good to me!"
5. "No coke. Pepsi!"
6. "But nooooooo!"
7. "It's always something."
8. "Never mind."
9. "We're from France."
10. "Generalissimo Francisco Franco is still dead."

JOHN BELUSHI
as the
Killer Bee

JANE CURTIN
as the—pardon
us—"ignorant slut"

LARAINE NEWMAN
as Connie
Conehead

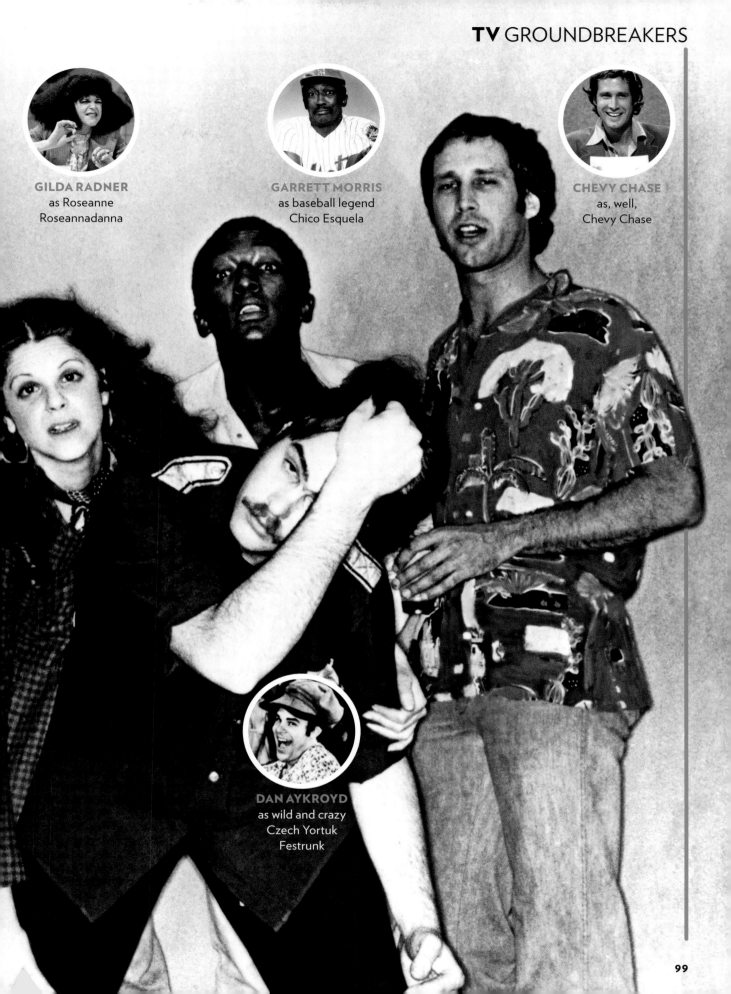

GILDA RADNER
as Roseanne
Roseannadanna

GARRETT MORRIS
as baseball legend
Chico Esquela

CHEVY CHASE
as, well,
Chevy Chase

DAN AYKROYD
as wild and crazy
Czech Yortuk
Festrunk

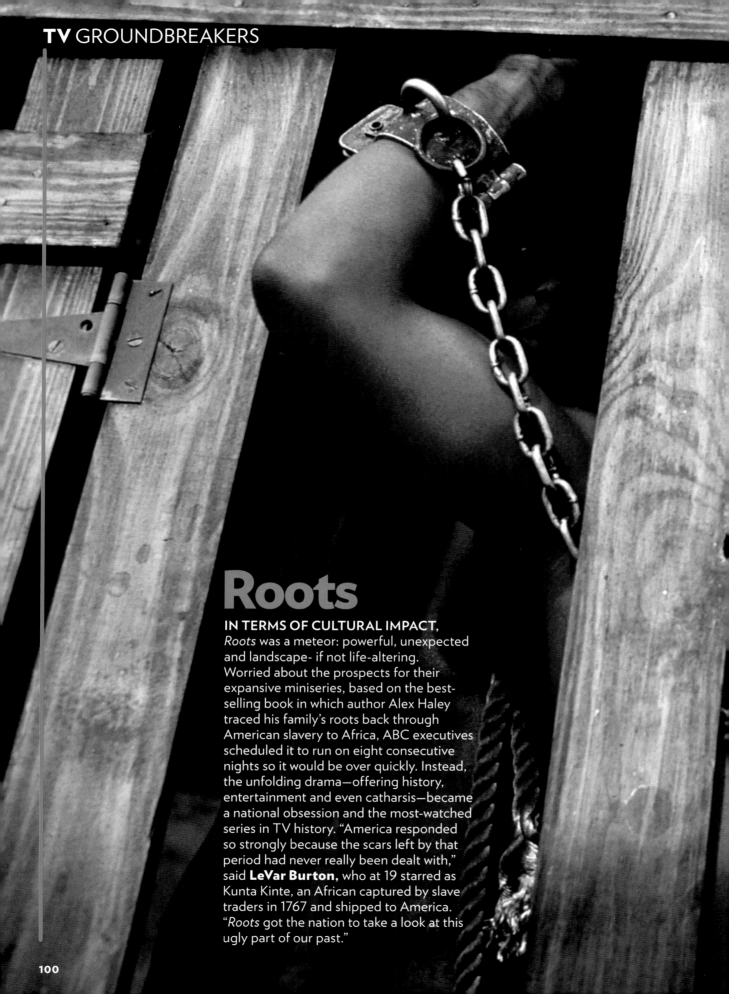

Roots

IN TERMS OF CULTURAL IMPACT,
Roots was a meteor: powerful, unexpected and landscape- if not life-altering. Worried about the prospects for their expansive miniseries, based on the best-selling book in which author Alex Haley traced his family's roots back through American slavery to Africa, ABC executives scheduled it to run on eight consecutive nights so it would be over quickly. Instead, the unfolding drama—offering history, entertainment and even catharsis—became a national obsession and the most-watched series in TV history. "America responded so strongly because the scars left by that period had never really been dealt with," said **LeVar Burton,** who at 19 starred as Kunta Kinte, an African captured by slave traders in 1767 and shipped to America. "*Roots* got the nation to take a look at this ugly part of our past."

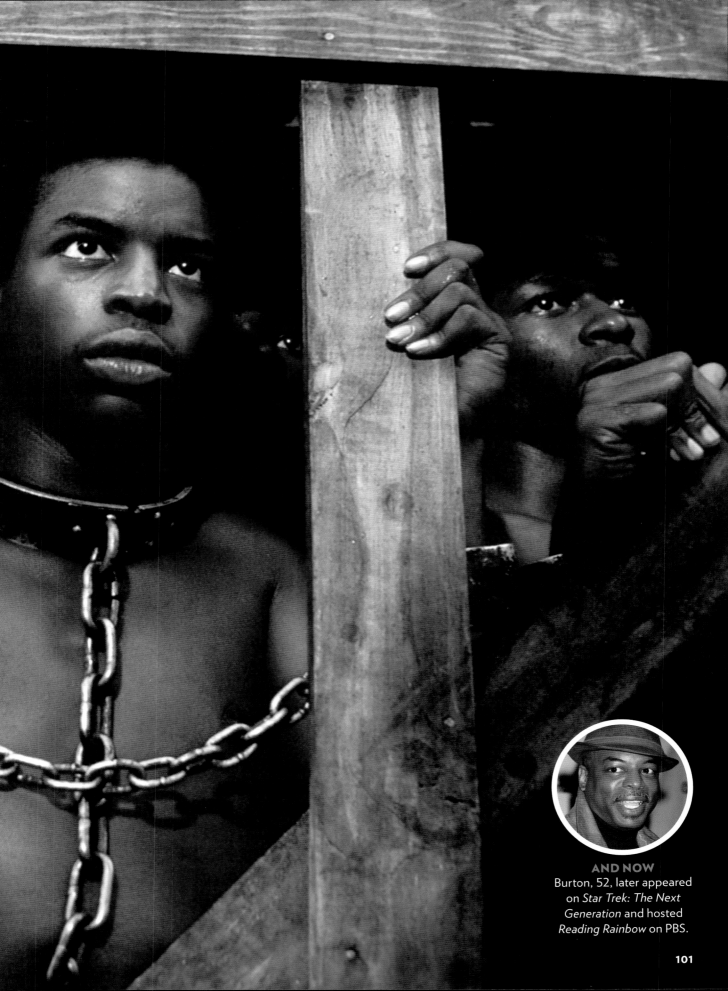

AND NOW
Burton, 52, later appeared on *Star Trek: The Next Generation* and hosted *Reading Rainbow* on PBS.

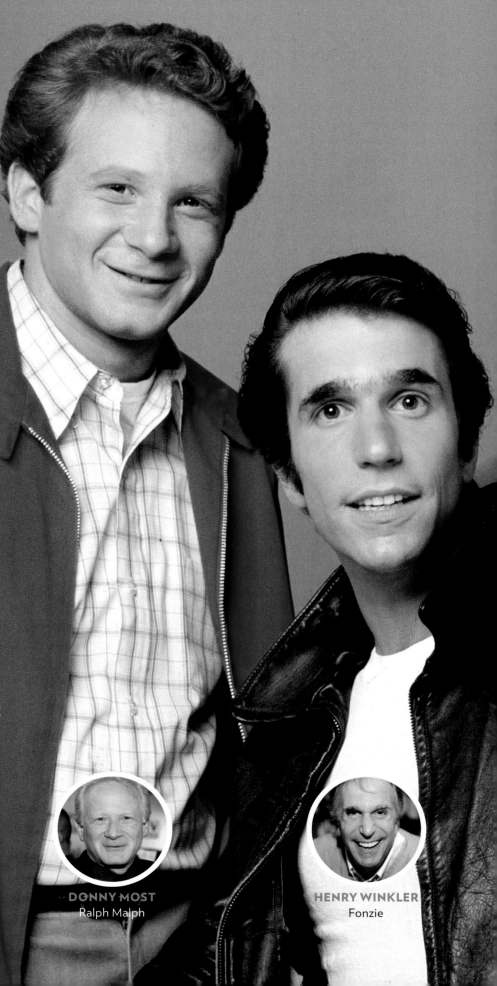

MAKE ME LAUGH

Not *everything* was radical in the '70s: The fun-for-the-whole-family sitcom thrived

Happy Days

TV WAS ONCE LIKE THIS: ABC executives, fearful that Henry Winkler's character, the Fonz, might look too thuggish, refused to let him wear a leather jacket on the show. Standing up for his art, creator Garry Marshall persuaded ABC to let the Fonz wear the jacket *if* he was riding or working on his motorcycle. Gradually ABC stopped paying attention, and Fonzie was allowed to wear it *anywhere*.

Such were the small victories in a TV world ruled by three networks and the FCC. *Happy Days*, a family-values-reinforcing sitcom about growing up in 1950s Milwaukee, ran for 10 years.

DONNY MOST
Ralph Malph

HENRY WINKLER
Fonzie

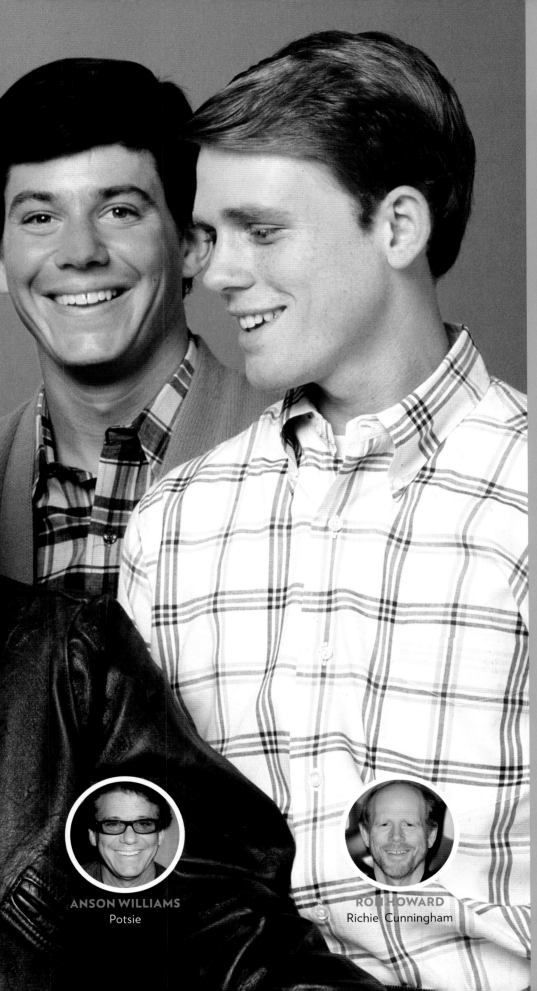

I, Potsie

VERY HAPPY DAYS
Before the show, the guys had to work hard "to get dates," says Williams. Then, suddenly, "we were hot."

ASK ANSON WILLIAMS, a.k.a. Potsie, to explain the success of *Happy Days* and he'll offer two words: Garry Marshall. "He and Ron Howard had such an amazing work ethic and humility," says Williams of the show's creator and director. "We just followed suit." And learned: Generous and charismatic, Marshall readily shared what he knew. "So much came out of collaborating on that set," says Williams. "Everyone kept their head on. To this day we're all in contact." Like Howard, Williams, now 59, turned to directing after *Happy Days* ended and went on to work on *Melrose Place,* the original *90210* and ABC Family's current hit *The Secret Life of the American Teenager.* He is father to five daughters ages 2 to 19 and markets a national line of skin-care products. "*Happy Days,*" he says, "was a life lesson that gave me the tools to climb other mountains."

ANSON WILLIAMS
Potsie

RON HOWARD
Richie Cunningham

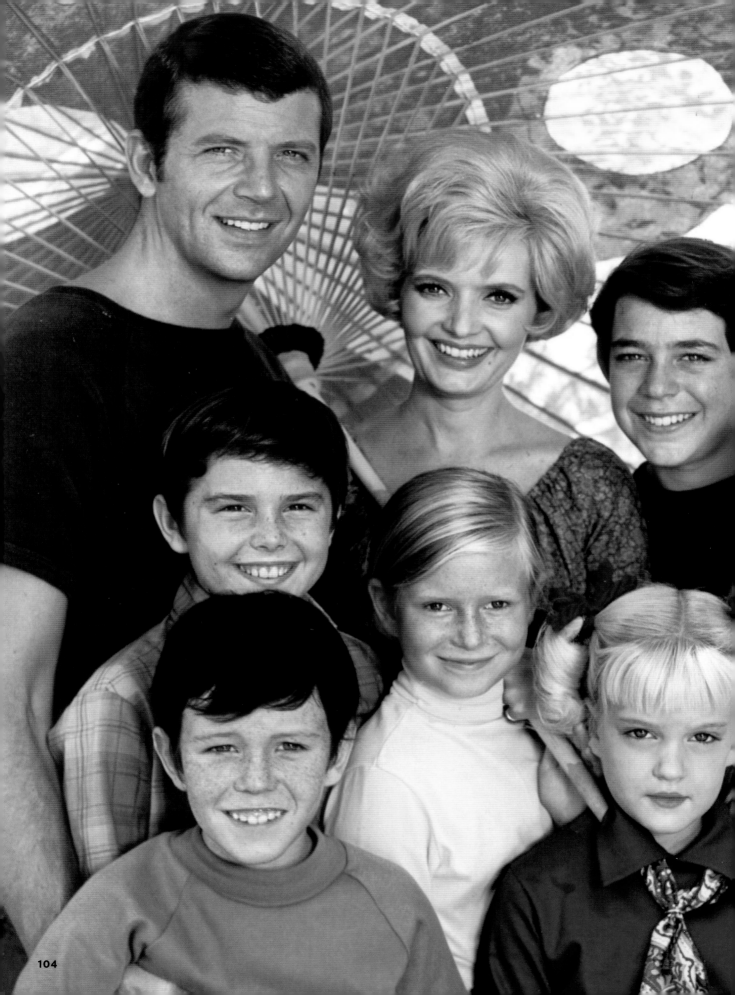

The Brady Bunch

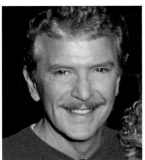
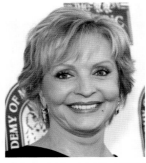

THE BUNCH NOW
Clockwise from top left: Robert Reed, who died in 1992; Florence Henderson; Barry Williams; Maureen McCormick; Susan Olsen; Eve Plumb; Mike Lookinland and Christopher Knight.

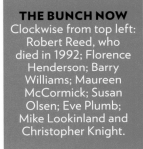
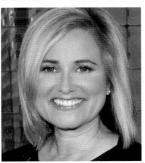

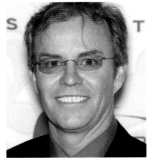
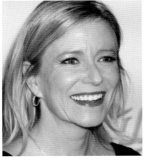

IF SHAG CARPET COULD TALK—AND had a laugh track—it might sound a lot like *The Brady Bunch*, whose perfect-pitch kitsch made it *the* '70s primal family sitcom. Three decades later, where is everybody? Florence Henderson (Mom Carol Brady), 75, makes appearances on TV and as a motivational speaker and recently donated one of her awards to the Smithsonian's National Museum of American History for its permanent collection; Eve Plumb (Jan), 51, is a painter; Maureen McCormick (Marcia), 52, is a country singer and *Celebrity Fit Club* alumna; Christopher Knight (Peter), 51, appeared on *The Surreal Life,* met Adrianne Curry, 26, an *America's Next Top Model* winner, and chronicled their romance on *My Fair Brady*; Barry Williams (Greg), 54, makes his living in musical theater; Susan Olsen (Cindy), 47, worked as a graphic designer and co-authored the upcoming book *Love to Love You Bradys*; and Mike Lookinland (Bobby), 48, runs a custom countertop business in Utah.

Mork and Mindy

Something many people know: **Robin Williams** (with **Pam Dawber**) became an overnight sensation when his sitcom spaceman took off in 1978. Something not everyone remembers: The show was a spinoff from *Happy Days*, where Mork first landed.

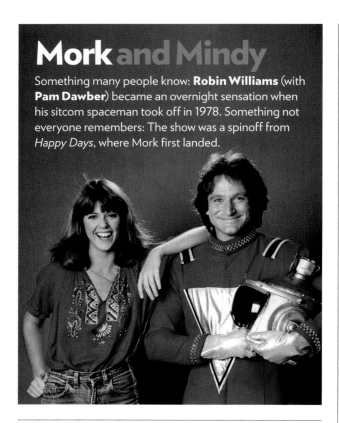

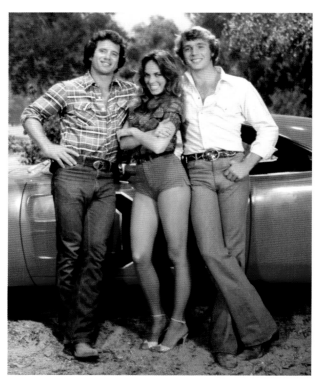

The Dukes of Hazzard

Think *Smokey and the Bandit* for the small screen. It starred **Tom Wopat, Catherine Bach** and **John Schneider,** but fans also had a strong interest in the boys' car, the General Lee, and Bach's ultrashorts—now universally called, in her honor, Daisy Dukes.

Laverne and Shirley

Yet another *Happy Days* spinoff, this one starred **Cindy Williams** (below) and **Penny Marshall** (sister of creator Garry Marshall) as hijinks-prone girlfriends who worked in a beer factory and shared a basement apartment. Hugely successful, *Laverne and Shirley* eventually beat *Happy Days* in the ratings.

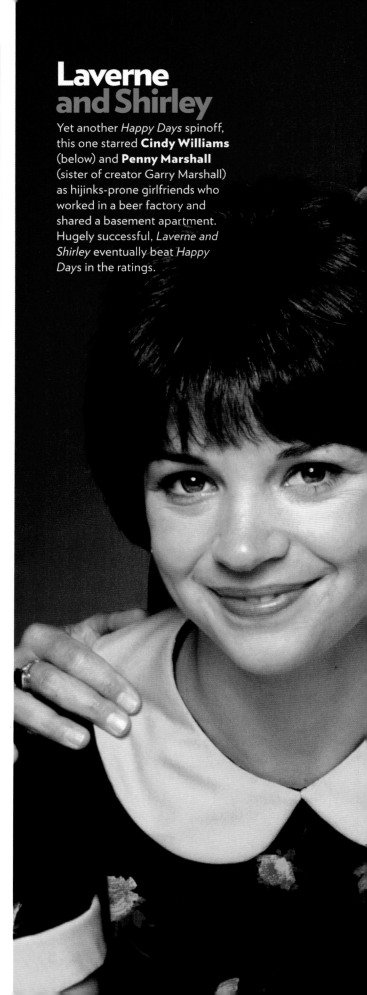

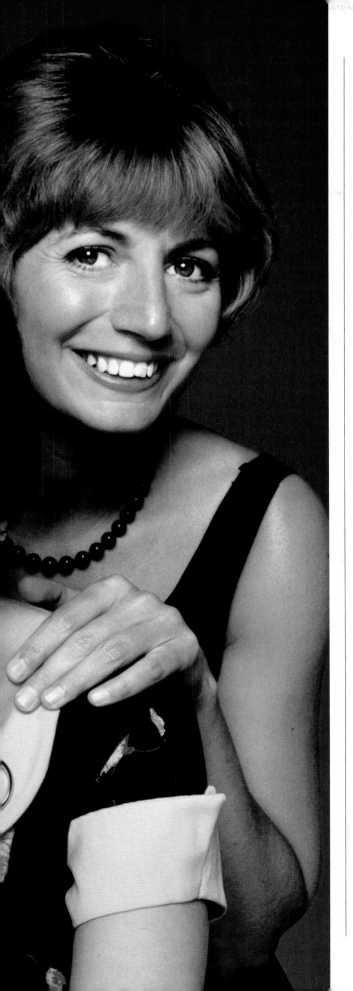

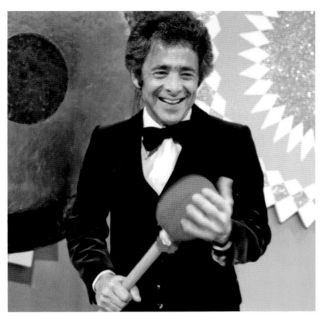

The Gong Show

When an *American Idol* wannabe shrieks tunelessly, you're hearing the echo of **Chuck Barris**'s *Gong Show*. The mother of all talent-slash-humiliation contests featured a dentist who played tunes with his drill and Count Banjula, who fingerpicked a banjo while hanging upside down.

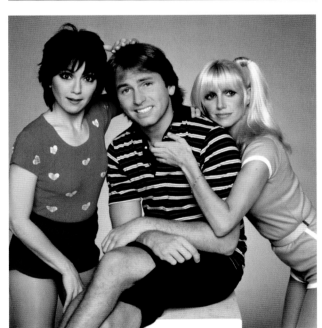

Three's Company

A top-ranked comedy whose premise seems utterly preposterous today: The landlord won't let hetero Jack (**John Ritter**) share an apartment with two women (**Joyce DeWitt**, left, and **Suzanne Somers**), so Jack must pretend, week after week, that he's homosexual. Wackiness ensues.

WHO SAID IT?

If you don't know, you *really* weren't watching enough prime-time TV

"Nanoo nanoo!" **1**

"Dyn-o-mite!" **4**

"Marcia, Marcia, Marcia!" **3**

"Book 'em, Dano" **5**

"Elizabeth… I'm coming to join you, honey!" **2**

A
Henry Winkler
The Fonz
Happy Days

B
Eve Plumb
Jan Brady
The Brady Bunch

C
Ralph Waite
John Walton Sr.
The Waltons

D
Marla Gibbs
Florence Johnston
The Jeffersons

E
Hervé Villechaize
Tattoo
Fantasy Island

"Stifle yourself, Edith!" **6**

"Ze plane! Ze plane!" **9**

"Good night, John Boy" **10**

"Aaaaaay!!!" **8**

"How come we overcame and nobody told me?" **7**

J
Robin Williams
Mork
Mork & Mindy

H
Jimmie Walker
James "J.J." Evans Jr.
Good Times

F
Carroll O'Connor
Archie Bunker
All in the Family

G
Jack Lord
Det. Steve McGarrett
Hawaii Five-O

I
Redd Foxx
Fred G. Sanford
Sanford and Son

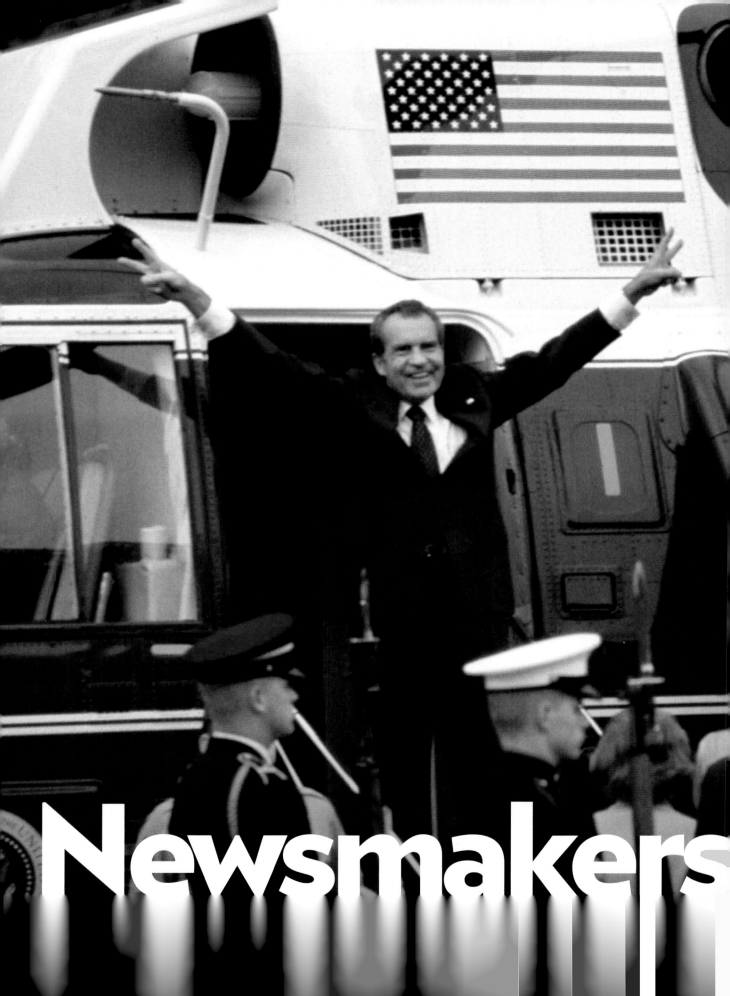

Newsmakers

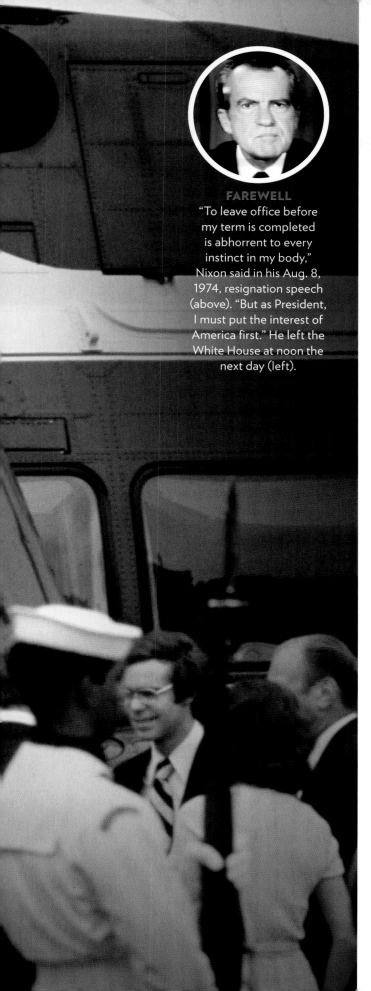

FAREWELL
"To leave office before my term is completed is abhorrent to every instinct in my body," Nixon said in his Aug. 8, 1974, resignation speech (above). "But as President, I must put the interest of America first." He left the White House at noon the next day (left).

Richard Nixon

YOU CANNOT MAKE THIS STUFF UP: IN JANUARY 1972, G. Gordon Liddy, the General Counsel for the Committee to Re-Elect the President, sat with John Mitchell, the Attorney General of the United States, and outlined an "intelligence" plan that called for electronic surveillance, abduction of radical leaders, muggings and the use of call girls to gather information from leading Democrats. Mitchell suggested that Liddy come up with something a little more "realistic."

The modified plan—not really *that* much smarter—involved, among other things, breaking into the offices of the Democratic National Committee at the Watergate complex in Washington, D.C. On June 17, security guard Frank Wills spotted a piece of tape holding a door latch open and summoned police. That tape—perhaps even more than those President Richard Nixon famously recorded in the Oval Office—led to the first resignation of a President in American history.

But only very slowly—and after forcing the nation to endure an agonizing two-year dance of political desperation. At first, the White House denied any connection to the break-in. "I can say categorically," Nixon told the nation, "that no one in the White House staff . . . was involved in this very bizarre incident." Then, gradually, revelations of money transfers and destroyed evidence began to unveil a cover-up equally shocking for its bold corruption and sheer tawdriness. Each day seemed to bring another startling headline, from the existence of a White House "Enemies List" to Nixon's firing of the Watergate special prosecutor, to the revelation that the President had secretly tape-recorded almost every conversation in the Oval Office—capturing for posterity what even a dismayed Republican senator called "deplorable, disgusting . . . and immoral performances." By Nov. 17, 1973, Richard Nixon felt forced to go on national television to declare, "I am not a crook."

Finally, with the walls closing in, Nixon admitted that he knew of White House involvement six days after the break-in and had tried to cover it up. Faced with the prospect of impeachment, which would inevitably have led to a Senate trial, he resigned on Aug. 9, 1974.

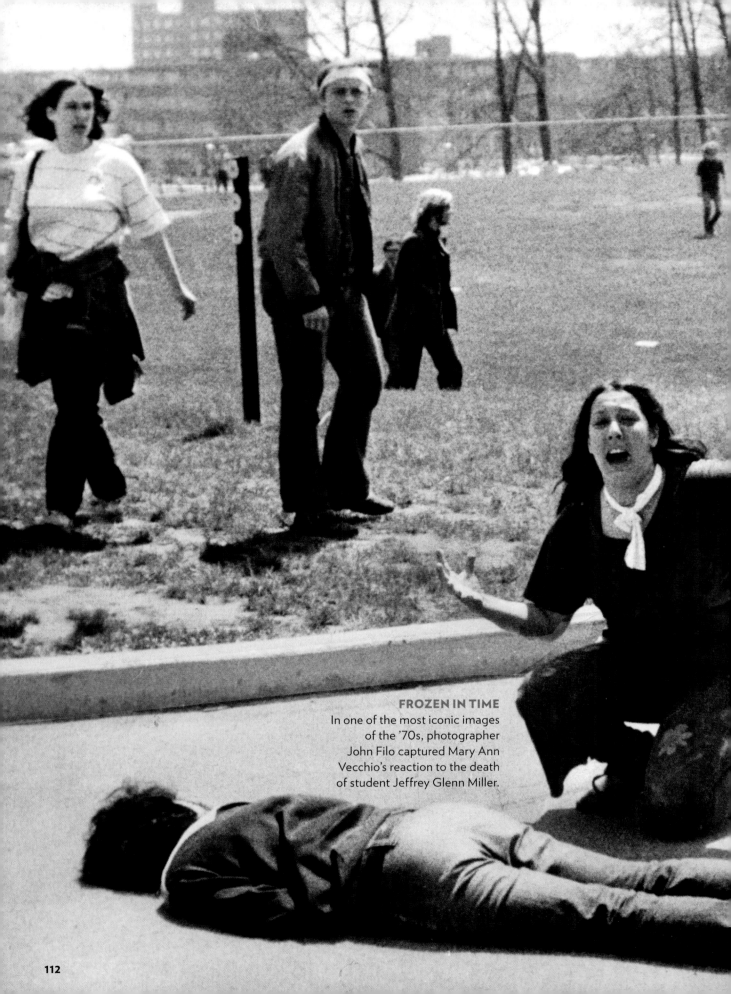

FROZEN IN TIME
In one of the most iconic images of the '70s, photographer John Filo captured Mary Ann Vecchio's reaction to the death of student Jeffrey Glenn Miller.

Kent State

"THEY ARE SHOOTING BLANKS—THEY ARE SHOOTING blanks," thought Kent State professor Charles Brill. "Then I heard a chipping sound and a ping, and I thought, 'My God, this is for real.'"

The firing ended in seconds, but 10 students were wounded—one would be paralyzed for life—and four lay dying. The tragedy at Ohio's Kent State University on May 4, 1970, stunned the nation: Americans, divided by the Vietnam War, were now killing one another at home.

Kent State was a lesson in how events spiral out of control and how not to respond to a crisis. When the trouble started, politics weren't involved: Beery students, on a muggy Friday night, blocked a busy street. A car tried to bull through, a mini-riot erupted, and police broke it up.

But the tension carried over, and the next day what was to have been a peaceful antiwar protest turned violent, with students setting fire to Kent State's ROTC building. The governor, calling the protesters "worse than Brownshirts and Communists," ordered in the National Guard—who, having just been on duty at a Teamster strike, arrived exhausted and carrying loaded M-1 rifles.

By Monday, uncertainty hung in the air. Perhaps 1,000 students gathered on the school commons, and a couple of thousand more, mostly curious, stood back and watched. Guardsmen with bullhorns ordered everyone to disperse; kids shouted "Pigs off campus." Guardsmen fired tear gas; students answered with rocks. One group of Guardsmen, when it ran out of teargas, began backing away nervously. Then, suddenly, they opened fire. William Schroeder, 19, Sandra Lee Scheuer, 20, Jeffrey Glenn Miller, 20, and Allison Krause, 19, were killed.

No one has ever been able to clearly determine why the Guard fired, or if there was an order from an officer. A civil suit brought against the Guardsmen, the university and the governor was settled out of court, with some of the wounded and parents of the victims receiving payments in the $15,000-$20,000 range. A presidential commission found the shootings "unnecessary, unwarranted and inexcusable." Looking back at the tragedy years later, the Guard's commander noted, "The first people called into an incident today would never have live ammunition."

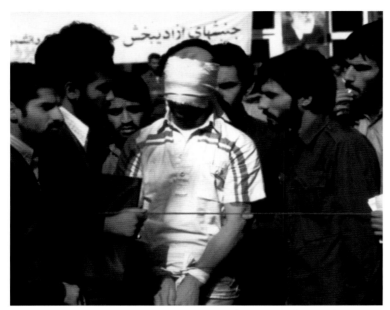

HELD FOR RANSOM In 1979, Iranian students paraded Barry Rosen, taken hostage at the U.S. Embassy, before cameras.

Iran Hostage Crisis

ON NEW YEAR'S EVE 1977, PRESIDENT JIMMY CARTER, IN Tehran, toasted Iran's leader, Reza Shah Pahlevi, as an "island of stability" in the Middle East. The Shah's own people were far less enthusiastic: Frustrated by unequal distribution of the country's oil wealth, terrified of his secret police and suspicious of growing Western influence, many wanted him out. When destabilizing riots erupted in 1979, the Shah fled to Egypt, and a Muslim fundamentalist cleric, Ayatollah Ruhollah Khomeini, swept into power.

The exiled Shah was suffering from cancer, and in October, Carter—not without qualms—allowed him into the U.S. for treatment. It was a fateful decision: On Nov. 4, Iranian students overran the U.S. Embassy in Tehran, took 66 Americans hostage and demanded that the Shah and his fortune be returned to Iran. Defying the most basic tenets of diplomacy, Khomeini condoned the mass kidnapping.

The stalemate went on for months. In April 1980, a top-secret rescue attempt brought tragedy and national embarrassment: Three malfunctioning helicopters forced the desert mission to be aborted, and eight American servicemen died when two aircraft collided during the evacuation. The Shah died in July, but the Americans were still not set free. "It's the worst feeling to think that nobody can do anything for your release," ex-hostage Marine Sgt. Rodney V. Sickmann said. Finally, after signing an agreement that called for America to lift sanctions and unfreeze $8 billion of the country's assets, Iran released its captives—444 days after their capture and only minutes after Jimmy Carter, who had lost the 1980 election to Ronald Reagan, left office.

The Fall of Saigon

AFTER 14 YEARS, AMERICA'S role in the Vietnam War came to a chaotic end on April 29, 1975, as the North Vietnamese prepared to enter Saigon and the last Americans and their allies desperately tried to evacuate. One of the most memorable photographs from that day shows a U.S. Huey helicopter on the roof of a Saigon building, the Pittman Apartments, as a man reaches to help people aboard. That man was Oren "O.B." Harnage, at the time a senior air operations officer with the CIA. In 1985, he told his story to PEOPLE.

It was a memorable day. Stopping at the U.S. Embassy, Harnage helped employees smash typewriters and radio transmitters with hammers before his evacuation run. At another location, a South Vietnamese soldier pulled the pin on a grenade and threatened to throw it if he wasn't allowed aboard; Harnage

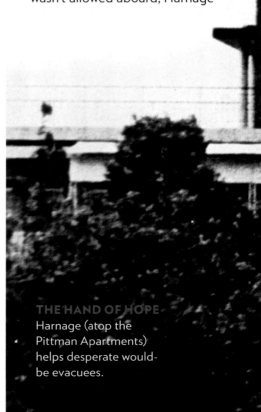

THE HAND OF HOPE Harnage (atop the Pittman Apartments) helps desperate would-be evacuees.

pointed a gun at him and warned that if he threw the grenade "he would never hear it go off" (the man put the pin back).

More than once, the pilot put the helicopter down atop the elevator shaft at the Pittman. "Those pilots were fantastic," Harnage said. "They flew those choppers until they had damn near dry tanks, never complaining. And they were all volunteers." A man tried to push his way aboard;

Harnage slugged him, knocking him down (on a later trip, the man, still bloody, asked politely if he could board; Harnage said yes). All day the helicopters made 30-mile, 15-minute runs to American-held Tan Son Nhut air base, where larger craft ferried evacuees offshore. On most trips, Harnage rode standing on the helicopter's skid to make more room.

For Harnage the war ended that night at 8:50 p.m. Landing

on rooftops in the dark was too dangerous even for the best pilots, and Harnage felt the evacuation had to come to an end. "We could have done this for days, and they'd still be coming up the ladder," he said. "Every time I left the Pittman, there were more people there than when I got there." The last light gone from the sky, Harnage himself boarded an evacuation helicopter and was flown to the USS *Denver*.

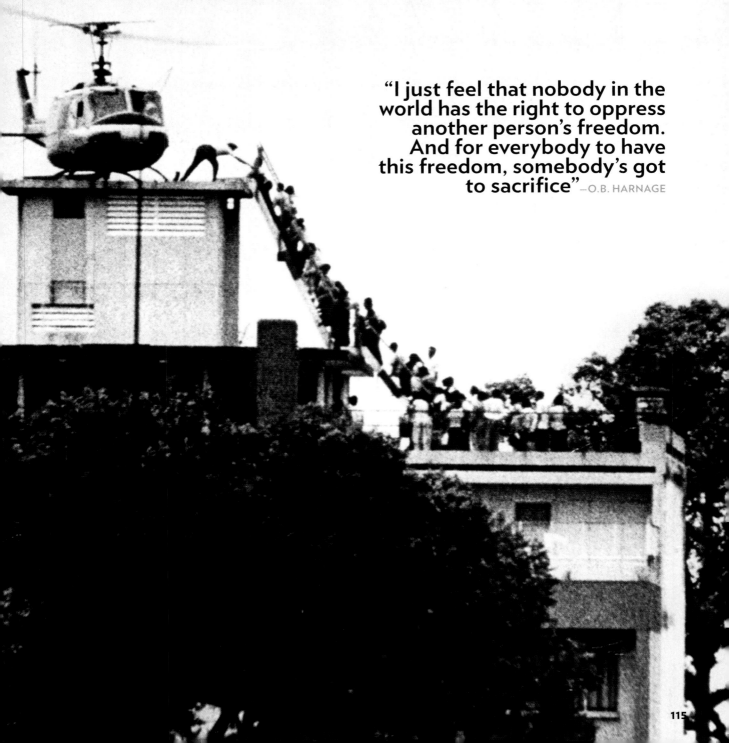

"I just feel that nobody in the world has the right to oppress another person's freedom. And for everybody to have this freedom, somebody's got to sacrifice" —O.B. HARNAGE

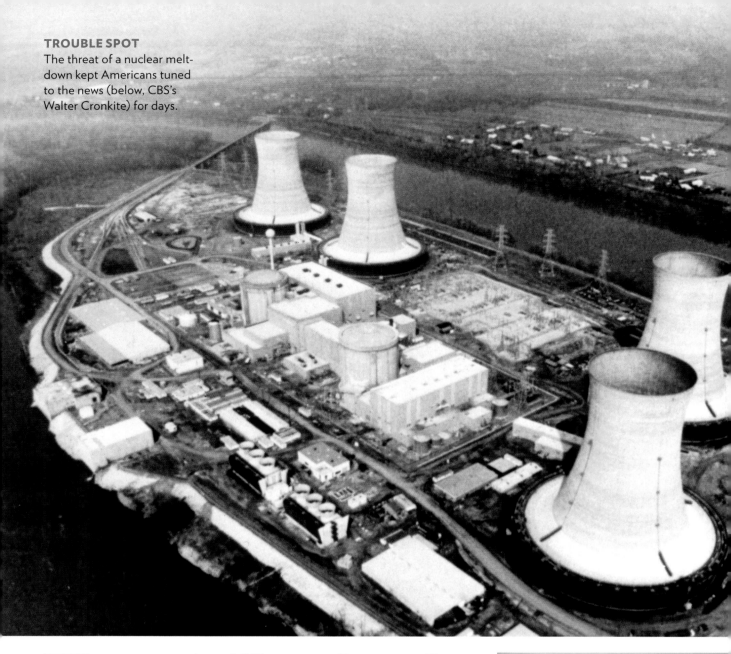

TROUBLE SPOT
The threat of a nuclear melt-down kept Americans tuned to the news (below, CBS's Walter Cronkite) for days.

Three Mile Island

AT 4 A.M. ON AN OTHERWISE tranquil night, alarm lights began blinking in the control room of Metropolitan Edison's Unit 2, a nuclear plant on **Three Mile Island,** near Harrisburg, Pa. Nobody at the plant panicked; this sort of "event"—the turbine, for some reason, had automatically shut down—had happened before, and technicians presumed that the cause would be easy to find and fix.

It wasn't—and in the days that followed the March 28, 1979, incident, ever more alarming reports

and a sense that the engineers were mystified fed fears of nuclear catastrophe. At first, MetEd said that a pump had failed but the problem wasn't serious. Then, they admitted, "a small amount" of radioactive water had leaked into the reactor building; quickly, the estimate of the leak jumped to 50,000 and then 250,000 gallons. MetEd's president admitted that, yes, some radioactive gases had leaked into the atmosphere; when asked how much, he replied, unreassuringly, "I'll be honest: I don't know." The

company initially estimated that less than 1 percent of the plant's nuclear fuel rods had been damaged; by week's end, the Nuclear Regulatory Commission increased that estimate

Jonestown Massacre

MORE THAN 900 MEMBERS OF his cult—men, women and children—followed the self-styled **Rev. Jim Jones** to Guyana, where his group, the Peoples Temple, were to build a spiritual community, Jonestown, in the jungle. Charismatic and delusional, Jones, 47, promised utopia but kept his followers in line with threats, electric shocks and exhausting labor.

After a series of alarming stories about Jones appeared in the media, California's Democratic Rep. Leo Ryan, 53, flew down to investigate. The visit alarmed Jones; when two families decided to return to the U.S. with Ryan, Jones feared their revelations would cause authorities to close him down.

As Ryan, the defectors and some journalists boarded small planes at a nearby airstrip, Jonestown loyalists appeared and opened fire. Ryan and four others were killed.

Certain now that he had sealed his own fate, Jones, who had previously forced his followers to rehearse for what he called "revolutionary suicide," gave the order to make it real: Surrounded by armed fanatics loyal to Jones—in case anyone had second thoughts—909 people met death. Some were injected with poison; most drank cyanide-laced grape Flavor-Aid. Many parents gave it to their children first before drinking it themselves.

The leader himself died by a single bullet, probably fired by an associate. The Reverend Jones's body was later identified by fingerprints police had on file—from a vice-squad arrest, five years earlier, in the men's room of an L.A. movie theater.

to 60 percent. Finally, after three days of assuring the public that the reactor core was cooling down, MetEd admitted that the core seemed to have stopped cooling, and they weren't sure why. Pressed for more answers, a company exec said, "I don't know why we need to tell you each and every thing we do."

In the end, the core temperature was brought down to a safe level, but nuclear energy itself suffered a fatal blow: Since the accident— eventually blamed on a mundane but nonetheless potentially catastrophic chain of human error and technological failure—no new nuclear plant construction permits have been issued in the U.S.

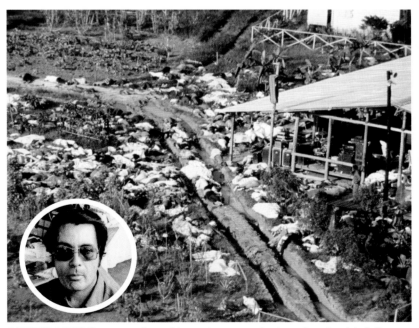

AFTERMATH On a tape found later, Jones can be heard urging his followers to drink the cyanide-laced Flavor-Aid: "Look children, it's just something to put you to rest. . . . Stop this hysterics! . . . I don't care how many screams you hear. . . . Hurry, hurry my children, hurry!"

Patty Hearst

AFTER THE REVOLUTION Hearst following her arrest (below); and in '04 with Lydia (left) and Gillian.

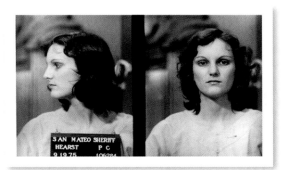

THIRTY-FIVE YEARS LATER, THE STORY SEEMS even more jaw-droppingly unbelievable: a 19-year-old heiress kidnapped from her Berkeley apartment on Feb. 4, 1974, by a ragtag gang of self-styled revolutionaries; her voice heard on audiotapes for weeks as she's forced to read the group's political agenda; hopes for her return surging after her parents donate millions to a food program for the poor; those hopes dashed soon after, when the young woman, astoundingly, announces that she has repudiated her past and joined her captors. Two weeks later Patty Hearst was

photographed, rifle in hand, helping the Symbionese Liberation Army rob a bank in San Francisco. "We're from the SLA!" one of the gang shouted, then added Patty's new nom de guerre: "This is Tania Hearst!" As they made their escape, their leader shot and wounded, at random, two passersby.

And when it seemed the drama couldn't build anymore, it did: Any doubt that Hearst was an unwilling participant in the bank robbery evaporated on May 16, 1974, when she opened fire on a suburban L.A. sporting goods store to provide cover for two SLA members who had been caught shoplifting. Clues from their getaway led cops to the rest of the gang, holed up in a South Central L.A. home. The resulting shoot-out, broadcast live, mesmerized the nation. By the time it was over, an estimated 9,000 shots had been fired, the house was incinerated, and six SLA members were dead.

It wasn't until the next day that the coroner was able to determine that Hearst was not among the victims. She had been elsewhere, and continued to live on the run—to the FBI's acute embarrassment—for another 16 months. In April 1975, the last SLA survivors, along with a handful of new recruits, robbed another bank, this time shotgunning to death a 42-year-old mother of four, Myrna Lee Opsahl, who was depositing her church's weekly donations. Hearst was not at the bank but was involved in the gang's escape.

When Hearst was finally captured that September, she gave a clenched-fist salute and listed her occupation as "urban guerrilla." Over time, however, she began to repudiate her acts and claimed that months of psychic, physical and sexual abuse had left her terrified and irrational. In 1976, she was sentenced to seven years for bank robbery; President Jimmy Carter commuted her sentence after 21 months, and President Bill Clinton pardoned her in 2001.

In 1979, Hearst, who recounted her ordeal in a bestseller, *Every Secret Thing*, married Bernard Shaw, who had been one of her bodyguards while she was out on bail facing trial. They live in Connecticut and have two daughters, Gillian and Lydia. In 2008, Patty Hearst's bulldog Diva was chosen as best female of her breed at the prestigious Westminster Dog Show.

Mark Spitz

BEFORE ANYONE HAD EVER heard of Michael Phelps—before Phelps was even *born*—there was Mark Spitz, a rangy, cocky swimming phenom from California. At the 1968 Olympic Games, age 18, he rashly predicted he would win six gold medals—and took home only two, in relay events. Somewhat wiser, Spitz returned for the 1972 Games in Munich and let his swimming do the talking, loudly: In a feat unprecedented in Olympic history, he won seven gold medals and, for good measure, broke seven world records along the way.

After the games, Spitz cashed in through product endorsements and personal appearances, and later sold real estate. When Phelps topped his 36-year-old record in Beijing, Spitz congratulated him on air: "They say you judge a person's character by the company you keep," he said, "and I'm glad I'm keeping company with Michael Phelps."

AND NOW
Spitz, 59, shaved his iconic mustache when it "started to turn gray."

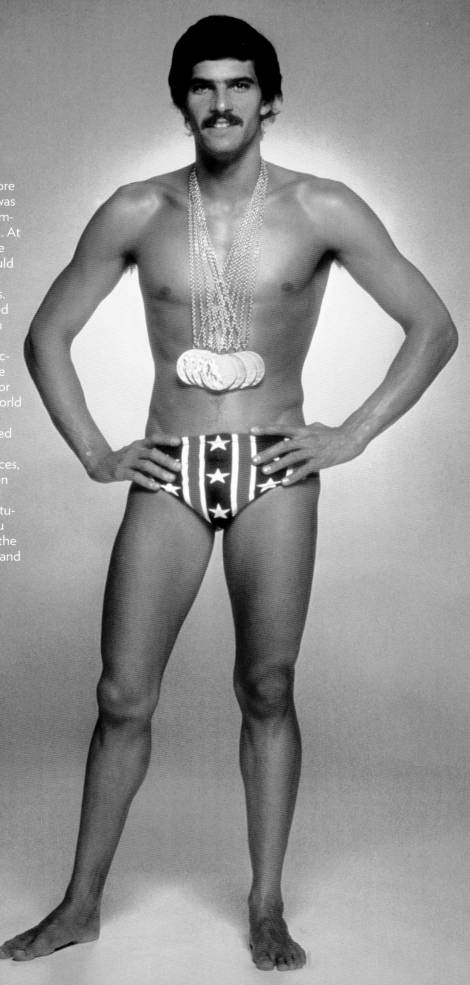

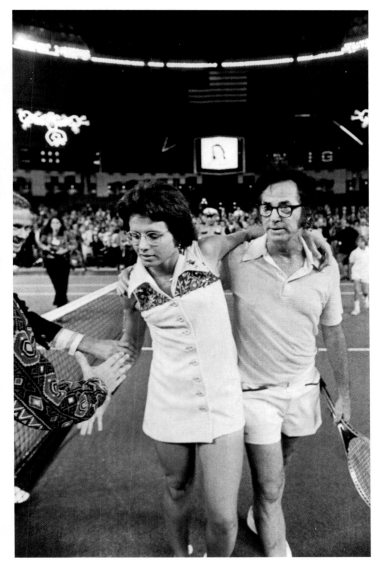

AFTER THE SHOW Riggs entered the Astrodome on a litter carried by busty women but left, defeated but richer, at King's side.

Billie Jean King

BOBBY RIGGS HAD BEEN A WIMBLEDON AND U.S. TENNIS champ, but those accomplishments paled beside his true calling: the art of the hustle. At a time when Women's Lib was a controversial cause and tennis hero Billie Jean King one of its leading lights, Riggs shrewdly began to quotably mock the movement ("A woman's place is in the bedroom and the kitchen, in that order") and announced that he, at 55, could beat any woman on the planet. The press ate the hype, King felt obliged to step up, and NBC paid $750,000 for TV rights to the 1973 "Battle of the Sexes." King crushed him 6-4, 6-3, 6-3, but Riggs, the happy hustler, reportedly walked away with over $100,000.

Nadia Comaneci

THE ROMANIAN PIXIE WAS only 14 when she scored the first-ever perfect 10 in Olympic gymnastics, at the Montreal Games in 1976. Then, having been certified "perfect," she did it *six more times* during the competition. The world applauded—and fell in love.

AND NOW

In a surprising encore, Comaneci—who eventually won nine medals in two Olympics—moved to the U.S. and, in 1996, married U.S. Olympic gymnast Bart Connor, himself a gold-medal winner. Together they run the Bart Connor Gymnastics Academy in Norman, Okla.; their son Dylan could be a top college prospect in 2024.

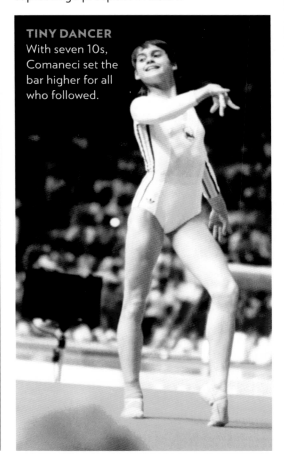

TINY DANCER With seven 10s, Comaneci set the bar higher for all who followed.

Bruce Jenner

HE FAMOUSLY WON THE DE-cathlon at the 1976 Montreal Olympics, but only lately has reality hit. More precisely, reality TV: After appearing in *I'm a Celebrity—Get Me Out of Here!* (2003) and *Skating with Celebrities* (2006), Jenner, 59, can now be seen alongside stepchildren Kim, Kourtney, Khloe and Rob Kardashian on E!'s rich-kids-and-their-problems serial *Keeping Up with the Kardashians*. Meanwhile, Brody Jenner, Bruce's son with ex-wife Linda Thompson (who was Elvis's former girlfriend), starred in two series, *Bromance* and *Princes of Malibu,* and has appeared on *The Hills.*

BRUCE ALMIGHTY Jenner's record effort brought a gold medal and Wheaties immortality.

AND NOW

'70s: **WHAT WE READ**

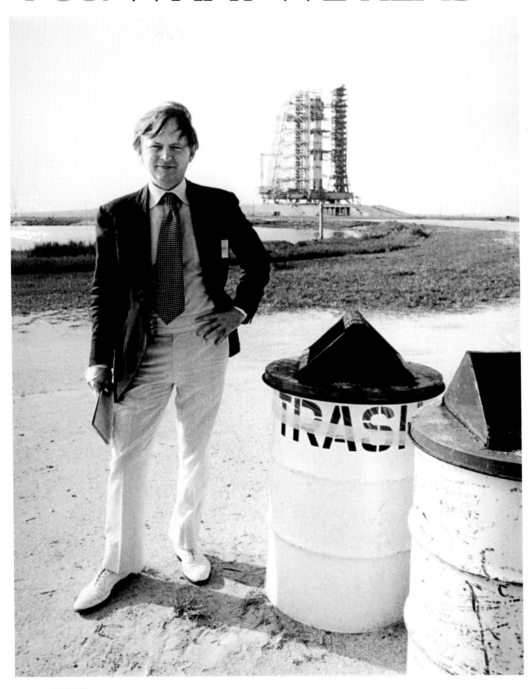

SHARP OF DRESS AND GIMLET OF EYE, WOLFE, WHO CO-
invented New Journalism in the '60s, book-ended the '70s
with tomes that told us who we were: *Radical Chic & Mau-
Mauing the Flak Catchers* (whose most famous essay lam-
pooned Leonard Bernstein for throwing a fund-raising party
for the Black Panthers) and *The Right Stuff*, about astronauts'
macho culture. But it was Wolfe's 1976 *New York* magazine
essay about Americans' growing obsession with "remaking,
remodeling . . . and polishing one's very self" that gave the
'70s a title that stuck: "The Me Decade."

GUIDE BOOKS
'70s bestsellers, both
novels and nonfiction,
often dealt with
personal growth—
spiritual, psychological
or sexual.

Mick Jagger & Bianca Perez Morena de Macias

RINGO AND PAUL WERE THERE. SO WERE HIPPIES, jet-setters and 100 photographers. And after their nuptials, on May 12, 1971, at the town hall in Saint-Tropez, Rolling Stone Mick Jagger, 27, and his Nicaraguan-born inamorata, Bianca Perez Morena de Macias, 26, were the very model of rock and roll newlyweds, '70s style (that's him with the joint, champagne and wide, peaked lapels; her with the veil, beguiling smile and exposed breast). After partying until dawn, the lovers departed by yacht on their honeymoon (and divorced eight years later).

Romance

Great celebrity love stories from long ago: Some called it magical, and some called it quits

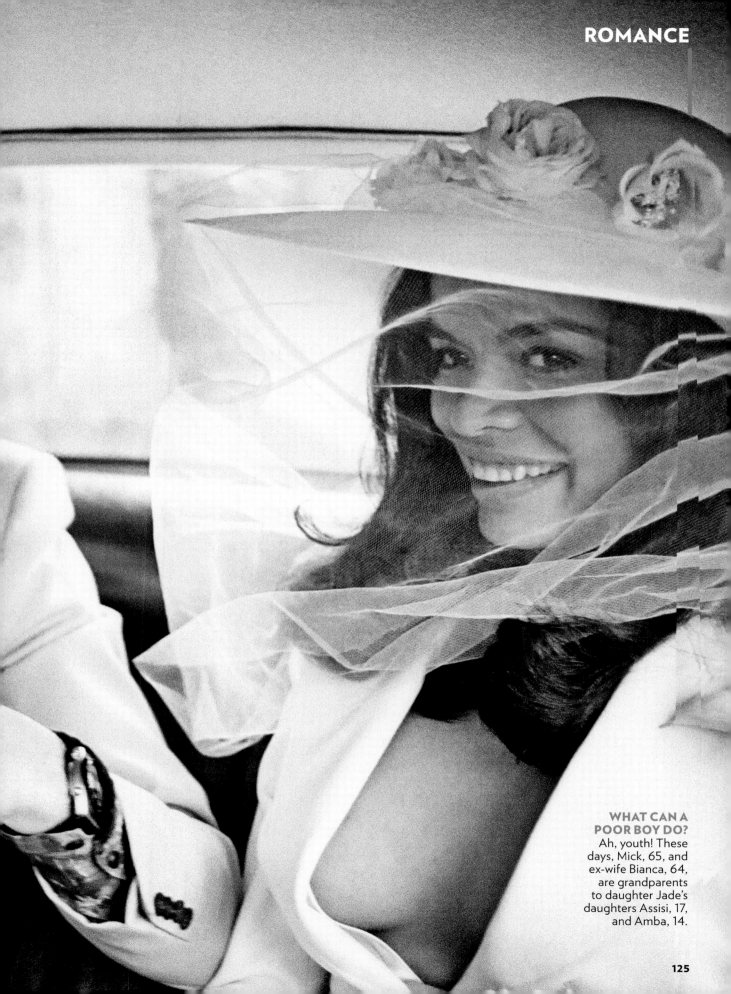

WHAT CAN A POOR BOY DO? Ah, youth! These days, Mick, 65, and ex-wife Bianca, 64, are grandparents to daughter Jade's daughters Assisi, 17, and Amba, 14.

Lee Majors & Farrah Fawcett

HE STARRED AS ABC'S *THE SIX MILLION Dollar Man*, and she was the radiant woman on his arm. Then, overnight, *Charlie's Angels* turned Farrah Fawcett into a superstar, and their marriage began to crumble, slowly, painfully and in public. Then came *another* surprise.

Lee and Farrah separated in 1979 as Farrah sought more independence. "I feel so bad for Lee," she said of their struggles to find a new balance. "Our relationship has got to be different because I am different. But it's so hard for him to understand."

Then, fatefully, while Lee was filming in Toronto, he asked his ol' buddy Ryan O'Neal to check in on his wife and make sure she wasn't moping. Instead, said Lee, "Ryan really made a play for her." O'Neal and Fawcett fell in love, and Lee, brokenhearted, was headed for divorce. "She's one of a kind, and I love her," he said. "It's that simple."

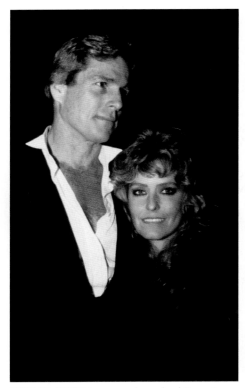

THE PLAYER Lee says he asked Ryan to back off a bit, but O'Neal replied, "I can't. I really love her." At that point, Ryan and Lee stopped speaking.

> "If you have ever loved something, you know that sometimes you just have to set it free—no matter how much it hurts"
> —LEE MAJORS

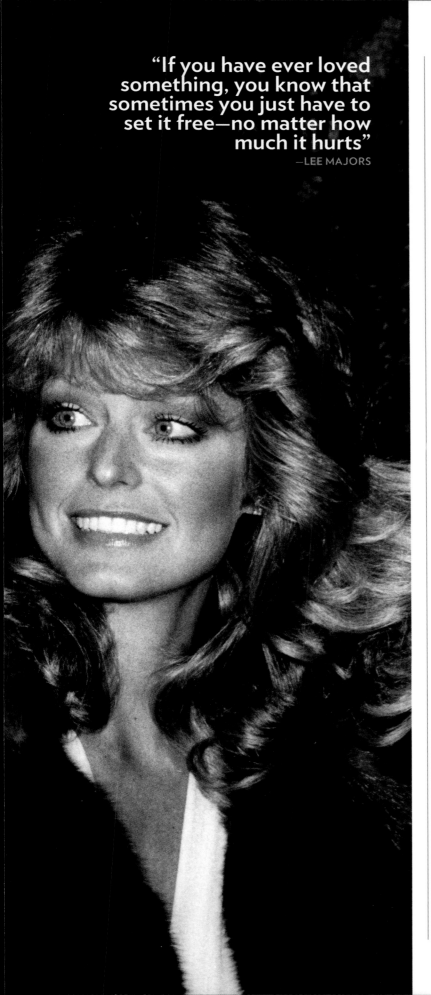

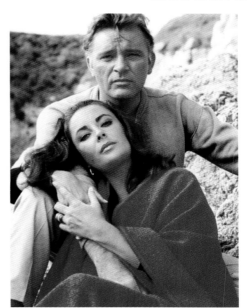

Elizabeth Taylor
& Richard Burton

EARLY ON, HE HAD FAMOUSLY DISmissed her as a "fat little tart." She swore she would be "the leading lady that Richard Burton would never get."

So much for vows. After their affair on the *Cleopatra* set made headlines around the world, Elizabeth Taylor and Richard Burton entered the '70s a married, if epically tempestuous, couple. They divorced in 1974, remarried in 1975 and divorced again in 1976. Taylor quickly wed would-be Republican senator John Warner and went on the rubber-chicken circuit to raise votes. He won, she gained about 40 lbs.—a magazine cruelly dubbed her "National Velveeta"—and they divorced in 1982.

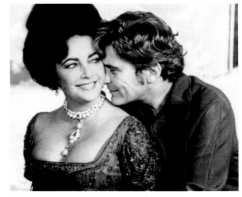

THE HELPMEET Taylor (with Burton, top, and Warner) began the decade a jet-set vixen and exited a senator's wife.

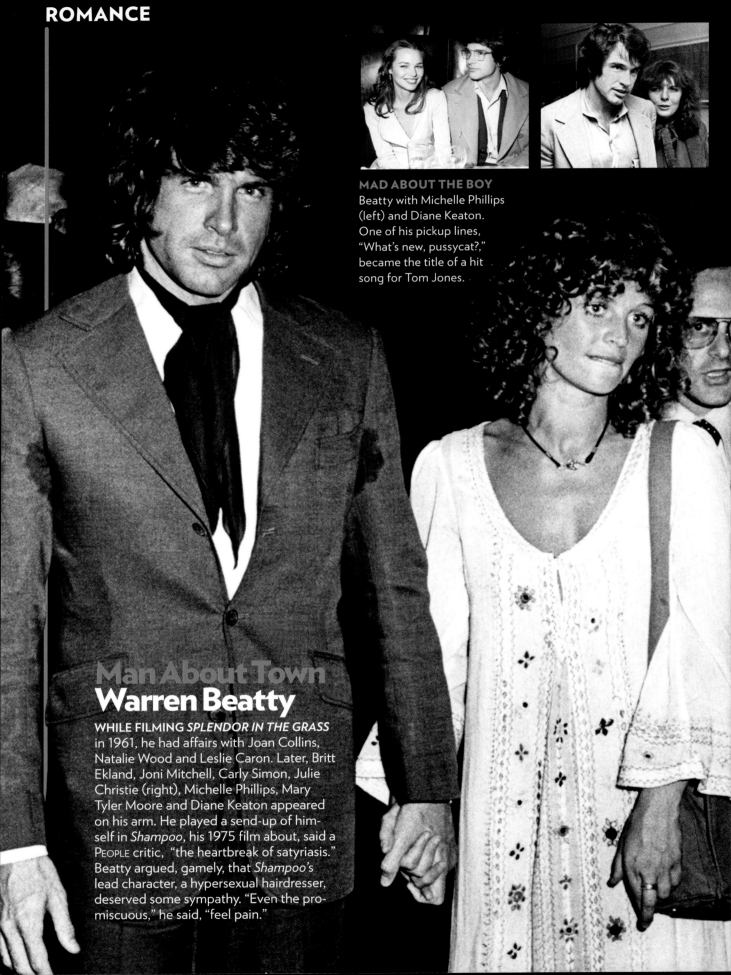

MAD ABOUT THE BOY
Beatty with Michelle Phillips (left) and Diane Keaton. One of his pickup lines, "What's new, pussycat?," became the title of a hit song for Tom Jones.

Man About Town
Warren Beatty

WHILE FILMING *SPLENDOR IN THE GRASS* in 1961, he had affairs with Joan Collins, Natalie Wood and Leslie Caron. Later, Britt Ekland, Joni Mitchell, Carly Simon, Julie Christie (right), Michelle Phillips, Mary Tyler Moore and Diane Keaton appeared on his arm. He played a send-up of himself in *Shampoo*, his 1975 film about, said a PEOPLE critic, "the heartbreak of satyriasis." Beatty argued, gamely, that *Shampoo's* lead character, a hypersexual hairdresser, deserved some sympathy. "Even the promiscuous," he said, "feel pain."

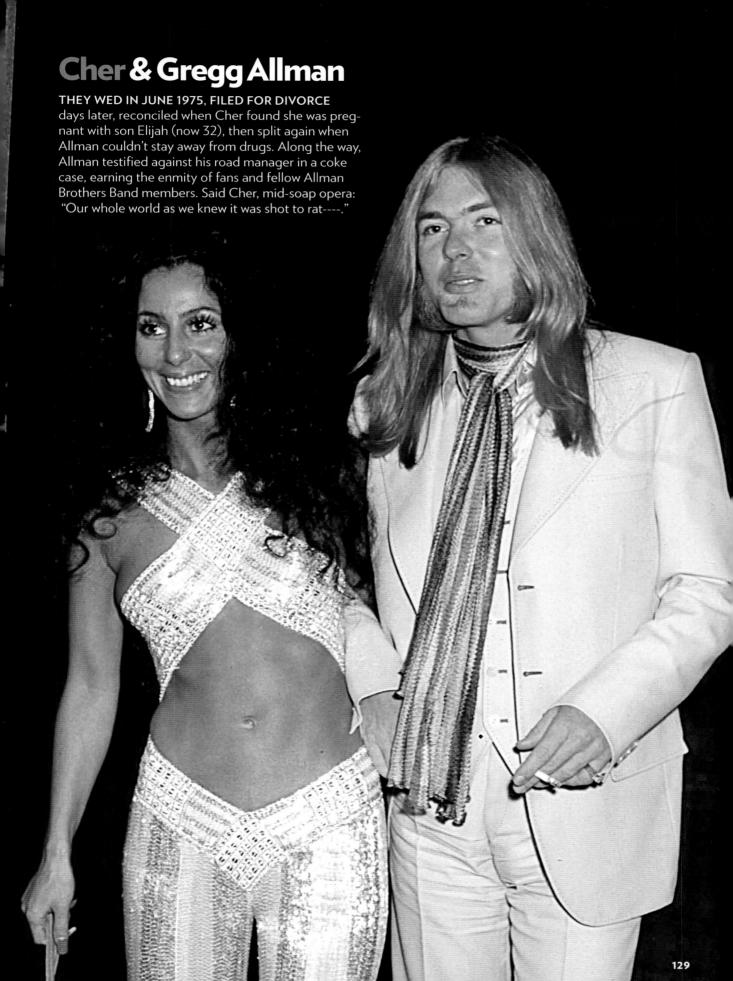

Cher & Gregg Allman

THEY WED IN JUNE 1975, FILED FOR DIVORCE
days later, reconciled when Cher found she was pregnant with son Elijah (now 32), then split again when Allman couldn't stay away from drugs. Along the way, Allman testified against his road manager in a coke case, earning the enmity of fans and fellow Allman Brothers Band members. Said Cher, mid-soap opera: "Our whole world as we knew it was shot to rat----."

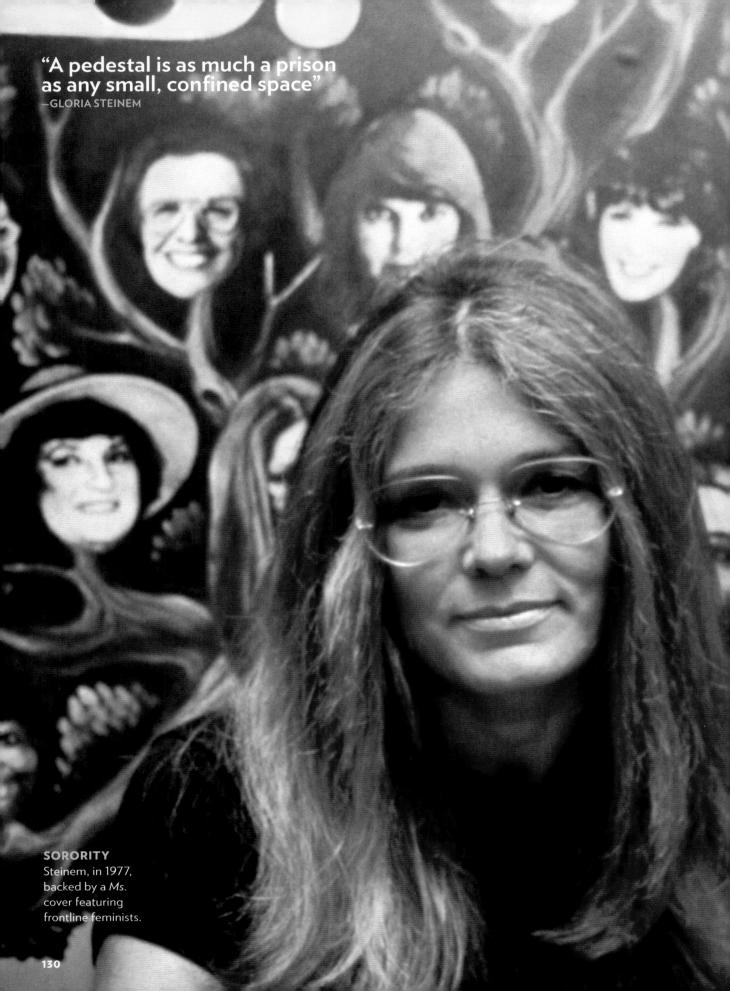

"A pedestal is as much a prison as any small, confined space"
—GLORIA STEINEM

SORORITY
Steinem, in 1977, backed by a *Ms.* cover featuring frontline feminists.

The Pop Culture Chorus

From Gloria Steinem to Evel Knievel and est's
Werner Erhard: heroes, mavericks and hucksters
who captured the national spotlight

Gloria Steinem

IN A TUMULTUOUS DECADE,
Steinem, who founded *Ms.* magazine
and helped lead the charge for the Equal
Rights Amendment, was feminism's most
famous face. In March 2009, on her
75th birthday, she noted that there is still
much to do, but also celebrated progress.
"Knowing that the system is crazy, not
you," she said of changes in her lifetime,
"is a huge leap forward."

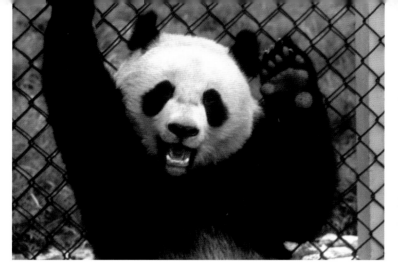

Ling **Ling**

A GOODWILL GIFT FROM CHINA TO HONOR President Richard Nixon's landmark 1972 visit, Ling-Ling and Hsing-Hsing—at the time the only giant pandas in the U.S.—ignited, as every headline writer in the United States was delighted to point out, panda-monium.

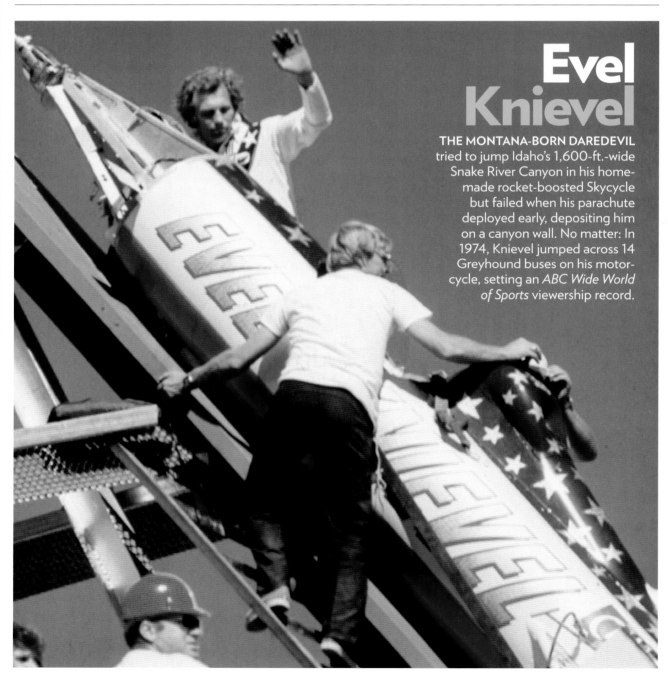

Evel
Knievel

THE MONTANA-BORN DAREDEVIL tried to jump Idaho's 1,600-ft.-wide Snake River Canyon in his home-made rocket-boosted Skycycle but failed when his parachute deployed early, depositing him on a canyon wall. No matter: In 1974, Knievel jumped across 14 Greyhound buses on his motor-cycle, setting an *ABC Wide World of Sports* viewership record.

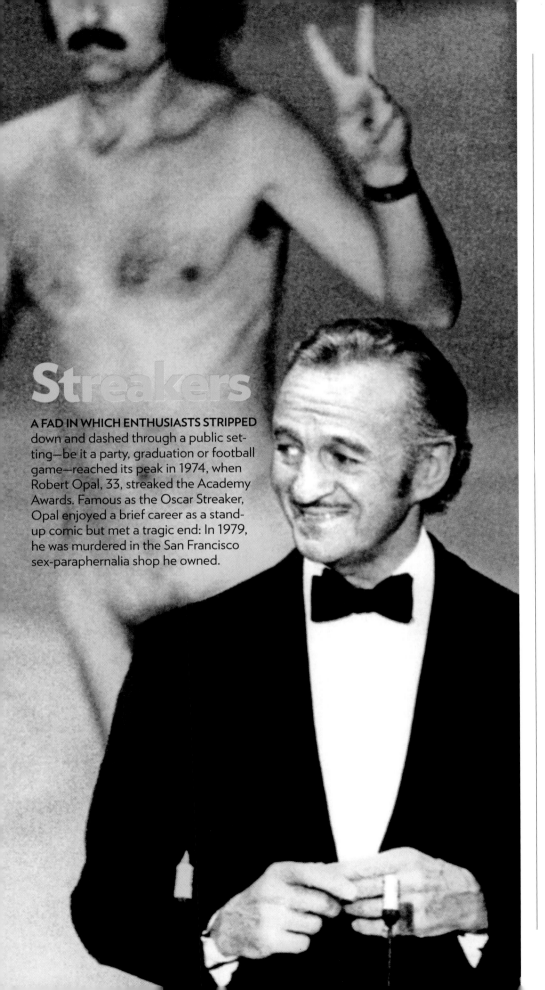

Streakers

A FAD IN WHICH ENTHUSIASTS STRIPPED down and dashed through a public setting—be it a party, graduation or football game—reached its peak in 1974, when Robert Opal, 33, streaked the Academy Awards. Famous as the Oscar Streaker, Opal enjoyed a brief career as a stand-up comic but met a tragic end: In 1979, he was murdered in the San Francisco sex-paraphernalia shop he owned.

Billy Beer

PRESIDENT JIMMY Carter's peanut-farmer brother cashed in while the getting was good, earning $500,000 in 1977—more than double the President's salary—by lending his name and image to Billy Beer and other products.

Stewart Brand

BEFORE THE INTERNET, BEFORE Google, if you wanted to find something, you looked in a catalog. And the coolest one around was Brand's *Whole Earth Catalog,* a guide to how to find all the stuff—from tents and tools to geodesic domes and buckskin vests— that the counterculture craved. A simple idea that met a huge need, the *Catalog* won a National Book Award and sold more than 2.5 million copies.

MARCH
Whole Earth Catalog $1

THE WORLD GAME

TOP OF THE WORLD
Nowadays, Brand (frolicking in 1973), 70, ponders, writes and consults about the future.

Werner Erhard

A FORMER ENCYCLOPEDIA SALES-man, Erhard, born Jack Rosenberg, developed a spiritual growth program called Erhard Seminars Training, or est, and marketed it brilliantly. Half a million Americans had paid up to $250 to hear the Gospel According to Werner, but skepticism and an IRS dispute dogged Erhard and in 1984, est was laid to rest. Nowadays, Erhard, 73, keeps a very low profile.

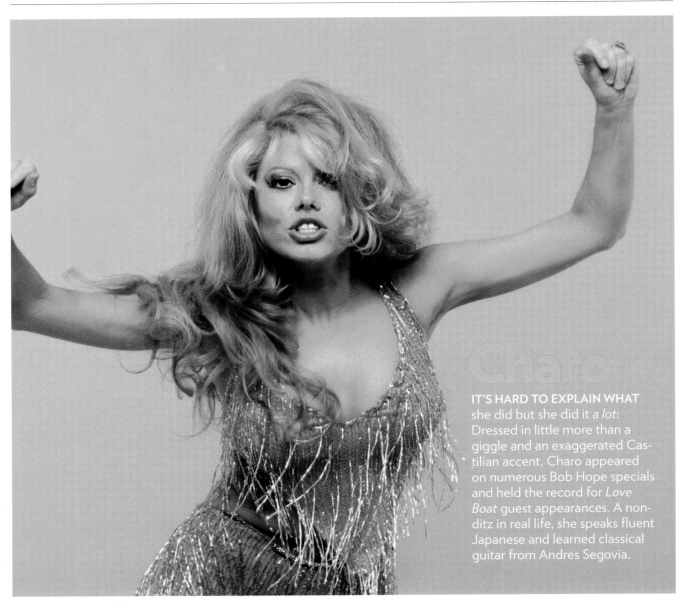

IT'S HARD TO EXPLAIN WHAT she did but she did it *a lot*: Dressed in little more than a giggle and an exaggerated Castilian accent, Charo appeared on numerous Bob Hope specials and held the record for *Love Boat* guest appearances. A non-ditz in real life, she speaks fluent Japanese and learned classical guitar from Andres Segovia.

HELLO...

Trends, fads and goofy fashions that will forever be associated with the '70s

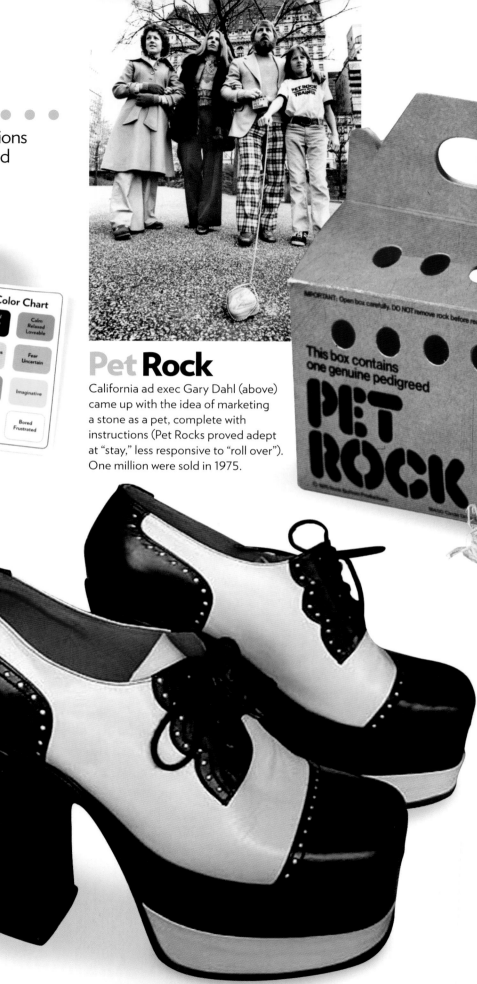

Mood Ring

If you were feeling blue—or lavender—even a stranger could tell (theoretically). A liquid crystal changed color according to body temperature, making (the creator claimed) emotion visible.

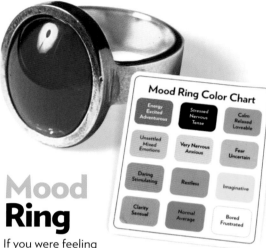

Mood Ring Color Chart

Energy Excited Adventurous	Stressed Nervous Tense	Calm Relaxed Loveable
Unsettled Mixed Emotions	Very Nervous Anxious	Fear Uncertain
Daring Stimulating	Restless	Imaginative
Clarity Sensual	Normal Average	Bored Frustrated

Pet Rock

California ad exec Gary Dahl (above) came up with the idea of marketing a stone as a pet, complete with instructions (Pet Rocks proved adept at "stay," less responsive to "roll over"). One million were sold in 1975.

IMPORTANT: Open box carefully. DO NOT remove rock before readin

This box contains one genuine pedigreed

PET ROCK

Men's Platform Shoes

The thing to wear with your hip-hugging, rust-colored disco bell-bottom. When the decade ended, the world seemed shorter.

Smiley Face **Button**

An estimated 50 million were sold in the early '70s; Harvey Ball, who created the design, was paid $45 for his work in 1964.

...GOODBYE!

Once ubiquitous, now extinct: Everyday items that, like Elvis, have left the building

ROTARY TELEPHONE
Kids: In the '70s "phone" meant large, rotary and tethered to the wall. And no text messaging. OMG!

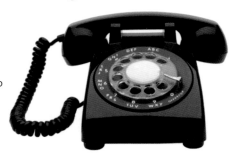

SUPER 8 CAMERA
Video killed not only (as the song goes) the radio star but also home movies, screens and projectors.

SLIDE RULE
The basic math tool vanished overnight when handheld calculators appeared in the early '70s.

BETAMAX RECORDER
Sony's video system lost out to VHS— but not before millions bought it.

ROLLER SKATES
The skate rolled on until we lined up for the in-line variety.

Earth **Shoes**

If Granola had feet, this is what it would wear: Invented in (where else?) Scandinavia, Earth Shoes had a heel lower than the toe—mimicking, it was claimed, a human footprint in sand and leading to better, more natural posture.

8-TRACKS AND RECORDS
Slamming a heavy-metal 8-track cassette into your dash was so much more satisfying than a wimpy CD; the end of albums meant the end of an art form: LP cover design.

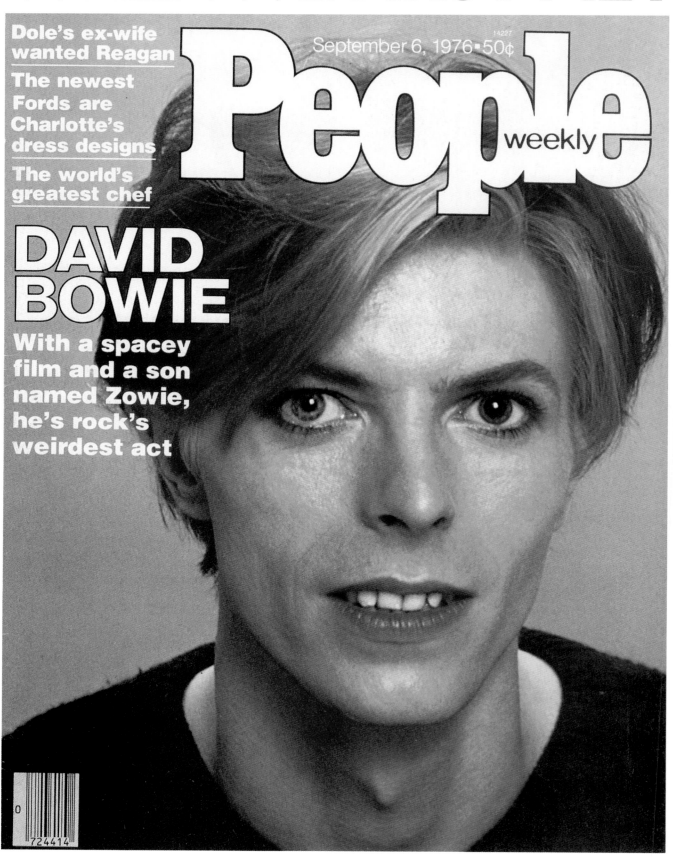

Dole's ex-wife
wanted Reagan

The newest
Fords are
Charlotte's
dress designs

The world's
greatest chef

September 6, 1976•50¢

14297

People weekly

DAVID BOWIE

With a spacey
film and a son
named Zowie,
he's rock's
weirdest act

724414

PEOPLE covers: No matter how famous you are—or become—the first time is always special

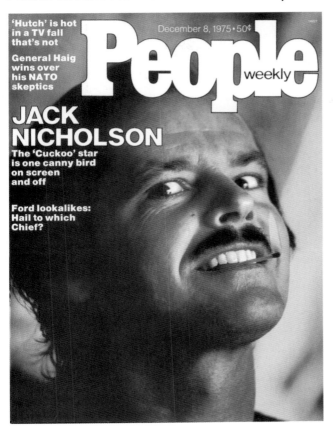

'Hutch' is hot in a TV fall that's not

General Haig wins over his NATO skeptics

December 8, 1975 • 50¢

JACK NICHOLSON

The 'Cuckoo' star is one canny bird on screen and off

Ford lookalikes: Hail to which Chief?

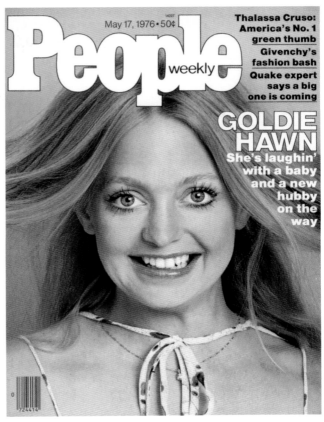

May 17, 1976 • 50¢

Thalassa Cruso: America's No. 1 green thumb

Givenchy's fashion bash

Quake expert says a big one is coming

GOLDIE HAWN

She's laughin' with a baby and a new hubby on the way

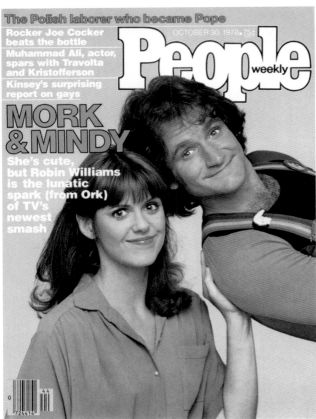

The Polish laborer who became Pope

Rocker Joe Cocker beats the bottle

Muhammad Ali, actor, spars with Travolta and Kristofferson

Kinsey's surprising report on gays

OCTOBER 30, 1978 • 75¢

MORK & MINDY

She's cute, but Robin Williams is the lunatic spark (from Ork) of TV's newest smash

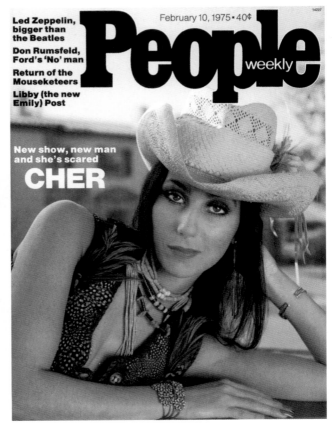

Led Zeppelin, bigger than the Beatles

Don Rumsfeld, Ford's 'No' man

Return of the Mouseketeers

Libby (the new Emily) Post

February 10, 1975 • 40¢

New show, new man and she's scared

CHER

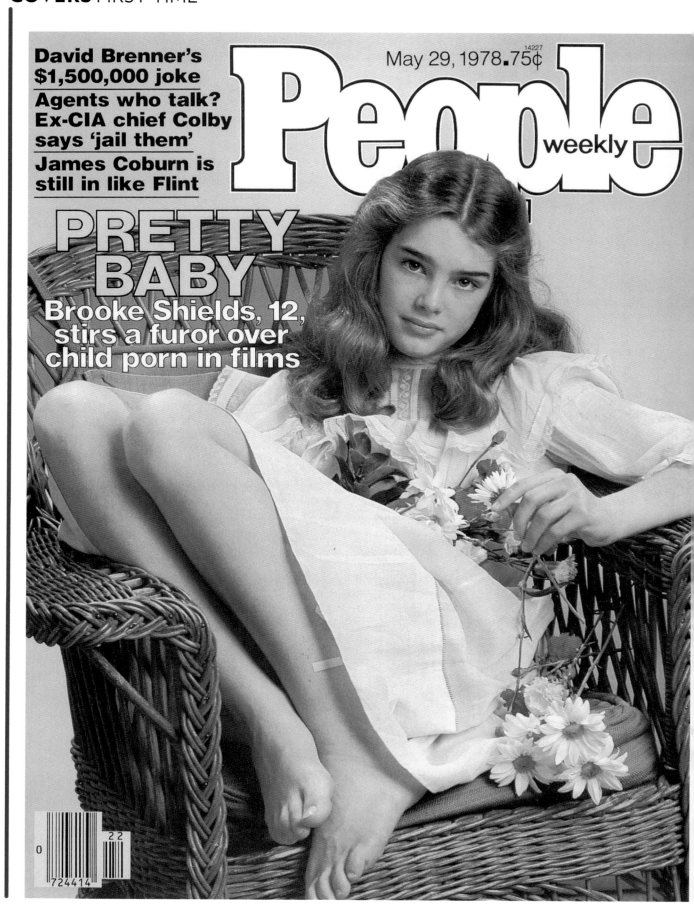

David Brenner's
$1,500,000 joke
Agents who talk?
Ex-CIA chief Colby
says 'jail them'
James Coburn is
still in like Flint

May 29, 1978.75¢

14227

People weekly

PRETTY
BABY
Brooke Shields, 12,
stirs a furor over
child porn in films

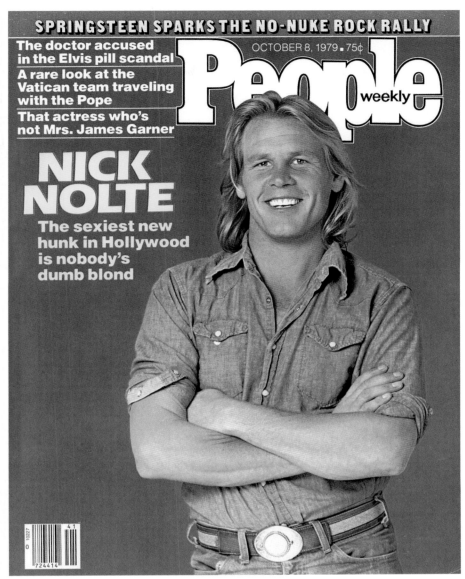

It seemed like a good idea at the time

(but it's unlikely we'll do it again soon . . .)

Any celebrity in a fez . . .

. . . Henry Winkler in drag . . .

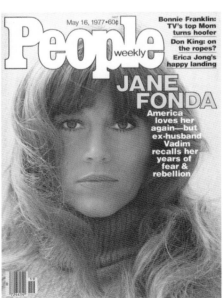

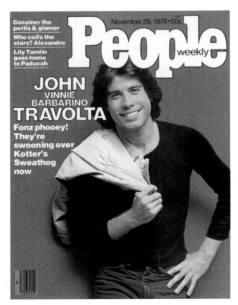

. . . forehead tic-tac-toe.

ON THE COVER

Telly Savalas
He made 'Kojak'
the No. 1 show

Bridget & Bernie
Now married for real

Cesar Chavez
A nonviolent man in
the fight of his life

The Minibikini
Less is more

Margaret Trudeau
A nursing mother on
the campaign trail

Charlie Quarry
The blonde in her
husband's corner

People weekly

35¢

July 1, 1974

The gentle side of a rugged sex symbol **JOE NAMATH**

People weekly

35¢

Also in this issue September 16, 1974

**The Ronald Reagans:
nobody's lame ducks**

**The shopkeeper who
dresses Betty Ford**

**Lindbergh's friend
who tends his grave**

**For Angela Lansbury,
'Gypsy' is all roses**

People weekly

June 27, 1977 • 60¢

**Aawwk! Horshack in
Shakespeare?**

**A cancer
victim fights
for Laetrile**

**J. L. Seagull's
Bach again**

**Peter
Frampton**

He's more alive than
ever — a new tour
and LP, the
Sgt. Pepper film
& feeling 'single'

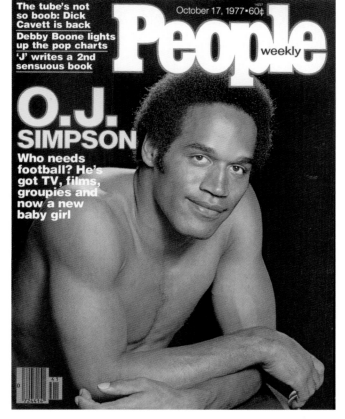

**The tube's not
so boob:** Dick
Cavett is back

**Debby Boone lights
up the pop charts**

**'J' writes a 2nd
sensuous book**

People weekly

October 17, 1977 • 60¢

**O.J.
SIMPSON**

Who needs
football? He's
got TV, films,
groupies and
now a new
baby girl

WORE CLOTHES
And we have the covers to prove it!

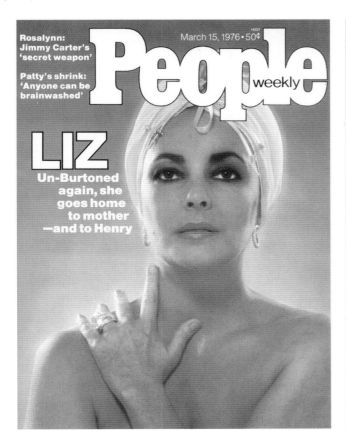

Rosalynn: Jimmy Carter's 'secret weapon'

Patty's shrink: 'Anyone can be brainwashed'

March 15, 1976 • 50¢

People weekly

LIZ
Un-Burtoned again, she goes home to mother —and to Henry

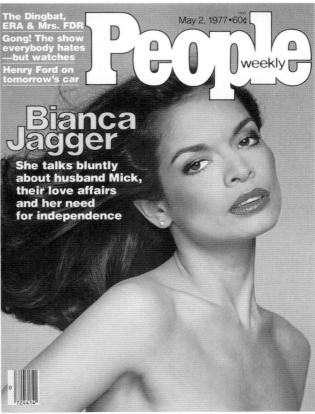

The Dingbat, ERA & Mrs. FDR

Gong! The show everybody hates —but watches

Henry Ford on tomorrow's car

May 2, 1977 • 60¢

People weekly

Bianca Jagger
She talks bluntly about husband Mick, their love affairs and her need for independence

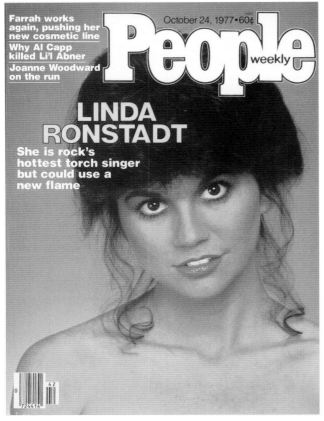

Farrah works again, pushing her new cosmetic line

Why Al Capp killed Li'l Abner

Joanne Woodward on the run

October 24, 1977 • 60¢

People weekly

LINDA RONSTADT
She is rock's hottest torch singer but could use a new flame

Lucy's lover-boy son Desi reforms

The 'rich S.O.B.' who is Carter's inflation fighter

Helping children cope with divorce

June 19, 1978 • 75¢

People weekly

CHERYL TIEGS
Who says there's no good news? The $2,000-a-day woman has a millionaire husband 'I never get tired of looking at'

CELEBRATE THE '70s

Masthead

EDITOR Cutler Durkee **DESIGN DIRECTOR** Sara Williams **DIRECTOR OF PHOTOGRAPHY** Chris Dougherty **ART DIRECTOR** Scott A. Davis **EDITORIAL MANAGER** Andrew Abrahams **PHOTOGRAPHY EDITOR** C. Tiffany Lee-Ramos **WRITER/REPORTER** Kara Warner **REPORTERS** Sabrina Ford, Summar Ghias, Mary Hart, Daniel Levy, Hugh McCarten, Gail Nussbaum, Christina Tapper **COPY EDITOR** Ben Harte **SCANNERS** Brien Foy, Stephen Pabarue **IMAGING** Francis Fitzgerald (Director), Rob Roszkowski (Manager), Charles Guardino, Jeffrey Ingledue **SPECIAL THANKS TO** David Barbee, Jane Bealer, Stacie Fenster, Margery Frohlinger, Ean Sheehy, Céline Wojtala, Patrick Yang

TIME INC. HOME ENTERTAINMENT

PUBLISHER Richard Fraiman **GENERAL MANAGER** Steven Sandonato **EXECUTIVE MARKETING SERVICES** Carol Pittard **DIRECTOR, RETAIL & SPECIAL SALES** Tom Mifsud **DIRECTOR, NEW PRODUCT DEVELOPMENT** Peter Harper **DIRECTOR OF TRADE MARKETING** Sydney Webber **ASSISTANT DIRECTOR, BOOKAZINE MARKETING** Laura Adam **ASSISTANT DIRECTOR, BRAND MARKETING** Joy Butts **ASSOCIATE COUNSEL** Helen Wan **BOOK PRODUCTION MANAGER** Suzanne Janso **DESIGN & PREPRESS MANAGER** Anne-Michelle Gallero **BRAND & LICENSING MANAGER** Alexandra Bliss **SPECIAL THANKS TO** Glenn Buonocore, Susan Chodakiewicz, Lauren Hall, Margaret Hess, Jennifer Jacobs, Brynn Joyce, Melissa Joy Kong, Robert Marasco, Amy Migliaccio, Brooke Reger, Ilene Schreiber, Adriana Tierno, Alex Voznesenskiy, Jonathan White

ISBN 10: 1-60320-067-3
ISBN 13: 978-1-60320-067-7
Library of Congress Number: 2009900529
Copyright © 2009 Time Inc. Home Entertainment.
Published by People Books, Time Inc., 1271 Avenue of the Americas, New York, N.Y. 10020. All rights reserved.

Please write to us at People Books, Attention:
Book Editors, P.O. Box 11016, Des Moines, IA 50336-1016.
● If you would like to order any of our hardcover Collectors Edition books, please call us at 1-800-327-6388 (Monday through Friday, 7 a.m.-8 p.m., or Saturday, 7 a.m.-6 p.m. Central Time).

Credits

FRONT COVER
(clockwise from top right) ABC/Retna; Neal Peters Collection; Fin Costello/Redferns/Getty Images; Everett; Steve Schapiro (2); Michael Ochs Archives/Getty Images

TITLE
Jim Britt/ABC/Retna

CONTENTS
2 (from top) Steve Schapiro/Corbis; Michael D. Brown/Shutterstock; **3** (clockwise from top left) Everett; Steve Schapiro; Kobal; Harry Langdon/Shooting Star; Owen Franken/Corbis

ICONS
4 Douglas Kirkland/Corbis; **5** ABC/Retna; **6** Douglas Kirkland/Corbis; **7** WENN; **8** Fin Costello/Redferns/Getty Images; **10** Ron Galella/Wireimage; **11** Steve Schapiro; (inset) Neilson Barnard/Rex USA; **12** Slick Lawson; **13** Jacqui Wong/London Features Int'l; **14** Bettmann/Corbis; (inset) Vinnie Zuffante/Startraks; **15** Getty Images; **16** Michael Ochs Archives/Getty Images; **17** ScreenScenes

STAR TRACKS
18 Michael Ochs Archives/Getty Images; **19** (from top) Gary Lewis/Retna; Bob Noble/Globe; **20** (clockwise from left) Phil Roach/IPOL/Globe; Elio Sorci/Photomasi/Camera Press/Retna; Ron Galella/Wireimage; **21** (from top) Phil Roach/IPOL/Globe; Michael Ochs Archives/Getty Images; **22** (clockwise from top left) Bobby Bank/Wireimage; Ron Galella/Wireimage; Everett; Ron Galella/Wireimage; **23** Phil Roach/IPOL/Globe

STYLE
24 Douglas Kirkland/Corbis; **26** Gene Trindl/MPTV; (insets from top) David Sutton/MPTV; Lynn Goldsmith/Corbis; **27** Phil Roach/IPOL/Globe (2); **28** Ron Galella/Wireimage; **29** (clockwise from top right) Stephen Shames/Polaris; MPTV; AP; Bruce McBroom/Getty

Images; **30** Alamy; **31** (from left) Courtesy Martin Taylor; Courtesy Armin Kussler; **32** Carlo Bavagnoli/Time Life Pictures/Getty Images; **33** (from top) John Olson/Time Life Pictures/Getty Images; Ralph Crane/Time Life Pictures/Getty Images; Mirrorpix/Everett

MOVIES
34 Kobal; **36-37** Kobal; (insets from left) Kobal; ScreenScenes; Photofest; **38** (clockwise from top left) Neal Peters Collection; Photofest; Kobal; ScreenScenes; **39** (from top) Nana Productions/Sipa; ScreenScenes; **40** Steve Schapiro; **41** (from top) Rex USA; Everett; **42** Alan Band/Keystone/Getty Images; (inset) Neilson Barnard/Getty Images; **43** Everett; **44** ScreenScenes; (insets from top) ScreenScenes; Everett; ScreenScenes; Everett; ScreenScenes; **45** (from top) Kobal; Photo 12/Polaris; **46** (from top) MPTV; Kobal (2); **47** (from top) ScreenScenes; Kobal; **48** (from top) John Jay/MPTV; Mark Savage/Elevation Photos/iPhoto; **49** WENN; **50** (from top) Everett; Kobal (2); **51** (from top) Everett (2); WENN; **52** ScreenScenes; (insets from left) Michael Ochs Archives/Corbis; Tammie Arroyo/AFF; **53** (from top) Neal Peters Collection; Everett (2); **54** (clockwise from top left) Kobal; Everett (2); Kobal; Photofest; **55** (clockwise from top right) Steve Schapiro; Everett (2); Kobal; Matthew Naythons/Liaison/Getty Images

MUSIC
56 Photofest; **58** Steve Schapiro; **59** Ian Dickson/Redferns/Retna; **60** Robin Platzer/Twin Images/Time Life Pictures/Getty Images; **62** (clockwise from top) Allan Tannenbaum/Polaris; Rose Hartman/Globe; Andy Warhol Foundation/Corbis; **63** (clockwise from left) Robin Platzer/Twin Images/Time Life Pictures/Getty Images; Bobby Bank/Wireimage; Lynn Goldsmith/Corbis; John Roca/Polaris; Bob Deutsch/Neal Peters Collection; **64** Robert Knight/Retna; **65** (from top) Chris Morris/Rex USA; Christopher

Harris/Globe; Terry O'Neill/Hulton Archive/Getty Images; **66-67** Henry Diltz/Corbis; (insets from left) Dave Hogan/Getty Images; Courtesy Mark Montgomery; Jon Levy/AFP/Getty Images; Clinton H. Wallace/Photomundo/Globe; **68** Jack Robinson/Hulton Archive/Getty Images; (inset) Damian Dovarganes/AP; **69** Jim McCrary/Redferns/Getty Images; (inset) Danny Moloshok/Reuters; **70** Michael Ochs Archives/Corbis; **71** (from top) Sam Emerson/Polaris; Everett; **72** Michael Ochs Archives/Corbis; **73** (from top) Jan Persson/Redferns/Getty Images; Jun Sato/Wireimage; **74** Olle Lindeborg/Retna; (insets from left) Niviere-Benaroch/Sipa; Dylan Martinez/Reuters; Patrik Sterberg/All Over Press/Polaris; **75** (clockwise from top left) Niviere-Benaroch/Sipa; Neilson Barnard/Getty Images; David Redfern/Redferns/Getty Images; **76** Lynn Goldsmith/Corbis; **77** (from left) Courtesy Felipe Rose; David Redfern/Redferns/Getty Images; **78** (clockwise from top right) Mick Rock/Retna; Kevin Mazur/Wireimage; Michael Ochs Archives/Getty Images; Jim Cooper/AP; **79** SMP/Globe; (inset) Barry Talesnick/IPOL/Globe; **80** Michael Ochs Archives/Corbis; **81** Lynn Goldsmith/Corbis; (inset) Express UK/Zuma; **82** Lynn Goldsmith/Corbis; (inset) Rebecca Sapp/Wireimage; **83** MPTV; **84** (top) Sam Emerson/Polaris; (inset) Courtesy Les McKeown; (bottom) Michael Ochs Archives/Getty Images; (inset) Barry Sweet/Polaris; **85** Michael Ochs Archives/Getty Images; (inset) Mavrix Photo; **86** Michael Ochs Archives/Getty Images; (inset) Laura Farr/Zuma/Corbis; **87** (clockwise from top right) MPTV; Mark Mainz/Getty Images; John Partipilo/Globe; R.Stonehouse/Camera Press/Retna; **88** (clockwise from top left) Chuck Boyd/Globe; Tom Hill/Wireimage; Anwar Hussein/Empics Entertainment/Abaca USA; Michael Ochs Archives/Getty Images; Photofest;

89 (clockwise from top right) Michael Putland/Retna; Michael Ochs Archives/Getty Images; B.C. Kagan/Retna; David Redfern/Redferns/Getty Images; Michael Ochs Archives/Getty Images

TELEVISION
90 Douglas Kirkland/Corbis; **92** (clockwise from top) Jeff Kravitz/Filmmagic; ABC/Retna (3); **93** CBS/Landov; **94-95** Bettmann/Corbis; (insets, clockwise from top left) Owen Franken/Corbis (2); Lynn Goldsmith/Corbis; NBC/Everett; Lynn Goldsmith/Corbis; NBC/Everett (2); **96** CBS/Landov; **97** (from top) Allan Tannenbaum/Polaris; Richard Noble/PBS/AP; **98** ScreenScenes; **99** (clockwise from bottom right) Gene Trindl/MPTV; CBS/Landov (3); **100** ABC/Retna; **101** Roger Karnbad/Celebrity Photo; **102** ABC/Retna; (insets from left) Lester Cohen/Wireimage; Geoffrey Swaine/Rex USA; Christina Radish/London Features Int'l; DFI-AAD/Starmax; **103** ABC/Retna; **104** ScreenScenes; **105** (clockwise from top right) Roger Walsh/Landov; Bill Davila/Startraks; Michael Tran/Filmmagic; Robert Pitts/Landov; Giulio Marcocchi/Sipa; Roger Walsh/Landov; Time Life Pictures/DMI/Getty Images; Alberto E. Rodriguez/Getty Images; **106** (clockwise from top left) Douglas Kirkland/Corbis; ABC/Retna; CBS/Landov; **107** (from top) NBC/Everett; ABC/Retna; **108** (clockwise from top left) Bruce McBroom/MPTV; CBS/Landov (3); ABC/Retna (2); **109** (clockwise from top right) ABC/Retna; NBCU PhotoBank; CBS Photo Archive/Getty Images; CBS/Landov

NEWSMAKERS
110 Bill Pierce/Time Life Pictures/Getty Images; **111** Ted Russell/Polaris; **112** Everett; **113** (from top) Eric Ryan/Getty Images; Eyevine/Zuma; **114** Alain Mingam/Liaison Agency/Zuma; **115** Bettmann/Corbis; **116** (from top) MPI/Getty Images; CBS Photo Archive/Getty Images; **117** Matthew Naythons/Liaison/Getty Images; (inset) Greg

Robinson/San Francisco Examiner/AP; **118** John P. Filo/Getty Images

SPORTS
120 Terry O'Neill/Hulton Archive/Getty Images; (inset) Peter Kramer/Getty Images; **121** (clockwise from top left) Ken Reagan/Camera 5/Time Picture Collection/Getty Images; Langbehn/Action Press/Zuma; Bettmann/Corbis; **122** Tony Duffy/Allsport/Getty Images; (insets from left) Courtesy General Mills; David Walstad/News & Views/ScreenScenes; **123** Bettmann/Corbis

LOVE STORIES
124 Lichfield/Getty Images; **126** (from left) John Roca/Polaris; Ron Galella/Wireimage; **127** (from top) Photofest; Terry O'Neill/Camera Press/Retna; **128** Ron Galella/Wireimage; (insets from left) Allan Tannenbaum/Polaris; Ron Galella/Wireimage; **129** Phil Roach/IPOL/Globe

POP CULTURE
130 Bettmann/Corbis; **132** (from top) Stan Wayman/Time Life Pictures/Getty Images; David Burnett/Contact Press Images; **133** (clockwise from left) Everett; Bernard Gotfryd/Getty Images; Sahm Doherty/Time Life Pictures/Getty Images; **134** Ted Streshinsky/Corbis; **135** (from top) Sandy Solmon/Globe; MPTV; **136** (Hello, clockwise from top left) Al Freni/Getty Images; Frank White; Al Freni/Getty Images; Michael D. Brown/Shutterstock; James Keyser/Time Life Pictures/Getty Images; Courtesy Dress That Man; **137** (Goodbye, from top) Seide Preis/Getty Images; Joe Tree/Alamy; Feng Yu/Shutterstock; Paul Brown/Alamy; Dan Sullivan/Alamy; Courtesy Queen of Hearts Vintage Thrift

BACK COVER
(clockwise from top left) CBS/Landov; David Burnett/Contact Press Images; Terry O'Neill/Hulton Archive/Getty Images; Lucas Films/Zuma; ABC/Retna; Everett; CinemaPhoto/Corbis; Everett; Photofest